Picturing Berkeley

A POSTCARD HISTORY

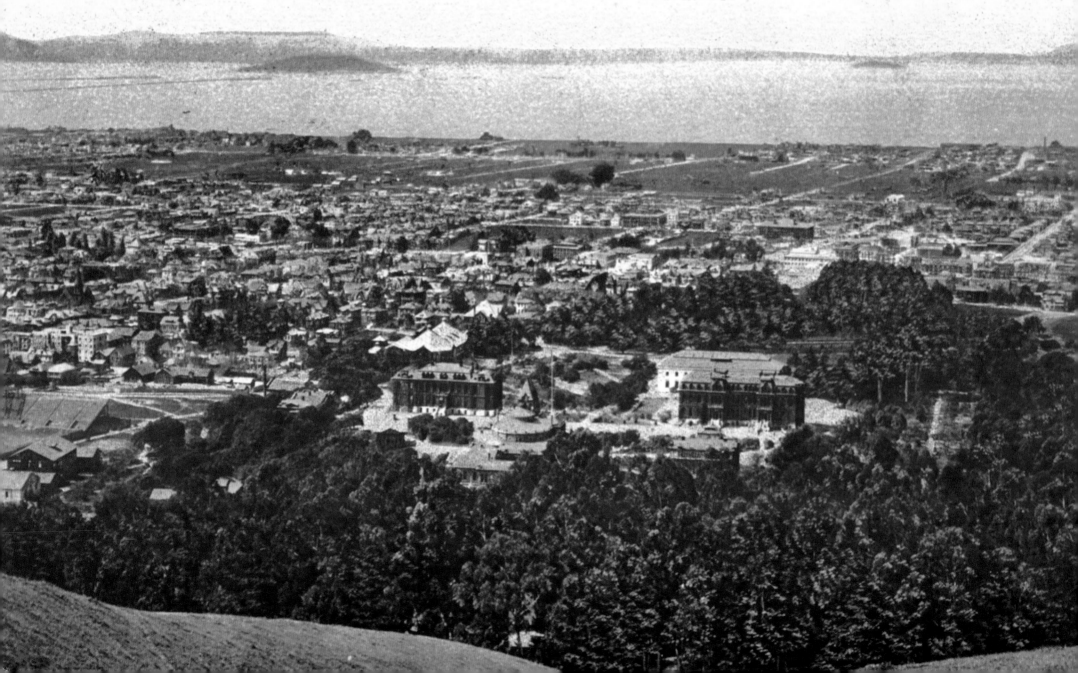

Panoramic View of Berkeley, California, showing the Golden Gate, Alcatraz, Goat Island and San Francisco in the distance.

Picturing Berkeley

A POSTCARD HISTORY

Burl Willes

Editor

CONTRIBUTORS

Anthony Bruce
Kenneth H. Cardwell
Susan Dinkelspiel Cerny
Ed Herny
Sarah Wikander
Burl Willes

Gibbs Smith, Publisher
Salt Lake City

First Edition
09 08 07 06 05 10 9 8 7 6 5 4 3 2 1

Published by
Gibbs Smith, Publisher
P.O. Box 667
Layton, Utah 84041
Order: 1.800.748.5439
www.gibbs-smith.com

Designed by Kathleen Tandy

Library of Congress Control Number: 2005920120
ISBN 1-58685-468-2

TABLE OF CONTENTS

SO MUCH TO SEE AT

BERKELEY

I COULD WRITE A BOOK
ABOUT IT.

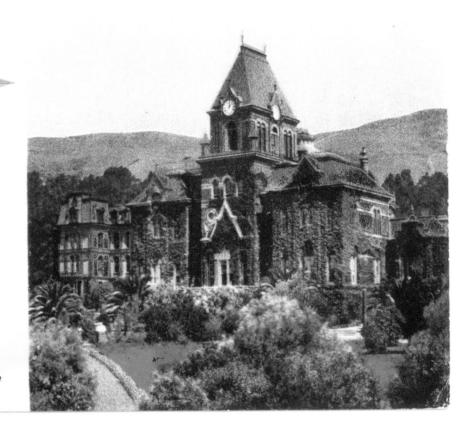

1566 — OLD LIBRARY BUILDING.

IT IS DIFFICULT TO IMAGINE TODAY JUST HOW POPULAR POSTCARDS WERE AT THE BEGINNING OF THE TWENTIETH century. Priced at a penny each, the picture postcard was bright, attractive, and an easy form of communication. A postcard sent in the morning mail could arrive that same day in the afternoon mail delivery.

By 1908, every town in America large enough to have a Main Street was pictured on postcards. That year, 677 million postcards were mailed in the United States, yet the population was only 88 million!

In Berkeley, however, there was more to photograph than its main street, Shattuck Avenue. The new University, the first in the West, was a great tourist attraction. The postcard possibilities were almost unlimited. When the Greek Theater opened in 1903, it was difficult to keep up with the demand for scenes of the new amphitheater.

Berkeley, proclaimed as the "Athens of the West," attracted creative people from all ethnic and cultural backgrounds. Postcards portrayed their contributions: homes, gardens, churches, hotels, social clubs, and schools. Whenever there was a potential market, postcard publishers were there to document local events for posterity: the visit of Teddy Roosevelt's Great White Fleet in 1908, the Morrell Airship Disaster in 1908, Berkeley's Golden Jubilee in 1916, and the 1923 Berkeley Fire.

When Ken Cardwell and I first decided to do a book on Berkeley postcards, we envisioned a small, simple book highlighting perhaps a hundred cards from the Berkeley Historical Society collection. The project became larger and grander when Sarah Wikander enthusiastically offered to let us use her collection of 1,600 Berkeley postcards. For the first time we saw many new scenes from Berkeley's past, and we knew then that we had a treasure to share and document. In addition, I have included a chapter entitled "The Other Side" to showcase some postcard messages together with brief biographical sketches of the recipients. The resulting book now encompasses a history of the picture postcard, chapters on Berkeley's downtown and the various residential neighborhoods, and a long chapter on the University of California and its special events.

These nostalgic, often hand-tinted picture postcards offer us a vivid picture of Berkeley's unique and diverse history.

—Burl Willes
Berkeley, California

"Old Library Building."
Souvenir Publishing Co.,
No. 1566.

South Hall.

Campus

The Oaks

North Hall

Palm Garden

Mechanics Hall

Library

UNIVERSITY OF CALIFORNIA BERKELEY, CAL.

Jan 21st 1904

The History of the Picture Postcard

...AND THE POSTCARD AS HISTORY

CREDIT FOR THE INVENTION OF THE POSTCARD IS GENERALLY GIVEN TO DR. EMANUEL HERRMANN, A PROFESSOR AT the Wiener-Neustadt Military Academy, who proposed the idea in a newspaper article in 1869. Later that year, the Hungarian government accepted the idea and began issuing postcards. In many parts of Europe and elsewhere, Dr. Herrmann is accepted as the "father" of the postcard, and celebrations have been held and postcards issued to commemorate the anniversary of his 1869 proposal. Subsequent research has established that John H. Charlton of Philadelphia produced and copyrighted postcards as early as 1861, so perhaps this acclaim should go to another. In any case, by the early 1870s, both in the U.S. and abroad, "government" postcards were being produced by many nations. Later on, government-issued cards with the stamp printed on them would be given the designation "postal card," and the term "postcard" would apply only to privately published cards.

At first, all of these cards lacked illustration. The first "picture" postcards began appearing in the early 1870s. These early cards were published sporadically in many different countries, and isolated cards from small private publishers were issued in connection with expositions and wars and as advertisements. During this period, they did not catch on with the general public.

It was not until the 1890s that the letter-writing public at large was taken with the idea of the postcard. Color on cards had first appeared in 1889 and quickly became the rule. The first true picture postcards in the United States were issued in 1893 for the World's Columbian Exposition in Chicago. Themed to commemorate the 400th anniversary of the European discovery of America, it opened a year late. It was a grand spectacle that drew millions of visitors and, as one of its greatest legacies, launched the picture postcard in America. Thus began an explosion of popularity for the humble postcard that would not abate until explosions of a different kind ended the world's innocence a quarter of a century later with the beginning of World War I. "The rest is history" is perhaps doubly true in this case, as collectors and historians of today avidly sift through the billions of cards that have poured forth from the publishers, each searching for those cards that reveal and illustrate the particular bits of history that captivate them.

Though the popularity of the postcard is evident from the hordes of surviving cards today, it is nevertheless difficult to appreciate the scale of popularity achieved by the postcard during its heyday (1907–1915). In the present day, the postcard's use has been reduced mainly to a means of communicating with one's "home front" while traveling far from home. Although this is how most people today see the postcard, this

"University of California, Berkeley, Cal."
Edward H. Mitchell.

This Mitchell "Private Mailing Card," copyright 1898, is one of the earliest printed picture postcards of Berkeley. Its multiple "vignetted" scenes are typical of its era.

use is drastically circumscribed in comparison to its role at the turn of the twentieth century, which makes it difficult for people today who are not collectors or historians to understand what the excitement was about.

Since very few people then had telephones in their homes, the postcard served as an inexpensive means of communicating brief messages to friends. Inquiries as mundane as asking about someone's health or whereabouts were frequent, as were the replies thereto. In an era when, somehow, the mail was often delivered more quickly than it is today, it was not unusual to send messages stating that the writer would be "arriving tomorrow" (!), and it was not unusual for folks back then to send postcards to their friends to let them know that they had just taken a "ferry across the bay." While most people are now accustomed to traveling great distances on vacations and business, the very idea of a vacation (from one's job) was then a new one, and these mostly short excursions gave millions an excuse to communicate with friends and family and (even better) to provide a picture of the destination.

We are the fortunate beneficiaries of this blizzard of illustrated correspondence. Anyone interested in the history of the early part of the twentieth century soon finds that if one requires pictures of any aspect of it, old postcards are the most productive place to look. Whether views of your home town, or where you went to school, or the means of transportation you used, or the people of the era—these images survive on postcards in greater number and variety than anywhere else.

The humble postcard—this stepchild of the letter, this ephemeral cousin of the book, this modest relation of larger works of art—has thus been transformed into the most effective medium we have for glancing backward at the world of our grandparents.

POSTCARD ERAS

Postcard collectors have, for some time, sought to impose some order on the great mass of published cards by categorizing them according to the types of cards that were published during different time periods or "eras." This effort at consensus, while of necessity inexact and fraught with exceptions, has proved useful, particularly to beginning collectors. While authors and authorities have differed slightly on the details, seven eras are generally accepted as encompassing the history of postcard publishing. The following designations apply only to privately published postcards, not government postal cards, and only to U.S. postcards.

1. Pioneer Era: 1870–1898

Cards that bear a postmark, copyright date, or sender's handwritten date from the above years can be attributed to this era with relative certainty. However, in the absence of this evidence, certain printing details often indicate a probable "pioneer" dating. These include the use of terms other than "postcard" on the backs of the cards, such as "Souvenir Card," "Correspondence Card," "Mail Card" (or "Mailing Card"), or combinations thereof. During this time period, the U.S. Post Office required a two-cent rate for these cards, while at the same time U.S. government postal cards required only one cent. This one-cent difference may not seem significant, but it resulted in private cards costing double the price to send; add the cost of buying the card, and it amounted to a significant disincentive.

2. Private Mailing Card Era: 1898–1901

By 1898, the still fledgling but growing public demand for privately printed picture postcards resulted in Congress passing a law that went into effect on May 19, 1898, that lowered the postal rate on private cards from two cents to one cent,

giving them parity with government postals. However, the act also had some specific requirements for the publishers. All private cards had to have the words "Private Mailing Card" printed prominently on their backs, together with the tag line "Authorized by Act of Congress of May 19, 1898." This act had the effect of legitimizing private postcards by taking them out of the legal gray area that they had previously occupied. This factor and, more importantly, the reduced mailing rate resulted in a great increase in the number of publishers and quantity of cards printed.

3. Undivided Back Era: 1901–1907

Congress acted again on December 24, 1901, by allowing the words "Post Card" to be used on the back. A size restriction included in the 1898 act was also removed, thereby allowing private cards to be full-size (3½" x 5½"). The only other proviso was that no message could be written on the back of the card, only the address. This, of course, meant that if the front of the card were entirely covered with the picture, there would be no room at all for any message. Publishers overcame this obstacle by "vignetting" the illustration or by leaving part of the front of the card blank so that senders could squeeze in a small personal message. This period saw a great surge in the popularity of sending picture postcards.

4. Divided Back Era: 1907–1915

During the American "Undivided Back" Era, most of the European countries had enacted postal regulations allowing the back of private postcards to be divided into two sections, one for the address and one for the sender's message. This was immensely popular, as much longer messages could now fit in the allowed space. By 1907, public pressure in this country convinced Congress to pass similar regulations allowing "divided backs" on postcards here. Once again, the popularity

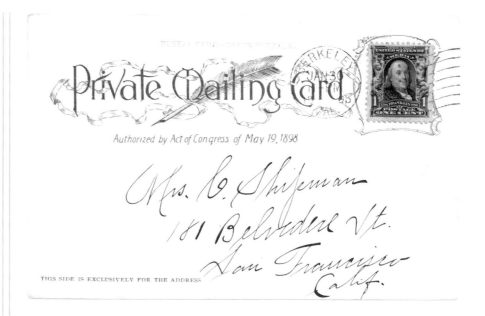

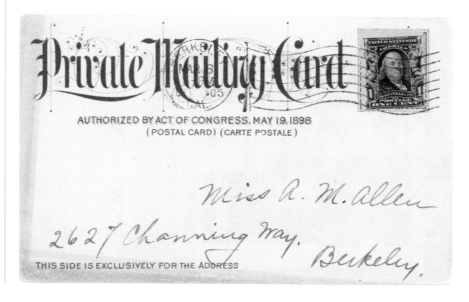

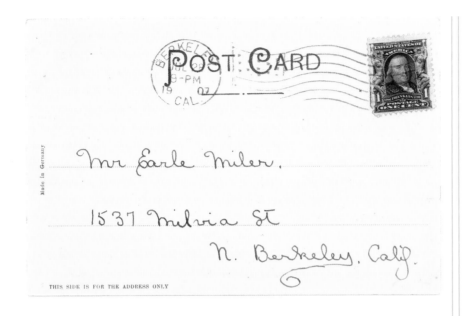

of picture postcards soared, and this period is now referred to by modern collectors as the "Golden Age of Postcards."

5. White Border Era: 1915–1930

World War I ended the Golden Age of the picture postcard. Prior to the war, many U.S. cards were printed in Germany, a practice that ceased with the outbreak of hostilities. Also, other wartime economic factors and many changes in popular culture combined to spell the end of the Golden Age. Certainly, cards continued to be published and sent, but the printing quality plummeted along with demand for cards. The cheaply printed cards that typify this period often have a narrow white border around the picture.

6. Linen Era: 1930–1945

Around 1930, a new printing process made it possible to print picture postcards on a type of card stock that had a "linen" textured surface. This technique quickly became popular, and most cards of this period were printed in this fashion. Also, the photographs were heavily retouched, giving the cards an almost hand-drawn look.

7. Photochrome Era: 1945–the Present

The cards of this period are printed by a process that results in a glossy finish, referred to by printers as "chrome" finish. These were the first postcards to be made using color photography (Kodachrome transparencies), so the finished product is known as a "Photochrome." Collectors today refer to these cards simply as "chromes."

Reverse side, "Undivided Back" postcard.

No message was allowed on the reverse side of an "Undivided Back" card.

Reverse side, "Divided Back" postcard.

In this typical "Divided Back" card, the publisher's typeset imprint serves as the dividing line between the message and address sections of the card.

"Birdseye View from University of California, Berkeley, California."
E. P. Charlton & Co., No. 348.

The picture side of a typical "Undivided Back" card. Since postal regulations forbade any message to be written on the reverse side, the publisher has left some white space on the front side.

"Birdseye View of Berkeley, from University of California."
Edward H. Mitchell, No. 348.

With the introduction of the divided back, blank space no longer needed to be reserved on the front side of the postcard. Publishers quickly expanded the "picture" to take the entire side.

"Telegraph Avenue and Bancroft, Berkeley, Calif."
Western Notion & Novelty Co., No. 30598.

A typical "White Border" card. These artistic borders were introduced in an era when postcard sales were slumping.

"Shattuck Avenue, Berkeley, Calif."
Stanley A. Piltz Company, "Pictorial Wonderland," Art Tone Series No. SA-H930.

"Linen" cards, which often had borders, were printed on a linen-like textured paper.

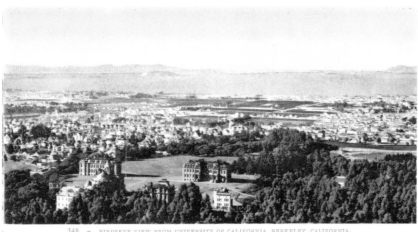

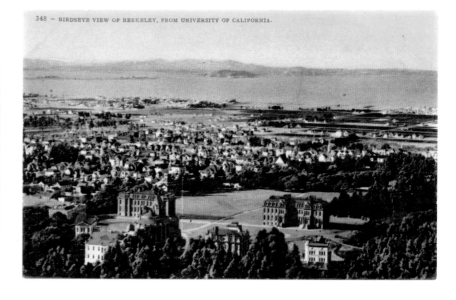

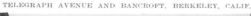

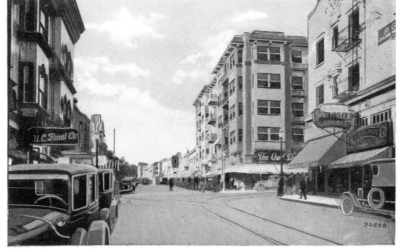

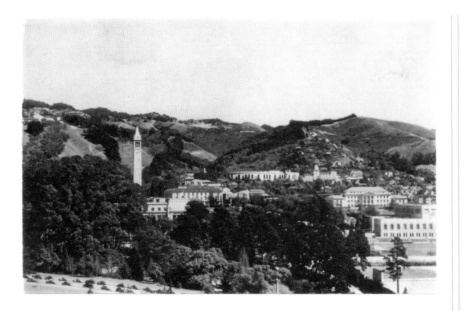

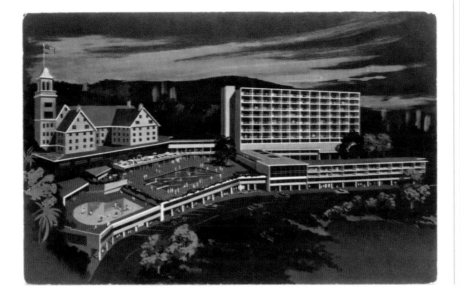

PRINTED OR REAL-PHOTO?

A further distinction in categorizing cards is whether a card is "printed" or "real-photo." At first, all postcards were printed, that is, produced by applying ink to paper. However, shortly after 1900, the growing popularity of photography caused some individuals and publishers to create cards that were actual photographs. These cards were made by exposing light-sensitive photographic paper by means of projecting light through a negative onto the paper and then immersing the paper in various chemicals to produce a photograph. Only cards made in this way can be called real-photo cards, since only they are real photographs. Much confusion occurs, particularly among new collectors, who mistake printed cards for real-photos because the image on the printed card was made from a printing plate created from a photograph. Real-photos can usually be recognized by the type of finish on the surface and also by the back of the card, which usually has the brand name of the photographic paper in the stamp box. The image, even under moderate magnification, is continuous in tone, rather than being composed of halftone dots. Real-photo cards were more difficult and expensive to produce and are therefore less common. Some were made by publishers in moderate quantities, some by individuals in very small quantities. Collectors generally consider real-photo postcards to be superior to printed cards of similar views, and the real-photo postcards are usually more expensive. They are almost always black-and-white, although occasionally they were tinted sepia or other shades, or hand-tinted with transparent colors. However, what they lack in color they often make up for in detail and beauty and, ultimately, in historical content.

"University of California, Berkeley."
Mike Roberts Studios, California "Color Card" No. C221.

The subtle colors of the earliest of the "Chrome" finished cards gave an almost monochromatic appearance.

"Hotel Claremont and Lanai Tower."

Later in the "Chrome" era, colors multiplied and became brighter. The back of this card was imprinted with the following message: "Just a line to show you what our new addition will be when completed summer '59."

**"Foot Ball Statue."
Students Cooperative
Society.**

*The sender of this undivided
back postcard took
advantage of every bit of
unprinted front-side space
to squeeze in all the words
possible, even up the left
margin.*

**"Foot Ball Statue,
U. C. Berkeley."
Armitage photo card,
No. 55.**

*This real-photo postcard is
a good example of the
extreme fineness of detail
possible with this process.*

**"Hearst Greek Theatre,
University of California,
Seating Capacity 8000."
N. J. Abbott & Son,
No. 306.**

*This gravure printed card
shows the great possibilities
for fine detail with this
technique.*

**"Trinity Methodist
Church, at Berkeley,
California."
N. J. Abbott & Son,
hand-colored.**

*This gravure was hand-tinted
for artistic effect.*

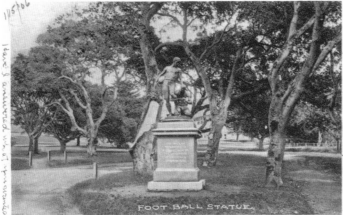

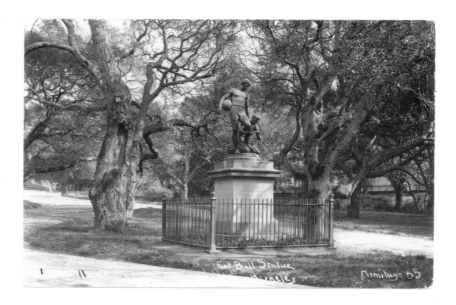

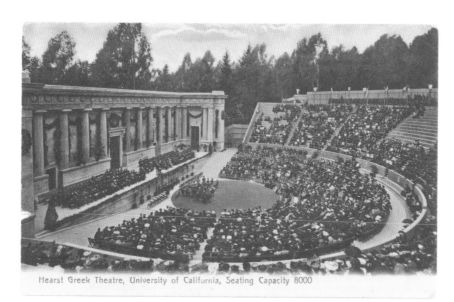

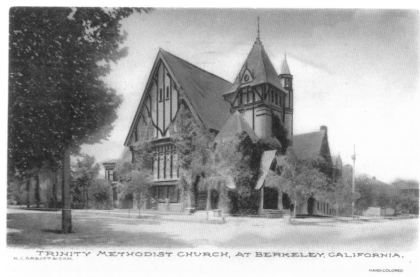

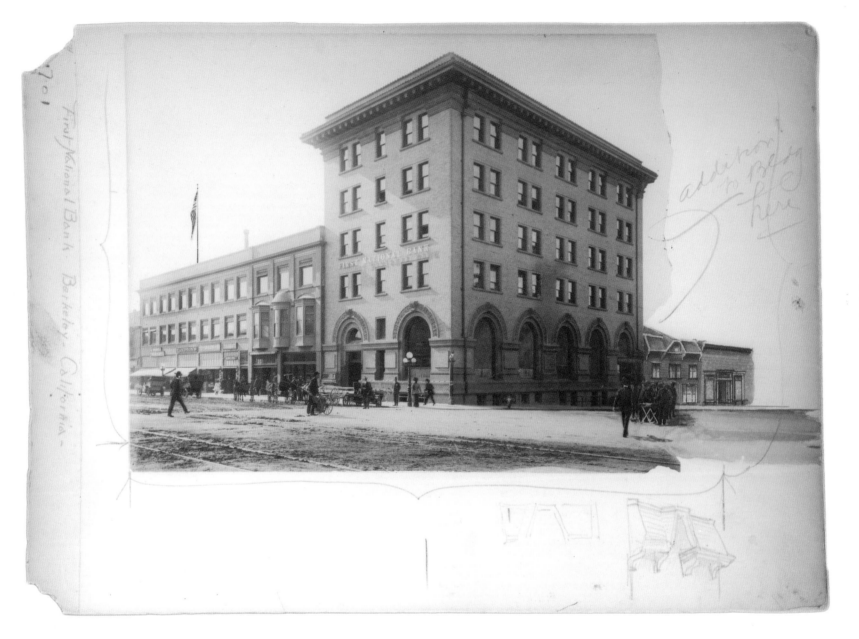

A Mitchell photo in the process of being retouched to improve the design.

Note at the bottom of the picture the sketch of the complicated roofline of the small building next to the bank. This was to aid the artist in drawing in these small buildings! Many of the people in the street are either drawings or small photos pasted onto the large picture.

All of the windows, the dentilled cornice, and other highlights of the buildings have been retouched with white so that these features could receive a light color in the finished postcard. "Addition to bldg here," a handwritten note presumably from a later date, reflects changes to the building and a subsequent edition of the card. According to the Berkeley Reporter, the "unsightly frame buildings that have been an eyesore on the south side of Center Street" were to be torn down and replaced by "a modern brick annex" to the bank building. *See the updated version on page 42.* *Courtesy of California Historical Society; FN-32680.*

POSTCARD PRINTING TECHNIQUES

The term "printed" encompasses all the various processes used to produce postcards that were not real photos. There are quite a few different methods, if one considers every minor difference in procedure, but these can be reduced to a small number of general categories.

Lithography was used extensively on early cards. The original process, referred to by collectors today as "stone" lithography, employed a slab of polished limestone as the printing plate. An image was drawn on it, requiring a different stone for each color, and it was placed in a press into which individual sheets of paper could be fed to produce printed images. The lithographs thus produced could be quite artistic, but the procedure was inefficient and expensive. Most advertising or "trade" cards (not postcards) of the nineteenth century were produced this way, but only a few true postcards were so produced (in the Pioneer and Private Mailing Card eras). The increasing popularity of the postcard led to a need for larger print runs and more mechanized and cost-effective processes, and these soon were developed.

One of these was the "gravure" process. It has many variations (and even more numerous trade names), but generally it was accomplished by using a photographic negative to acid-etch a metal plate with a continuous tone image. The resulting printing plate could then be inserted in relatively high-speed printing presses to produce many cards inexpensively. Most often these gravure cards were printed in one color (monotones). However, the one color could be whatever the publisher chose, and many were printed in tones of sepia, brown, green, or blue. Because the process used "continuous tone"—that is, it did not break the image up into isolated dots—fine detail was possible and often achieved. One note-

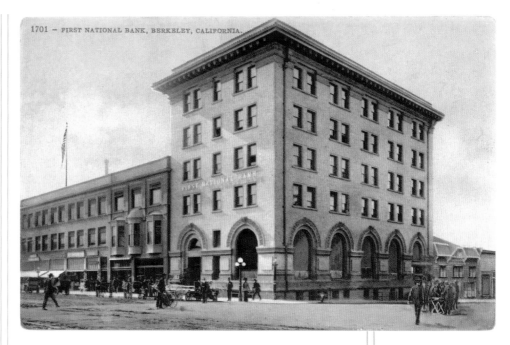

1701 – FIRST NATIONAL BANK, BERKELEY, CALIFORNIA.

worthy variation of this method is the "hand-colored" gravure. As the designation implies, monotone gravures had multiple colors applied by hand, usually with brushes. Depending on the skill of the "colorist," the outcome could vary from slapdash to meticulous.

Another innovation was "photo-offset" lithography. This process, still in use today, was perhaps the one most frequently used. The name is something of a misnomer, as no actual "stone" is employed, despite the retention of the prefix "litho" in the name. Instead, the original image for the card was photographed through a screen, which broke it up into a symmetrical gridwork of tiny dots. This photographic image was then used to etch a steel plate, producing either one-color or multicolor images, depending on the number of different

"First National Bank, Berkeley, California." Edward H. Mitchell, No. 1701.

This is the finished card made from the Mitchell photo that was retouched. It is also typical of the photo-offset lithography process.

Berkeley Gazette, August 28, 1909

MANY VIEWS OF BERKELEY ON POSTALS

Berkeley evidently is a favorite field for producers of post cards, as the views about the University City have been pictured by all the companies that are engaged in producing the popular post cards that may be seen in the windows of dealers in curios and the like.

Already the Berkeley Chamber of Commerce has supplied more than a hundred photographs to manufacturers of post cards, and the demand still continues. This week F. M. Metzgar put in two days making pictures of Berkeley and the University of California to be used by Mitchell & Co. of San Francisco in making post cards. The issue of Mitchell & Co. consists of 18,000 in each edition, and frequently the editions have to be repeated many times. These pictures are sent to all the big cities of eastern states and Europe, making Berkeley familiar to people all over the world. Among the scenes obtained by Mr. Metzgar are the following: Complete panorama of the Hearst Greek Theater, showing every seat and the stage, something that few others have been successful in doing; California field panorama, showing both sides of the seats and the arena (this was taken last Saturday, when the freshman-sophomore pushball game was in progress); street view on Telegraph avenue; the new building of the Berkeley National Bank; scene on Center street, looking up toward the University entrance; the Unitarian Church; the new city hall; the new Polytechnic High School building; the geranium wall near the home of President Wheeler of the University; street scene at Alcatraz; street scene at Ashby, and several other views in and about the city and the University.

A short time ago the Berkeley Chamber of Commerce supplied photographs for an artistic album of California views to be placed on exhibition in the American store that is gaining so much popularity in London, England.

plates prepared. The actual printing was done by first transferring the ink to a thin rubber mat and then to paper. It is this use of an intermediate medium that is referred to by the word "offset." This process could be used in very high speed presses and had the advantages of greater efficiency and longer working life of the printing plates. Certainly, more cards were printed in this way than in any other. The quality varied tremendously, depending on the particular variations of the process used by the publisher. Certain early publishers, such as Mitchell and Detroit, developed highly artistic methods, and their cards were justly acclaimed for their beauty.

The cards of the "chrome" era were also printed by photo-offset lithography; their glossy finish was achieved through the use of special coated paper. In the early days, high-gloss finish could only be achieved by applying a thin skin of transparent cellophane after the card was printed. While this could be attractive, the "skin" usually began fraying and peeling off after any significant handling.

Other methods—from engraving and blockprinting to silk screening and many more—were occasionally seen on postcards. These, however, were usually employed only on low-volume artistic projects.

—Ed Herny

EDWARD H. MITCHELL
PUBLISHER OF
COLORED POST CARDS

3363 ARMY STREET
NEAR MISSION
SAN FRANCISCO, CAL.

"University Grounds,
Berkeley, Calif."
A & W photo card,
No. 37.

"University Grounds,
Berkeley, California."
Edward H. Mitchell,
No. 104.

"University Grounds,
Berkeley, California."
Bardell Print.

"University Grounds,
Berkeley, California."
Bardell-O'Neill,
"Fototone" No. 110.

*These cards illustrate how
the same original photo-
graph could be printed
using various processes to
make four very different
postcards. The first is a
real-photo postcard, the
second and third are
monochromes (one sepia
and one black) printed by
photo-offset lithography,
and the last is similar to
the second but has been
printed on paper and then
"tipped" (pasted) onto a
card stock mount.*

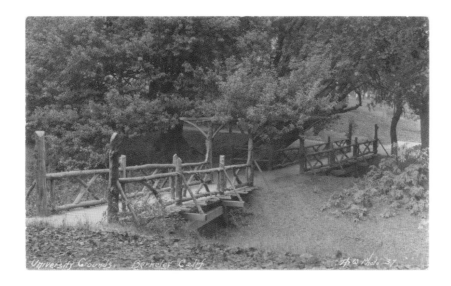

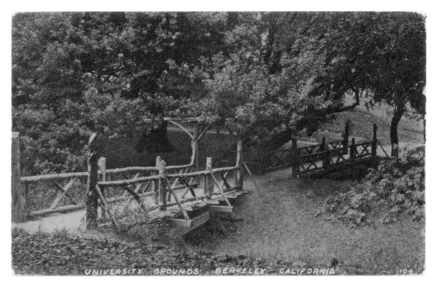

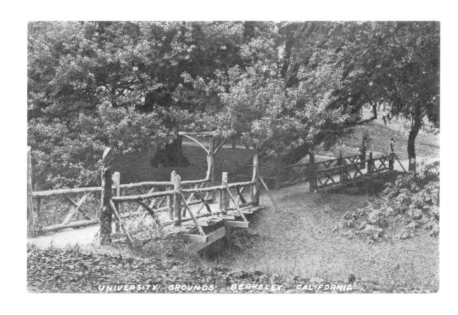

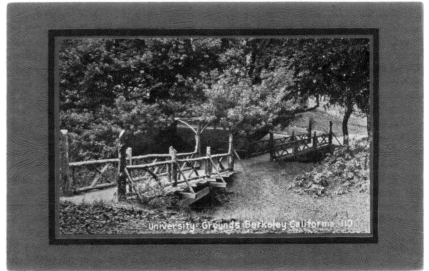

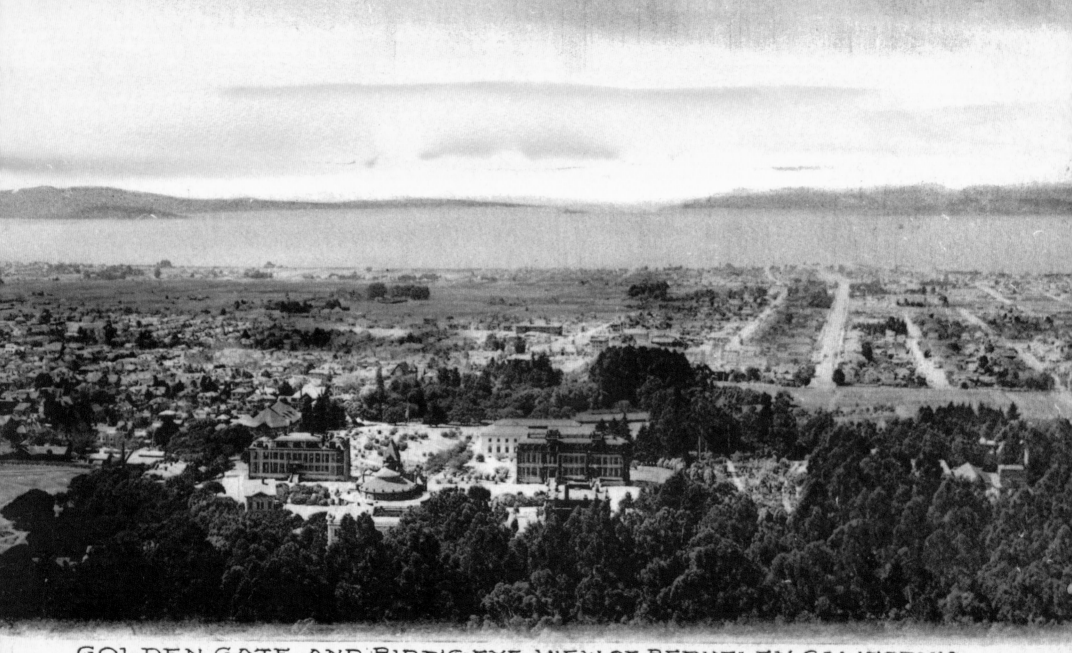

GOLDEN GATE AND BIRD'S-EYE VIEW OF BERKELEY, CALIFORNIA.

N.J.ABBOTT & SON.

HAND-COLORED

The City Beautiful

Berkeley, the home of the University of California…lies on a sloping plain and on picturesque hill-sides—a site matchless for beauty of prospect…. When all the State was open for choice, this spot was selected, on account of its many points of superiority, as an ideal college seat…The place thus chosen lay facing the…Golden Gate.

There is a superb outlook from Berkeley over the bay and city of San Francisco, over the neighboring plains and the mountains beyond the bay, over the ocean through the Golden Gate. The glory of this scene is never two days alike, and even one magnificent sunset would be worth a long trip to observe.

—Berkeley, California, A City of Homes, 1905

B ERKELEY'S LOCATION, DIRECTLY OPPOSITE THE GOLDEN GATE, HAS GIVEN THE CITY A DISTINCT GEOGRAPHIC advantage in terms of beauty. It was not an exaggeration in the early 1900s, nor is it now, to call the city "Beautiful Berkeley."

When the Trustees of the College of California chose this location for their new campus in 1860, it was not only the verdant creekside location that attracted them, but also the exquisite views of bay, mountain, and distant ocean, as well as the ever-changing spectacle of nature that the views provided.

From no other place in the Bay Area are there views directly through the Golden Gate to the Pacific Ocean beyond, and in no other place do the forces of nature provide a constantly varying panorama of spectacular visual events. The wide vista of water and sky are continually affected by the tides, wind, and fog and present a different face at different times of the day and in different seasons. Brilliant sunsets merge into the ocean depths or silently settle in silver streaks behind an incoming fog. On days of sparkling clarity, when winds have blown away haze and mist, along the far horizon the Farallon Islands appear in silhouette. The pageant seizes the imagination of the beholder to this day.

From the time of the earliest settlement, painters—and then photographers—attempted to capture the quality of this unique and intriguing vista. And, naturally, when postcards were first being published of Berkeley, bird's-eye views of the Golden Gate from the hills overlooking the University of California were of special interest to postcard publishers. In fact, many of the earliest Berkeley postcards featured panoramic views. At the same time, postcards depicting buildings would often also include bits of natural landscape features, such as the Berkeley hills, Grizzly Peak, rock outcroppings, or ancient oaks.

Promoting Berkeley meant promoting its natural beauty, and the Chamber of Commerce commissioned many of the photographs that postcard publishers later used for their images.

The University grounds themselves were extolled early and often for their natural beauty. During the postcard heyday, although not officially a "park," the campus was the largest

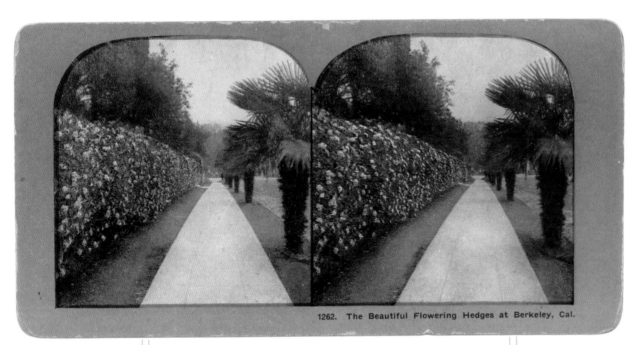

1262. The Beautiful Flowering Hedges at Berkeley, Cal.

boundary demarcation. These later grew to forest the bare hills and provided a rich backdrop for the buildings of both Town and Gown. In 1865, Frederick Law Olmsted was asked by the Trustees of the College of California to plan a residential subdivision for the new college town. His gently curving Piedmont Avenue with its "parked" median and "overbowering" trees was the result, and it survives to this day. By 1900, steep hillside streets north of the campus began to be improved with terracing, and retaining walls were planted with ivy geranium, left to spill over in artistic fashion. Soon after, developers used similar design principles to create subdivisions with contoured streets, lush plantings, and other civic amenities. Even a man-made reservoir could double as a placid lake with the sunset glow reflected in its still water. The citizens of Berkeley were proud of such civic improvements, and their eye-catching appeal is demonstrated by their appearance in the postcards of the day.

—Susan Dinkelspiel Cerny
Anthony Bruce

park-like site on the east side of the bay, and people had long been accustomed to using it almost as a "public pleasure ground." The features that were especially beloved by residents and visitors alike were the two meandering forks of Strawberry Creek and the grove of oaks near the west entrance to the campus. A writer in the 1880s wrote that the natural areas, "dotted with fine specimens of live-oak, have, though untouched, a finished park-like appearance, and are gay with wild poppies, buttercups, primroses, and blue lilies through winter and spring."

The fact that Berkeley was blessed with one of the world's most spectacular natural settings did not prevent Berkeleyans from enhancing what was there. In the early days, farmers planted stands of eucalyptus trees as windbreaks and for

**Untitled (Bear Fountain).
Real-photo postcard,
Edward H. Mitchell.**

*As the centerpiece for the
Northbrae development, a
Beaux Arts-inspired round-
about was planned for the
point where five side streets
converge with Marin Avenue.
To define the center, a
fountain was designed by
University architect John
Galen Howard in 1911. The
bear cubs, representing the
State of California, were
sculpted by Arthur Putnam.
The fountain was destroyed
by a runaway truck in 1958,
and the spot sat empty until
1996, when, through citizen
effort, the fountain was
replicated and rededicated
with an impressive public
ceremony.*

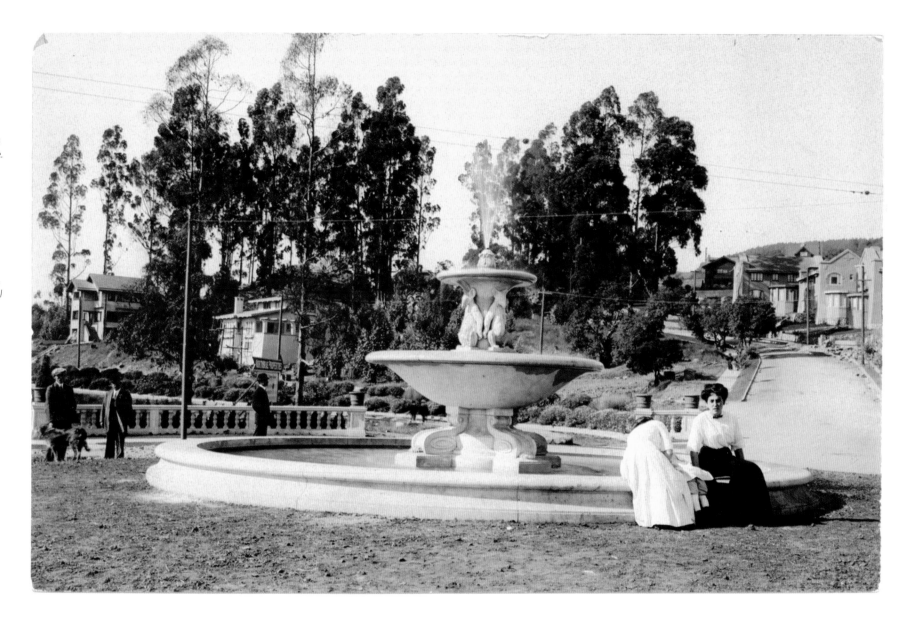

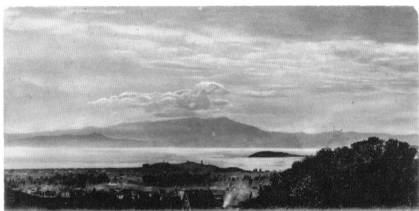

Mt. Tamalpais, from Berkeley, California *My dear – Do you think you can stand a visitation on the Sabbath – me from 10:25 to 4 – 5 and Mother from 1 to same hour of closing? If you have nothing else doing, we'll come. If you have, speak now or forever hold. All right here – and hope your household is better. Lovingly – T.C.* 5/1/06

"Mt. Tamalpais, from
Berkeley, California."
N. J. Abbott & Son.

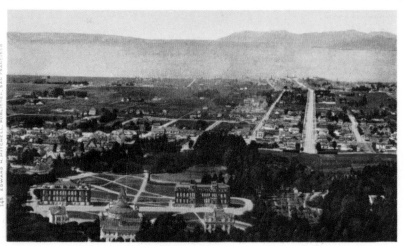

BIRDSEYE VIEW FROM UNIVERSITY OF CALIFORNIA, BERKELEY, CALIFORNIA.

Birds-Eye of Berkeley, Cal.

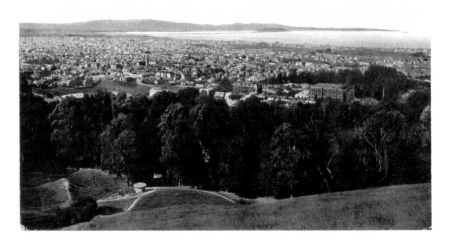

"Birdseye View from
University of California,
Berkeley, California."
Edward H. Mitchell,
No. 348.

*The picture dates from 1900,
but the card, with its undi-
vided back, was published
some time between 1901
and 1907. Note the areas
of settlement around the
University and in West
Berkeley at the end of broad
University Avenue. Most of
central Berkeley was still
open fields.*

"Birds-Eye of
Berkeley, Cal."
Pacific Novelty Company,
"Quality Series" No. B. 36.

*Only the first floor of
California Hall has been
built, which can be seen to
the left of North Hall, dating
this view to the middle of
1904. The tall spire to the
left in the distance is the
Congregational Church at
Durant and Dana; beyond
lies Oakland.*

"Bird's-Eye View of University of California and Berkeley."
Newman Post Card Co., No. W. 5.

The three views on this page are quite similar, with this card and the Abbott card (far right) being identical. Due west of the nearly finished California Hall, the new, brown National Bank of Berkeley can be seen beyond the trees, standing at the corner of Shattuck Avenue and Center Street in the heart of downtown.

"Panoramic View of Berkeley, California, showing the Golden Gate, Alcatraz, Goat Island and San Francisco in the distance."
Pacific Novelty Company, "Quality Series" No. B. 18.

By 1908, central Berkeley was beginning to fill in with houses. To the left, in the bay, the thin line of the Key Route pier can be seen reaching across toward Goat Island, now Yerba Buena Island.

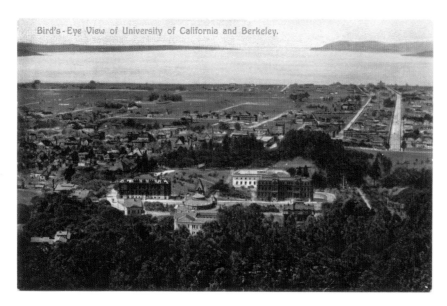

Bird's-Eye View of University of California and Berkeley.

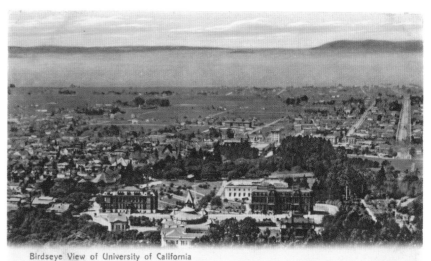

Birdseye View of University of California

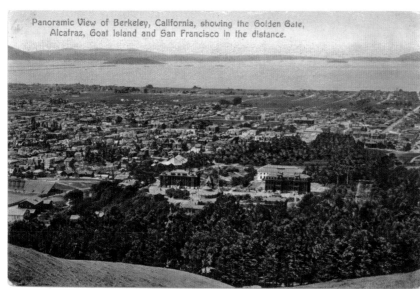

Panoramic View of Berkeley, California, showing the Golden Gate, Alcatraz, Goat Island and San Francisco in the distance.

"Birdseye View of University of California."
N. J. Abbott & Son, No. 304.

A magnifying glass reveals that the tiles were just then being laid on the roof of California Hall, dating this card to the spring of 1905.

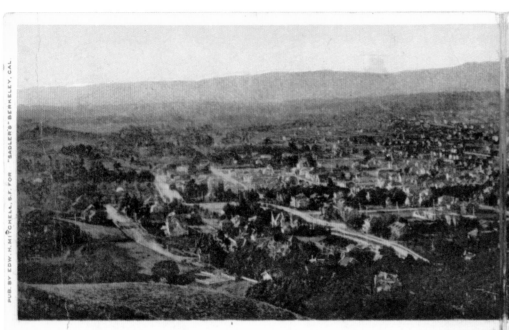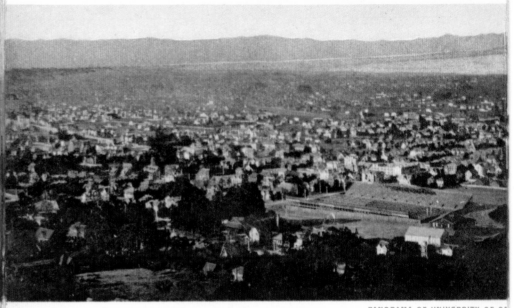

PANORAMA OF UNIVERSITY OF CA

"Panorama of University of California and Berkeley, California."
Fold-out postcard, Edward H. Mitchell for "Sadler's."

*This unique four-part, full-color fold-out card was commissioned
by Sadler's, one of three downtown Berkeley stationery stores that
published their own line of postcards. The panoramic view was taken
in the fall of 1905, and the card probably manufactured soon after.
In the first panel, the green median of Olmsted's Piedmont Avenue
can be seen. This was Berkeley's finest residential neighborhood,
with fanciful Victorian homes (most designed by architect Clinton
Day) set on large "villa" lots. The second panel shows the wooden
bleachers of California Field (John Galen Howard, Architect, 1905)
on the campus. The Hillegass property had been purchased by the
University in 1900, which extended the boundary south to Bancroft
Way. Beyond Bancroft can be seen what was then a neighborhood
of family homes.*

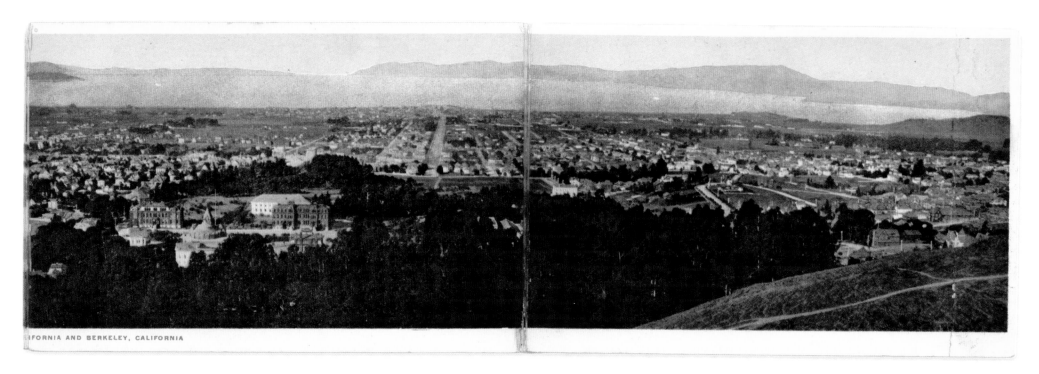

FORNIA AND BERKELEY, CALIFORNIA

The third panel is the standard bird's-eye view showing the main campus buildings: Bacon Hall flanked by South and North halls, with the white granite surfaces of the newly completed California Hall gleaming behind North Hall. The brown-shingle houses in Daley's Scenic Park, Berkeley's first hillside neighborhood, are visible in the fourth panel. This is the area where the Hillside Club's philosophy of "building with nature" flourished and many of architect Bernard Maybeck's earliest houses were built. The white building at the left in this panel, seen behind the eucalyptus trees, is the President's House on the Hearst Avenue edge of the campus.

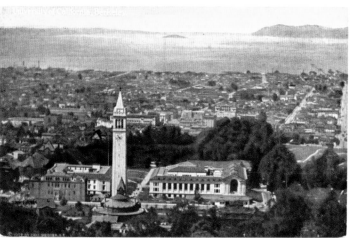

"University of California, Berkeley."
Pacific Novelty Company, No. B-105.

The same view as panel three above, but from the early 1920s, is offered for contrast. Berkeley was by then almost completely developed. On the campus, old North Hall had been razed and Wheeler Hall and Doe Library have been built. The most striking difference is the addition of the tall Campanile to Berkeley's skyline.

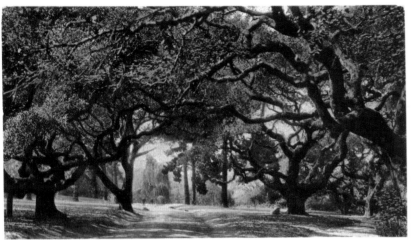

181 Berkeley, California. Oaks at University Grounds.

776 University of California, Berkeley, California — Ancient Indian burial ground.

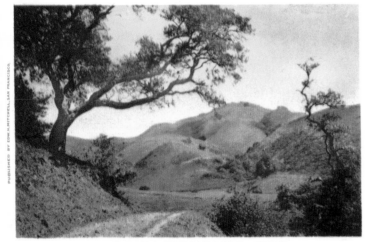

349 GRIZZLY PEAK, UNIVERSITY OF CALIFORNIA, BERKELEY

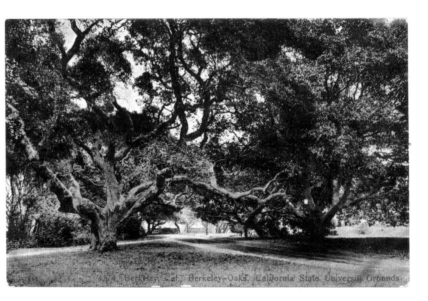

"Berkeley, California, Oaks at University Grounds."
Charles Weidner, No. 181.

The grove of magnificent old live oaks at the confluence of the two forks of Strawberry Creek on the University campus was left untouched when other areas of the grounds were graded and planted. Visitors to the campus entering on foot from Center Street approached through this quiet and shady natural area, as they still do today.

"University of California, Berkeley, California—Ancient Indian burial ground."
Cardinell-Vincent Co., No. 776.

The location of this picture is a mystery. Most likely, it is the rocky, oak-dotted region far north of the campus, later developed as the Thousand Oaks neighborhood, which was referred to as the "burial grounds" in literature of the time.

"Grizzly Peak, University of California, Berkeley."
Edward H. Mitchell, No. 349.

Grizzly Peak, at 1,800 feet above sea level, is the most visible peak in the Berkeley Hills.

"Berkeley, Cal., Berkeley Oaks, California State University Grounds."
Paul C. Koeber Co., "The PCK Series" No. 4174.

Two oaks guard the path leading to a bridge over Strawberry Creek and to Douglas Tilden's Football Statue.

"Walk in University of California grounds, Berkeley, Cal."
Paul C. Koeber Co., No. 4171.

This peaceful late afternoon scene among the oaks shows a walkway south of the present Campanile. At the right, the ground falls away to Strawberry Creek and Faculty Glade.

"Berkeley, Cal., Le Conte Oak, California State University."
Paul C. Koeber Co., "The PCK Series" No. 4173.

The most revered of the campus oaks was the LeConte Oak, shown in the center. In 1898, it was named to honor two beloved members of the faculty, John LeConte, third University president, and his brother Professor Joseph LeConte. This "chieftain" tree of the grove succumbed to old age in 1939 and was replaced.

"The Oaks, University of California, Berkeley."
Edward H. Mitchell, No. 346.

"Berkeley Oaks, Berkeley, Cal."
Newman Post Card Co., No. W. 20.

These gnarled oaks flanked the curving private drive leading to the Frederick Russ House, off Claremont Avenue. The contours have been preserved in present-day Oak Vale Avenue.

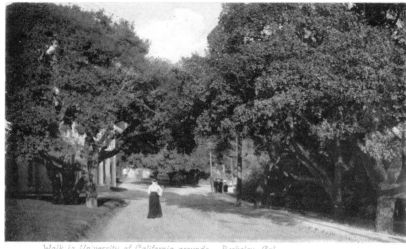

Walk in University of California grounds, Berkeley, Cal.

4171.

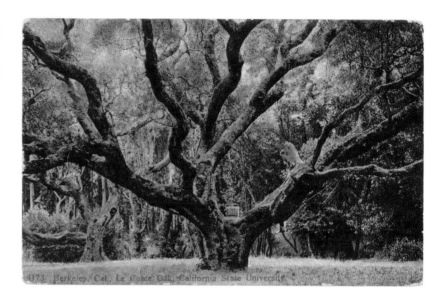

4173 Berkeley, Cal., Le Conte Oak, California State University

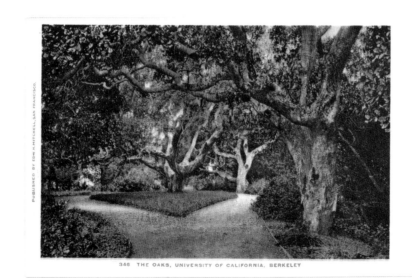

346 THE OAKS, UNIVERSITY OF CALIFORNIA, BERKELEY

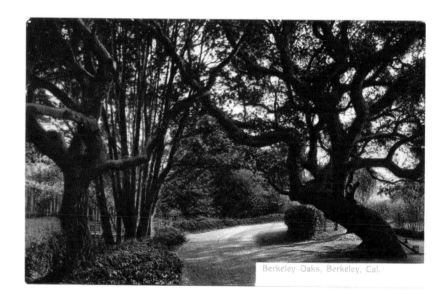

Berkeley Oaks, Berkeley, Cal.

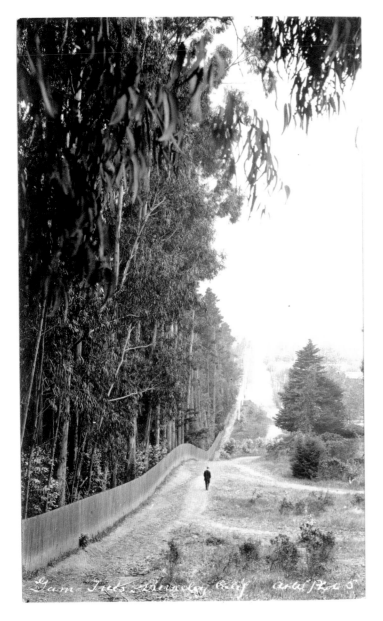

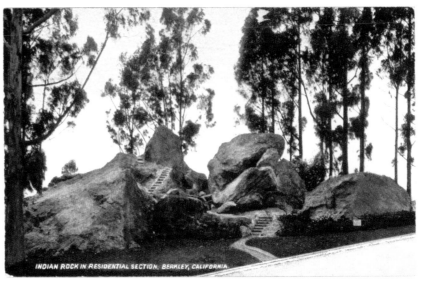

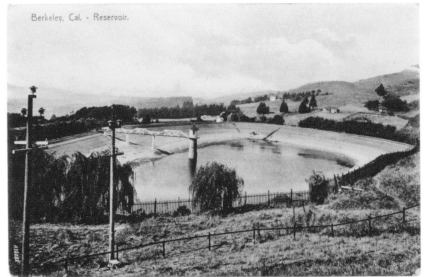

"Gum Trees, Berkeley, Calif."
Real-photo postcard,
A & W Photo, No. 5.

When the California School for the Deaf was established here in 1867, the hillside at the back of the property was planted with 1,000 eucalyptus, or Australian gum trees. The trees had grown into a dense forest by the time this picture was taken from the top of Dwight Way looking west.

"Indian Rock in Residential Section, Berkley [sic], California."
The O. Newman Co.,
No. W 24.

The developers of the North-brae subdivision preserved three impressive rock outcroppings and dedicated them to the City of Berkeley as public parks.

"Berkeley, Cal.—Reservoir."
Pacific Novelty Co., No. 21.

In the 1870s, Henry Berryman purchased extensive acreage in North Berkeley from pioneer Napoleon Bonaparte Byrne. Envisioning a developing town, Mr. Berryman, as owner of the Berkeley Waterworks, built the Berryman Reservoir and also extended the steam train north on Shattuck to Vine Street. Berryman Reservoir stands, now covered with a roof, on the east side of Euclid Avenue, opposite the Berkeley Rose Garden.

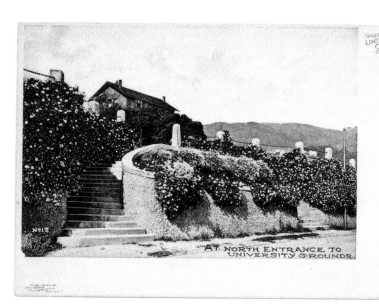

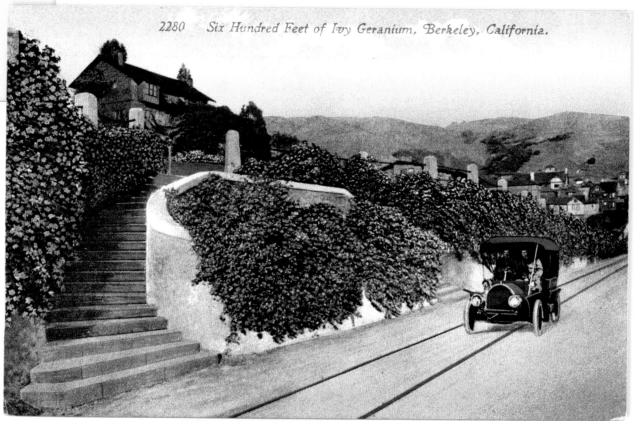

"Six Hundred Feet of Ivy Geranium, Berkeley, California."
Edward H. Mitchell, No. 2280.

When President Theodore Roosevelt visited the University in 1903 to receive an honorary degree at the first commencement exercises held in the Greek Theater, his procession entered the campus from Center Street. There, on both sides of the street, a grand reception was given him by Berkeley schoolchildren, who were, according to the account in the Berkeley Gazette, "flower decked and holding great wreaths and garlands." The children from the Hillside School had gathered the famous ivy geraniums from Hearst Avenue, which they wore for the occasion.

2280 *Six Hundred Feet of Ivy Geranium, Berkeley, California.*

"At North Entrance to University Grounds."
Students Co-operative Society.

The Berkeley newspaper referred to Hearst Avenue, along the northern edge of the campus, as "mountainous." In 1900, Town Engineer Charles L. Huggins devised a plan to remedy its extreme steepness with a divided, two-level roadway. A graceful stairway allowed residents of Scenic Avenue—University President Benjamin Ide Wheeler among them— easy access to the University campus.

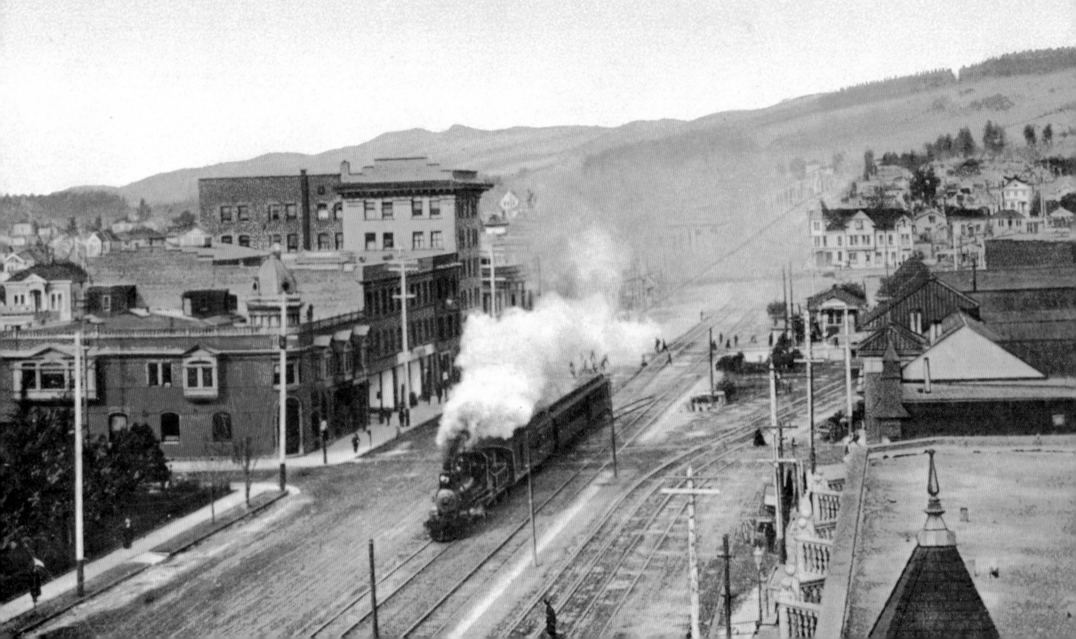

S. P. Train, Shattuck Ave., Berkeley, Cal.

Downtown – the Heart of the City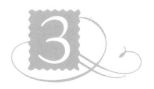

DURING THE PERIOD WHEN POSTCARDS WERE AT THEIR MOST POPULAR, 1907 TO 1915, DOWNTOWN BERKELEY was being transformed from a pioneer downtown of nineteenth century one- and two-story wood-frame buildings into a Classic Revival style downtown built of masonry.

In the early 1900s, Berkeley experienced a dramatic increase in population. There were three important catalysts influencing this growth: the introduction and then the expansion of electric streetcar lines, the growth of the University, and the surge in population after the 1906 Earthquake and Fire.

Electric streetcar service was introduced in 1891 and ran from Oakland to Berkeley along Grove Street (now Martin Luther King Jr. Way) and on Shattuck Avenue. In 1892 these two lines were connected, and service was also established on Telegraph Avenue. By 1903, most independent streetcar lines throughout the East Bay were consolidated as part of Francis Marion "Borax" Smith's Oakland Transit Company, later known as the Key System.

The University of California, which had opened its Berkeley campus in 1873 with fewer than 200 students, had a student population of 4,000 by 1900, bringing a corresponding increase to the population of the town.

In the months following the 1906 Earthquake, about 20,000 San Franciscans moved permanently to Berkeley. The newly coordinated streetcar service stimulated residential development in outlying areas. The connection with Oakland and San Francisco became faster and more convenient, with the San Francisco run advertised as a 36-minute trip.

The economic growth stimulated by the increased population and the expanding University directly supported the rebuilding of Berkeley's downtown after 1900. The stately and impressive new masonry structures were designed by the leading architects of the day, who had been inspired by the 1893 Chicago World's Fair to incorporate the Neoclassical elements of the City Beautiful Movement into the design of these new buildings. During this time, new buildings were constructed each year in downtown, and it is possible to accurately date many of the postcards by which buildings are visible.

The intersection of Shattuck Avenue and Center Street— known as "Berkeley Station"—was established as the main hub of transportation in 1876 when Francis Kittredge Shattuck (1824–1898) brought a spur line of the Central Pacific (later Southern Pacific) Railroad into Berkeley. The terminus was the two-block stretch in the middle of Shattuck, from Center Street north to University Avenue (now Shattuck Square and Berkeley Square). Leading east from the train station, Center Street became the primary pedestrian route to the University campus, as it is today with the Bay Area Rapid Transit (BART) station

only a few feet from where the train station once stood.

Berkeley's Chamber of Commerce eagerly promoted downtown business by commissioning photographs of downtown buildings and streets that illustrated Berkeley's new affluence, permanence, and growth. The Chamber then licensed the use of these photographs to the publishers of postcards. Often, the same photographs were used by several different postcard publishers.

After its completion in 1908, the new train station in the middle of Shattuck Avenue was a favorite postcard subject. Replacing a small wood-framed depot built in the late 1870s, this elegant Classic Revival style station, designed by D. J. Patterson, was the pride of Berkeley. Its exterior was of dark red brick ornamented with Doric columns, arched entries, balustrades, and frieze-work of light buff-colored concrete. It served as the Southern Pacific Railroad Station from opening day, April 6, 1908, until it was demolished in 1938.

There are many postcards of Shattuck Avenue showing the important new commercial buildings, and these often include at least a corner of the train station. Successful businesses depended on good transportation, and the inclusion of the attractive new train station conveyed the appropriate message. These street scenes are intriguing to us today because most of the early masonry buildings are still standing, although a few have been altered beyond recognition. Present-day Shattuck Avenue has retained enough of its early twentieth century character to be fully recognizable in the old postcard images.

Center Street was also a favorite subject, and the postcards show that the south side of Center Street appears today much as it did then. Although the building that now stands on the corner of Oxford was erected in 1995, it is a close replication (based on images from postcards) of the 1902 original.

Even some of the businesses are similar to those that lined the street in 1915. There are several restaurants and snack shops and stationery stores selling postcards!

None of the buildings on the north side of Center Street are still standing, even though the most prominent one, on the corner of Center and Shattuck, was once Berkeley's tallest building. This was the six-story Berkeley National Bank Building (now the site of a smaller Bank of America building), designed by John Galen Howard and completed in 1908. Postcard publishers loved the grandeur of this imposing edifice, and it is depicted on several postcards.

Berkeley's Civic Center got its start in 1899 when Berkeley's Town Hall was moved from Sacramento Street and University Avenue to Grove Street and Allston Way, then on the western edge of downtown. The new Classic Revival style high school was built on Grove Street, across from Town Hall, in 1901. Although the original building is no longer standing, the high school remains today in the same location.

A town's civic buildings, often its most imposing, were natural candidates for postcards. Berkeley's civic buildings, located downtown, were no exception and were pictured by the major publishers. Many of the cards featured the library building, set amid the greenery of the Shattuck Estate. Rosa Shattuck had given the land for Berkeley's first public library, which was designed by John Galen Howard in 1903, with construction funded by a grant from Andrew Carnegie. This library was replaced by a larger building designed by James Plachek in 1930 and then enlarged and remodeled in 2002.

After the old Town Hall burned in 1904, a new and more substantial replacement was built. The design for a Town Hall by Bakewell and Brown placed first in a competition held in 1907, and the completed Beaux-Arts style City Hall opened in

"Berkeley, California—
A busy street scene."
Cardinell-Vincent Co.,
No. 785.

*In 1907, Berkeley made
a quixotic and ultimately
unsuccessful bid to move
the State Capitol to the
University town. This view
shows the city turned out
in force at Berkeley Station
to greet State legislators
arriving from Sacramento.
The group of over 200
arrived late and, after having
a meal of "spring chicken,"
were whisked away in
awaiting automobiles. The
group viewed the proposed
site in Northbrae and were
favorably impressed. The
item appeared on the
November 1908 ballot,
but public support was
not forthcoming. One of
the legacies of this endeavor
is the group of streets in
Northbrae named for
California counties.*

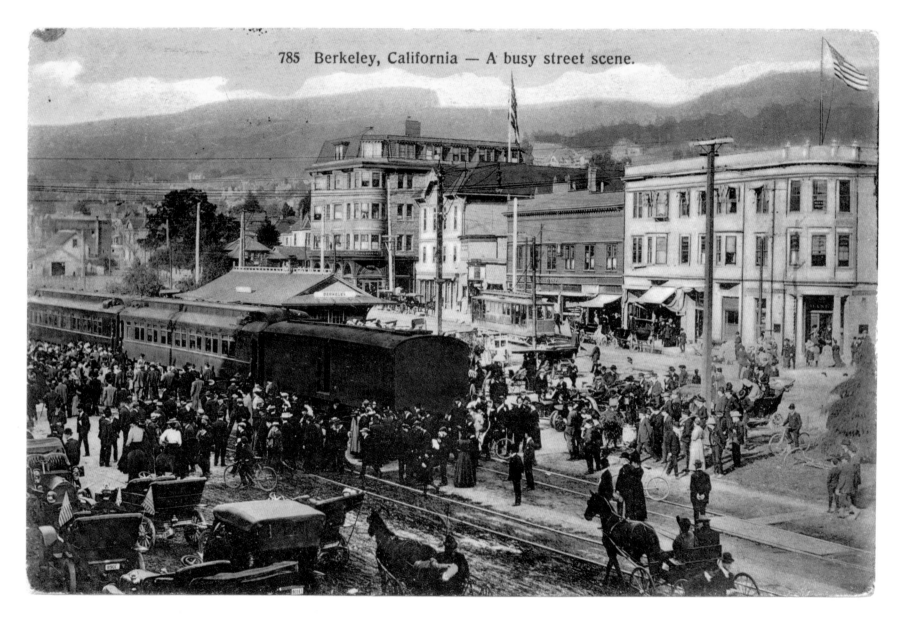

785 Berkeley, California — A busy street scene.

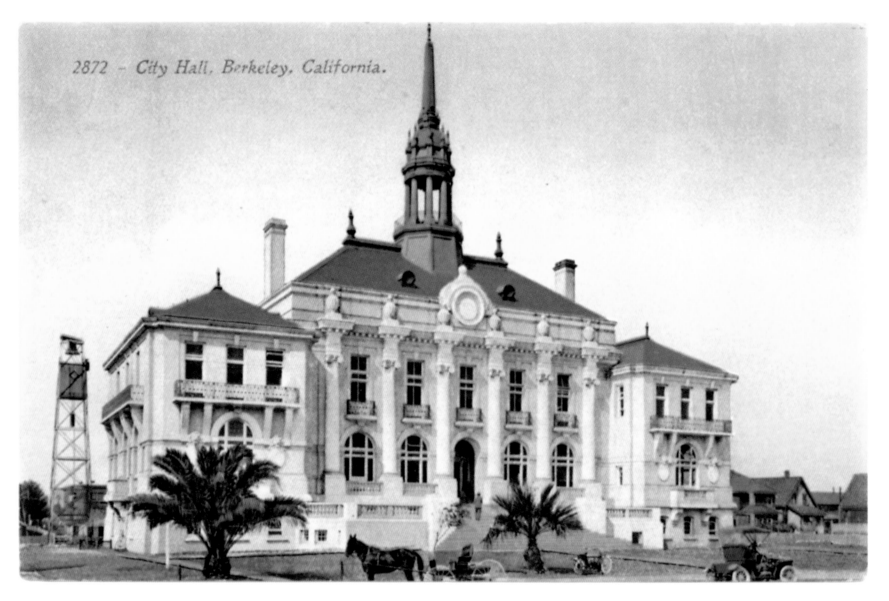

2872 – City Hall, Berkeley, California.

"City Hall, Berkeley, California."
Edward H. Mitchell, No. 2872.

John Bakewell and Arthur Brown, Jr., based their design for Berkeley's City Hall on a city hall in Tours, France, designed by their professor at the Ecole des Beaux Arts, Victor Laloux. After viewing the plans, Berkeley's Town Trustees initially felt that the tower was too imposing and decided that "a city hall without a tower would be about the right thing in the way of a municipal structure," according to the San Francisco Call. Fortunately, wiser heads prevailed, and the splendid French Renaissance style building—complete with tower—has long been the gem of Berkeley's Civic Center. The City Council continues to meet every Tuesday evening in the second floor Council Chambers. Note the three forms of transportation visible in the picture: horse and buggy, automobile, and motorcycle.

1909. (A new charter passed in the interim changed Berkeley's status to that of a city.) Many postcards show the City Hall with what appears to be the "town alarm bell" in the background.

The most photographed downtown building was the Shattuck Hotel, downtown's largest and most elegant. The north section of the hotel was built in 1909 and the south section in 1913, and the many postcards that were published record the hotel's development. It was designed by Benjamin G. McDougall and built on the site of the Shattuck home and grounds. Francis Shattuck died in 1898, and after his wife, Rosa, died in 1908, the hotel was built by Shattuck heirs. Early postcards show that there were once balconies on the third floor and that the interior was lavishly appointed.

Shattuck heirs gave land for the Y.M.C.A., which was built in 1910 and, like the hotel, designed by Benjamin G. McDougall. This building is still standing on the east side of the Civic Center. Across the street from the "Y," and also part of the Civic Center, is the beautiful United States Post Office with its elegant arched loggia. It was designed by Oscar Wenderoth and constructed in 1914. The Veterans Building was built in 1928, and the final piece of Berkeley's Civic Center was completed in 1942 with the dedication of Civic Center Park. Berkeley's Civic Center is listed on the National Register of Historic Places.

The numerous postcards produced of Berkeley's downtown during this period recorded the building boom and are especially interesting today. While the postcards of downtown are mostly pictures of buildings, there are other pieces of the urban fabric in these images to delight the eye as well. Notice the street lights, telephone poles or lack thereof, flags, signs, streetcars, trains, horses and buggies, automobiles, and, especially, the people.

—Susan Dinkelspiel Cerny

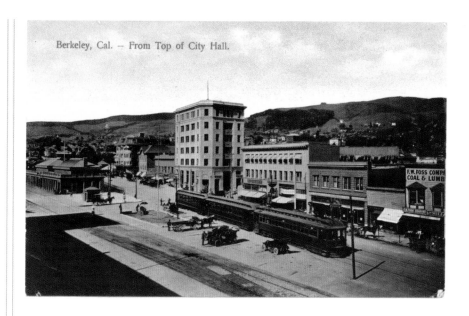

Berkeley, Cal. – From Top of City Hall.

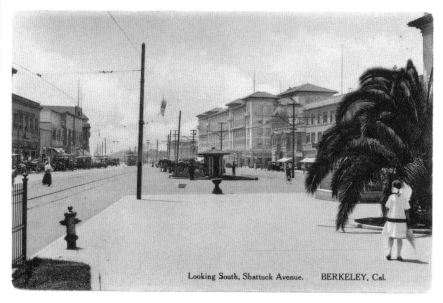

Looking South, Shattuck Avenue. BERKELEY, Cal.

"Shattuck Ave., Berkeley, California."
Edward H. Mitchell, No. 1802.

When the yellow brick building in the center was built (Meyers & Ward, Architects, 1906), the Berkeley Gazette reported that "with the completion of this building, Shattuck Avenue will be solidly built on both sides from University Avenue to Bancroft Way." The Colonial style Wanger Block at the right was designed in 1903 by William Wharff. With apartments above, the ground floor was the first location of the J. F. Hink & Son department store, a Berkeley institution until its demise in 1985.

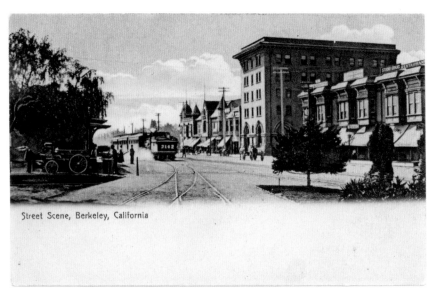

Street Scene, Berkeley, California

"Street Scene, Berkeley, California."
N. J. Abbott & Son, No. 301.

There is activity around the Southern Pacific Depot, opposite the imposing First National Bank. This evocative photograph was taken in 1905 by amateur photographer Dale Tyrrell and was published as a postcard (both in blue and in sepia) by Abbott's Book Store, located on nearby Center Street. The same picture illustrated an article on "commercial Berkeley" in the November 1906 issue of Sunset.

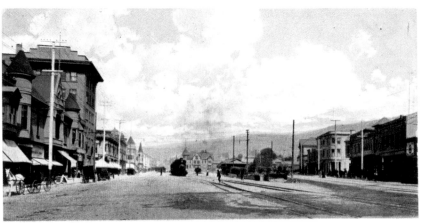

182 Berkeley Station, California.

"Berkeley Station, California."
Charles Weidner, No. 182.

The great width of Shattuck Avenue—enough to accommodate a train depot in its center—is apparent in this 1905 view looking north. The new brick First National Bank Building looms over its wooden neighbors, all of which would be replaced in the next few years.

"Berkeley, Cal. Shattuck Avenue, East Side."
Pacific Novelty Company, "Quality Series" No. B.22.

Here is one wooden building that survived the early transformation of downtown, only to be stripped of its Romanesque ornament in 1941 and, finally, almost completely demolished in 1997. The Hulbert Block was designed in 1897 by William Koenig for civic leader John Hinkel and was home to the well-loved Edy's ice cream parlor for over sixty years.

"Berkeley Station."
Pacific Novelty Co., No. 24.

The name "Berkeley Station" referred not only to the depot itself, but also to the surrounding downtown business district as well. This was one of five stops within the city on the Southern Pacific branch line, which ended about a half-mile north at Berryman Station, Shattuck Avenue and Vine Street.

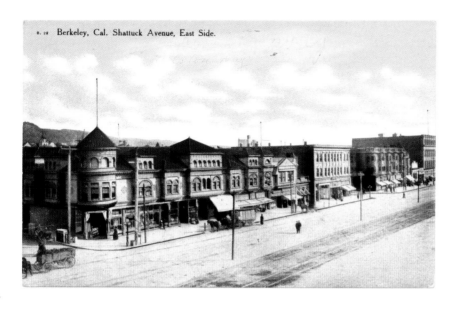

Berkeley, Cal. Shattuck Avenue, East Side.

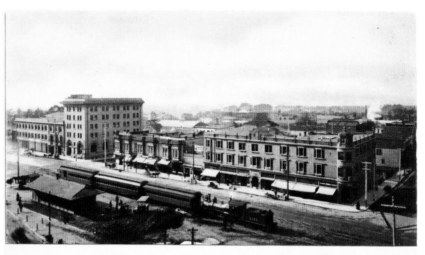

SHATTUCK AVENUE AND RAILROAD STATION, BERKELEY, CAL.

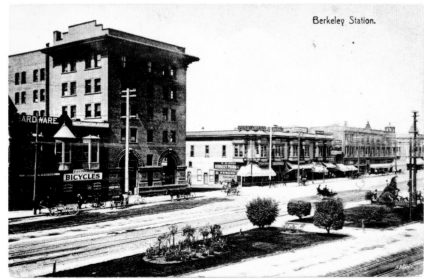

Berkeley Station.

"Shattuck Avenue and Railroad Station, Berkeley, Cal."
The Polychrome Co.

Prominently featured is the turreted Francis Shattuck Building, designed by Stone & Smith in 1901 for the Shattuck estate. As the first brick building built on Shattuck Avenue, it signaled the beginning of the transformation of Berkeley's pioneer main street. The third floor wood-paneled lodge halls were home to the Native Sons of the Golden West. This view also shows the old wooden train station in the foreground.

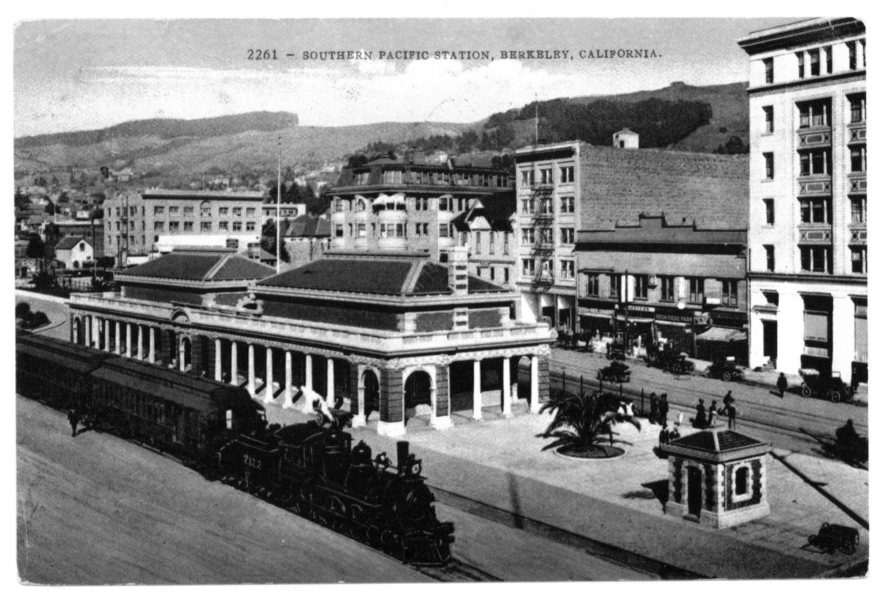

2261 — SOUTHERN PACIFIC STATION, BERKELEY, CALIFORNIA.

"Southern Pacific Station, Berkeley, California."
Edward H. Mitchell, No. 2261.

At a dinner party, University President Benjamin Ide Wheeler and local poet Charles Keeler mentioned to Southern Pacific President Edward Harriman that the existing train station was unworthy of the new "Athens of the West." The result of this conversation was a new station that opened in April 1908. Company architect D. J. Patterson designed the station in 1906 specifically to harmonize with John Galen Howard's classical University buildings, and, according to the Berkeley Independent, it was the "prettiest railroad depot that the Southern Pacific has anywhere west of Ogden."

The distinctive "Mitchell" coloring enlivens this Southern Pacific Station card. The Berkeley Hills and four substantial brick buildings form a backdrop to the crisply detailed station.

"S. P. Station, Berkeley, California."
Newman Post Card Co., No. W. 25.

"Key Route Train, Berkeley, California."
Pacific Novelty Co., No. 1804.

In competition with the long-established Southern Pacific line, the first Key Route electric interurban train made its way down Shattuck Avenue in 1904 on its own set of tracks. Of course, the grand S. P. Station was "off limits," so in 1907 a small Key Route Station was built between the Studio Building and the U.C. Pup hot dog stand—to the right of the train in this view.

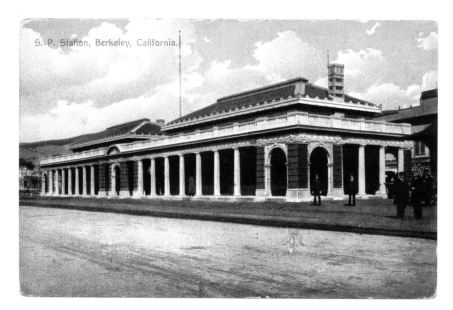

S. P. Station, Berkeley, California.

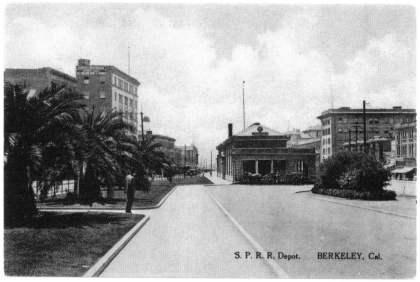

S. P. R. R. Depot. BERKELEY, Cal.

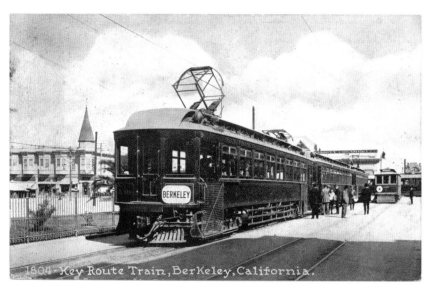

1804—Key Route Train, Berkeley, California.

"S. P. R. R. Depot. Berkeley, Cal."
The Albertype Co.

Improvements to grounds were started in 1906 and completed before construction of the new station began: a palm-dotted plaza and entrance drive on the site of the former freight yards to the north. When the Southern Pacific Company gave the park to the City in the 1920s, it was sold for development.

Shattuck Avenue, Berkeley, Cal.

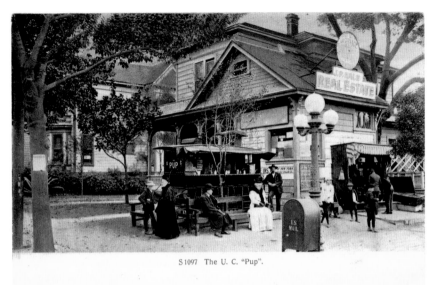

S 1097 The U. C. "Pup".

This special edition postcard was an advertisement for Bill "The Dog Man" Henderson's hot dog stand, a fixture at University and Shattuck avenues, near the train station. There is Bill, standing to the right of the stand. On the back of the card is the "U.C. Pup Yell," a take-off on a popular U.C. yell: "Doggie Wow-wow!, Muddie Wee-wee! Oli-Tamale-le, Holy-Billy-le, The Dog Man, Wow!"

"Shattuck Avenue,
Berkeley, Cal."
Richard Behrendt, No. 116.

This picture was taken in 1907, and two major changes were about to take place. Work on the new train station began that year, and the bay-windowed Schmidt Building (A. H. Broad, Designer, 1898) with its red-and-white striped awnings was razed in September to make way for the six-story Berkeley National Bank Building. In the background stands the Studio Building, the first home of the California College of Arts & Crafts and Berkeley's second "skyscraper," completed in late 1906.

"The U.C. 'Pup'."
Cardinell-Vincent Co.
for J. W. Henderson,
No. S 1096.

"Yeppitei!, The dogs do cry, Clear from Bill's, to the Berkeley High!" The signs behind the counter advertise pork and beans, and chile, as well as "Bill's Romeo."

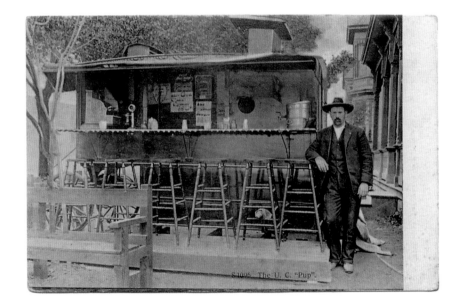

S 1096 The U. C. "Pup".

"Shattuck Avenue, Berkeley, California."
Edward H. Mitchell, No. 2871.

The patch of green with the tall flagpole south of the Southern Pacific Station is Constitution Place, which remained in the center of Shattuck Avenue, in various incarnations, until the street was reconfigured to accommodate the BART station.

"Business Section — Berkeley, Cal."
Cardinell-Vincent Co.

Four of the large masonry buildings that were changing the appearance of Shattuck Avenue are visible here. Left to right are the Acheson Physicians Building (George L Mohr, Designer, 1908), the Studio Building (1905–1906), the Chase Building (William Wharff, Architect, 1909), and the Berkeley National Bank Building (John Galen Howard, Architect, 1907–1908).

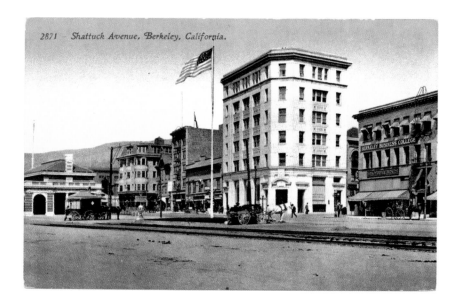

2871 – Shattuck Avenue, Berkeley, California.

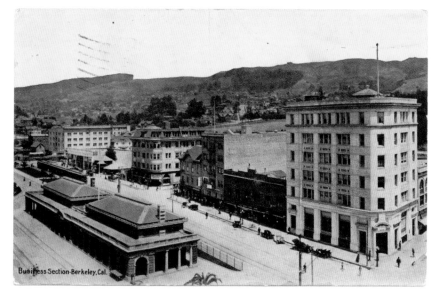

Business Section-Berkeley, Cal.

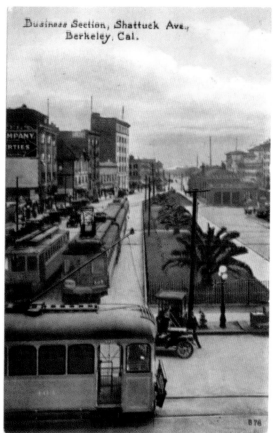

Business Section, Shattuck Ave., Berkeley, Cal.

"Business Section, Shattuck Ave., Berkeley, Cal."
Pacific Novelty Co., No. B. 78.

Two types of streetcar and a Key Route electric train make for an exciting transportation hub at University and Shattuck avenues, with the Southern Pacific Station in the distance. This image of a bustling metropolis was also used as the cover of a 1912 Chamber of Commerce promotional brochure.

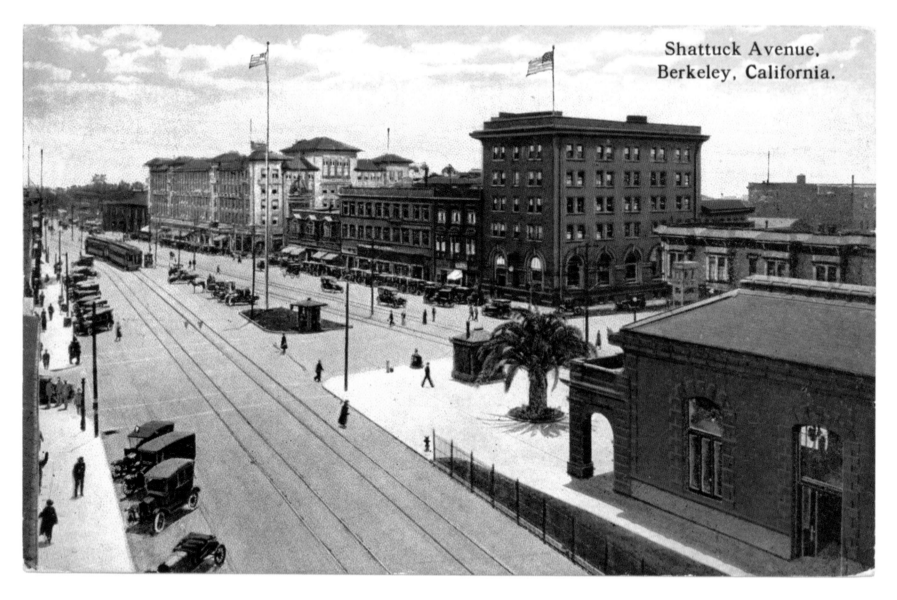

Shattuck Avenue.
Berkeley, California.

"Shattuck Avenue,
Berkeley, California."
Cardinell-Vincent Co.,
No. 121.

This perspective shows the convergence of both the train tracks and the west and east branches of Shattuck Avenue near the Shattuck Hotel. The two blocks of Shattuck east of the station were once called Stanford Place.

"Shattuck Avenue, Berkeley, California."
Real-photo postcard, American Industrial Photo Co., No. 1001 E.

A colorful array of street life is presented in this undated real-photo postcard showing the west side of Shattuck Avenue looking toward Center Street. Automobiles are in abundance and a bicyclist is casually making his way down the middle of the street.

"Center St., Berkeley, Calif."
Real-photo postcard, A & W Photo, No. 46.

To the left in this photo is the Eastman Block (Stone & Smith, Architects, 1902) at the corner of Oxford Street, opposite the entrance to the University grounds. When architect John Galen Howard came to Berkeley to supervise the Hearst Plan for the University, he taught his architecture classes in rented rooms in this building. In the far distance is Howard's First National Bank Building, and to the right, his unfinished Berkeley National Bank.

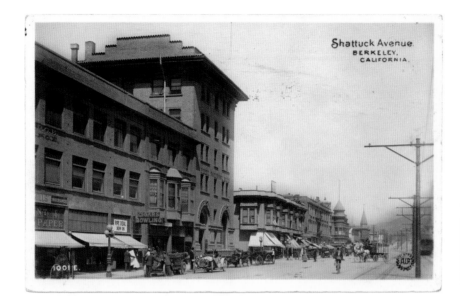

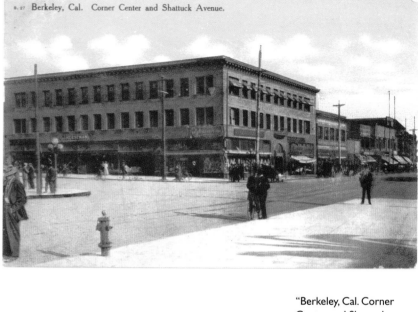

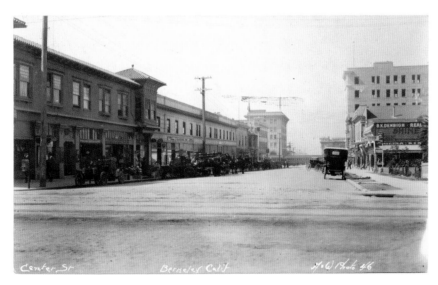

"Berkeley, Cal. Corner Center and Shattuck Avenue."
Pacific Novelty Company, "Quality Series" No. B. 27.

The Wright Block (William Knowles, Architect, 1906) is the only building from the early 1900s remaining at the important intersection of Shattuck and Center. It replaced a picturesque wooden building that burned in April 1906 and is depicted on page 54.

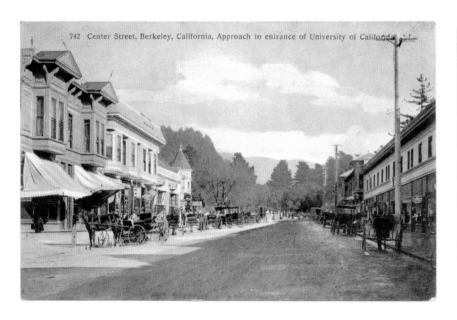

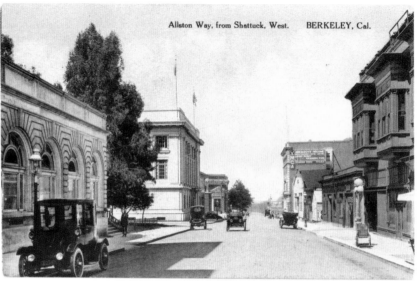

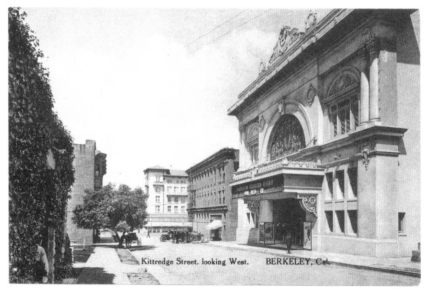

"Center Street, Berkeley, California, Approach to entrance of University of California." Cardinell-Vincent Co., No. 742.

The nineteenth century buildings on the north side of the street are long gone— as are the horses and carriages—but this view toward the oak grove on the campus remains the same.

"Allston Way, from Shattuck, West. Berkeley, Cal." The Albertype Co.

This view, from about 1915, looks west, past the arched windows of a recent addition to the Shattuck Hotel dining room, toward the Civic Center. Visible beyond are the newly completed Elks Club (Walter H. Ratcliff, Jr., Architect, 1913–1914), the pedimented entry of the Home Telephone Building (Ernest Coxhead, Architect, 1908), and the four-story Y.M.C.A. Building.

"Kittredge Street, looking West. Berkeley, Cal." The Albertype Co.

It is hard to imagine that this ornate Beaux Arts movie theater, the T & D (A.W. Cornelius, Architect), is, in fact, the same building as today's sleek Art Deco style California Theater. The T & D opened in December 1914, bringing the number of motion picture theaters in Berkeley to ten. It received its facelift when it was outfitted for sound in 1929.

"Center Street, looking toward University of California, Berkeley, Cal."
The Albertype Co.

With the Campanile still the imposing landmark today, Center Street continues to serve as the pedestrian entrance to the University from the transit lines on Shattuck Avenue.

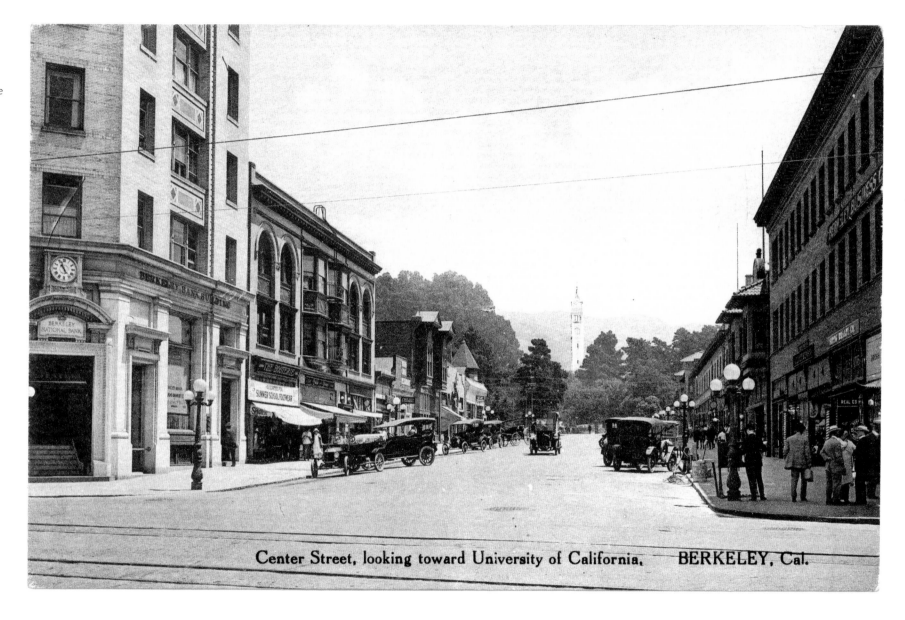

Center Street, looking toward University of California. BERKELEY, Cal.

"First National Bank, Berkeley, California."
Edward H. Mitchell.

The First National Bank Building was downtown's most significant building when construction began in 1903. Not only was it Berkeley's first "skyscraper," but it was also the first downtown building designed by noted University architect John Galen Howard. Its completion seemed to proclaim that the vision of an "Athens of the West" would not be confined to just the University campus.

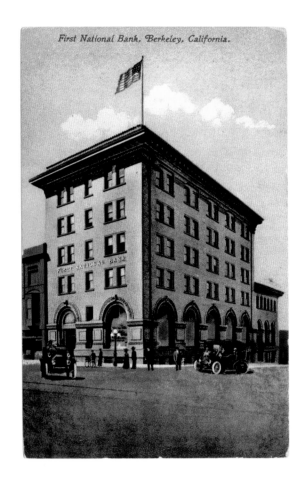

First National Bank, Berkeley, California.

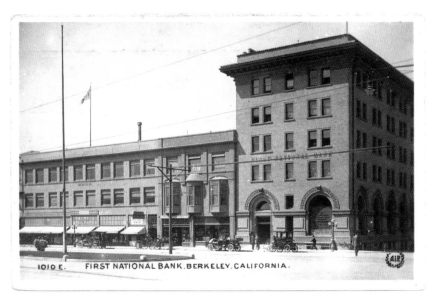

1010 E. FIRST NATIONAL BANK, BERKELEY, CALIFORNIA.

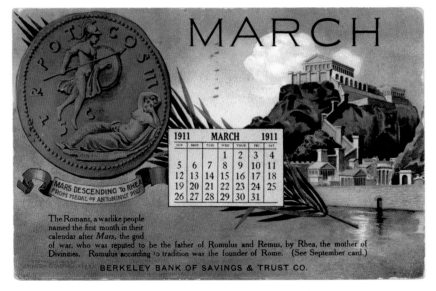

MARCH

1911 MARCH 1911

MARS DESCENDING TO RHEA FROM MEDAL OF ANTONINVS PIVS

The Romans, a warlike people named the first month in their calendar after *Mars*, the god of war, who was reputed to be the father of Romulus and Remus, by Rhea, the mother of Divinities. Romulus according to tradition was the founder of Rome. (See September card.)

BERKELEY BANK OF SAVINGS & TRUST CO.

"First National Bank, Berkeley, California."
American Industrial Photo Co., No. 1010 E.

To the south of the bank is the three-story Havens Block (A. H. Broad, Designer, 1906), completed, with difficulty after the Earthquake, when materials shipped from the East were earmarked for the rebuilding of San Francisco. By the time this picture was taken, an addition had incorporated an earlier bay-windowed structure.

"March."
Calendar advertising postcard, Edward H. Mitchell. (Copyright 1910 by Johnston-Dienstag-Ayres, San Francisco; artwork by W. H. Briggs.)

Generic advertising cards imprinted with a message from the Berkeley Bank of Savings and Trust Company include fitting imagery for Berkeley, the "Athens of the West." Each card was a calendar depicting the origin of the month's name and was mailed to arrive in bank customers' homes on the first of the month. The Berkeley Bank of Savings was affiliated with the First National Bank and had its offices in the three-story addition facing Center Street, completed in December 1910.

"November."
Calendar advertising
postcard, Edward H.
Mitchell. (Copyright 1910
by Johnston-Dienstag-
Ayres, San Francisco;
artwork by W. H. Briggs.)

"This building will be
completed and occupied in
October by the Berkeley
National Bank and the
University Savings Bank."
Bardell Art Printing Co.

*This unique "under construc-
tion" postcard is postmarked
September 17, 1908. With
excavating begun in Septem-
ber 1907, construction of this
skyscraper followed closely on
the heels of the Southern
Pacific Station.*

"Berkeley National Bank,
Berkeley, California."
Edward H. Mitchell,
No. 2256.

*This bank was one of four
downtown buildings designed
by University architect John
Galen Howard, all of which
have been destroyed. Howard
maintained a Berkeley office
on the top floor.*

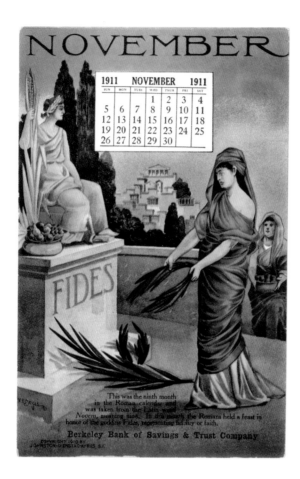

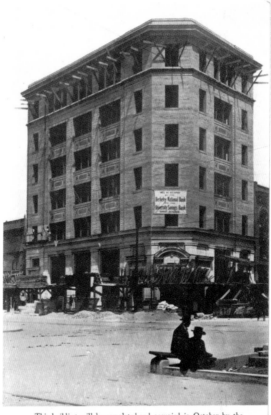

This building will be completed and occupied in October by the
BERKELEY NATIONAL BANK and the UNIVERSITY SAVINGS BANK

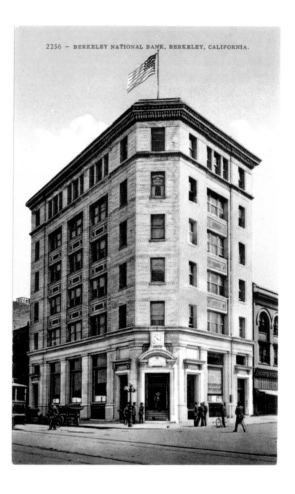

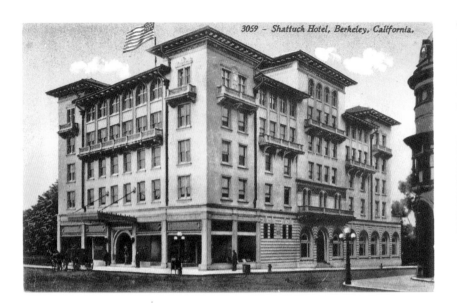

3059 - Shattuck Hotel, Berkeley, California.

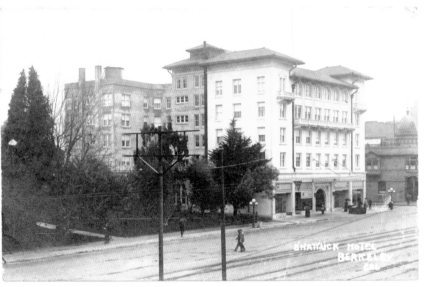

"Shattuck Hotel, Berkeley, Cal."
Real-photo postcard.

This early view of the hotel—the shops are not yet occupied—shows the unpainted concrete of the interior light court and the fifth "penthouse" floor, which commanded a view of the parklike grounds of the Shattuck estate.

"Shattuck Hotel, Berkeley, California."
Edward H. Mitchell, No. 3059.

The original Shattuck Hotel building (Benjamin G. McDougall, Architect, 1909) still stands at the corner of Shattuck Avenue and Allston Way. This square-towered version of the Mission Revival style had been pioneered at the Midwinter Exposition in San Francisco in 1894 by the McDougalls (a father-and-sons architectural firm). The decorative balconies were removed about 1950.

"Berkeley, Cal.— A typical residence."
Pacific Novelty Co., No. 22.

This large Queen Anne house (W. H. Weilbye, Architect, 1891) was the home of Rosa and Francis Kittredge Shattuck. It was a replacement for an earlier Shattuck House built in 1868 that sat elsewhere on the extensive grounds. As the property was developed for the hotel, the two houses were moved to nearby Kittredge Street and subsequently torn down.

Berkeley, Cal. - A typical residence.

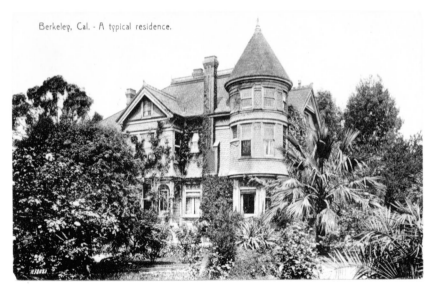

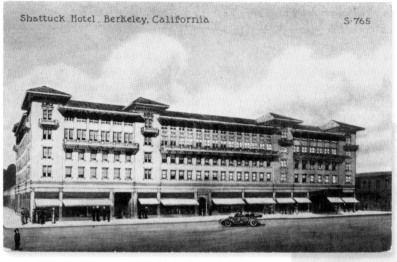

Shattuck Hotel, Berkeley, California. S-765

"Shattuck Hotel,
Berkeley, California."
Souvenir Publishing Co.,
No. S-765.

This is the architect's rendering of the major addition that expanded the hotel to a full block in 1913 and made it the longest building in the Bay Area at the time. It has been said that the owners were encouraged by a promise from Hink's department store to lease the ground floor space.

"Hotel Shattuck,
Berkeley, California."
Edward H. Mitchell,
No. 3059.

After the expansion.

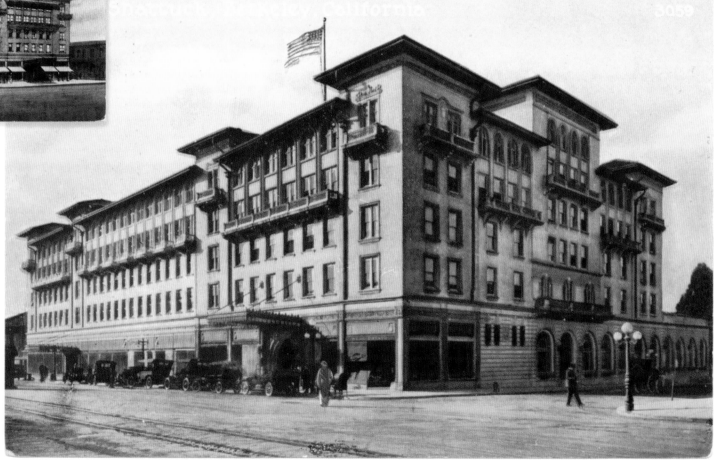

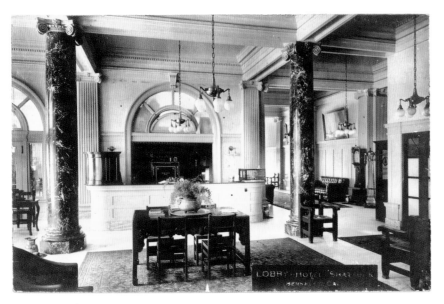

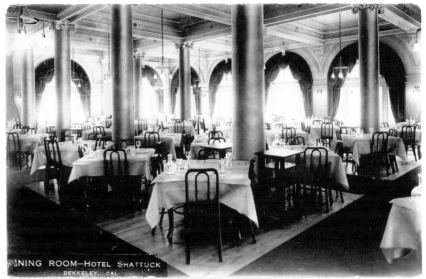

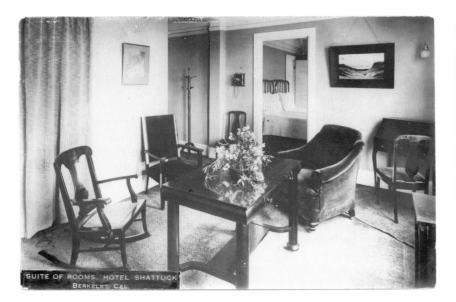

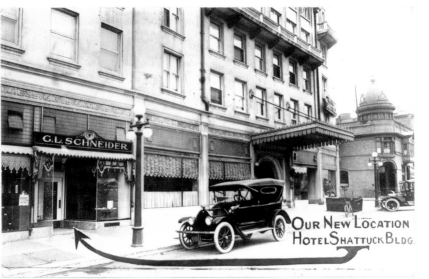

"Lobby—Hotel Shattuck, Berkeley, Cal."
Real-photo postcard, Cosmo.

The original lobby featured scagliola columns (simulated marble) and Mission furniture. The hotel could be entered from Shattuck Avenue (the corridor at the right) as well as from Allston Way.

"Dining Room—Hotel Shattuck, Berkeley, Cal."
Real-photo postcard, Cosmo.

The Thonet bentwood chairs were used for almost eighty years.

"Suite of Rooms. Hotel Shattuck, Berkeley, Cal."
Real-photo postcard, Cosmo.

When the hotel opened in December 1910, it was reported that each room had a color of its own. "If a room has blue wallpaper it also has a blue carpet, blue comfort on the bed, blue linoleum on the bathroom floor, etc. You will find that the rim around the water pitcher, cuspidor, and match stand is also blue." Axminster carpets and circassian walnut and mahogany furniture were installed by W. & J. Sloan of San Francisco.

"Our New Location [1916] Hotel Shattuck Bldg."
Real-photo postcard.

The decorative frieze above the storefronts was hidden by subsequent remodelings and is now being restored.

"View of Spanish Patio,
Hink's Department Store,
Berkeley, California."
Hink's Engraving
Department,
from oil painting by
Elmer G. Schmidt.

*In 1926, the J. F. Hink & Son
department store, in the
Shattuck Hotel Building since
1914, was remodeled and
expanded westward to
Harold Way by architect
Walter H. Ratcliff, Jr.
The new store featured
an arcade along Shattuck
Avenue, a limed oak interior,
and this "Spanish Patio" on
the roof of the new addition.
It seems to have been
intended for the use
of employees.*

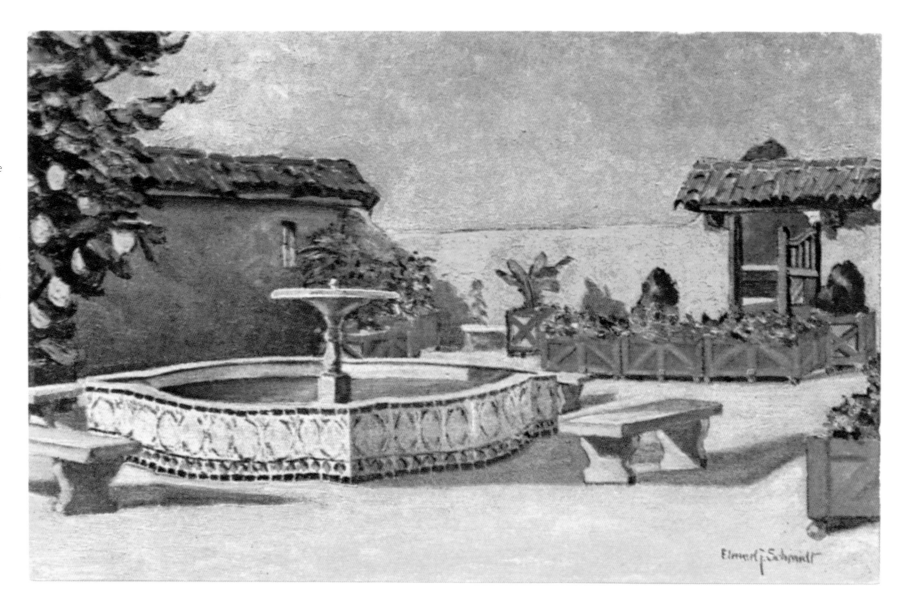

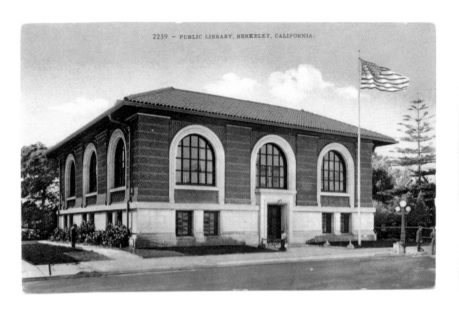

2259 – PUBLIC LIBRARY, BERKELEY, CALIFORNIA.

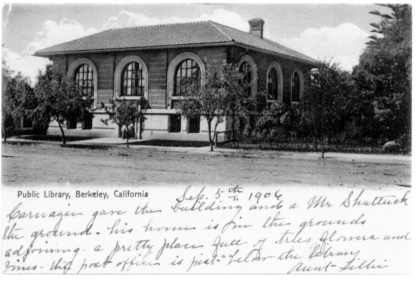

Public Library, Berkeley, California

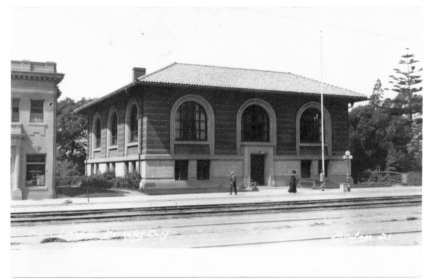

"Public Library,
Berkeley, California."
Edward H. Mitchell,
No. 2259.

*Berkeley was fortunate to
have the services of University
architect John Galen Howard
to design such a handsome
new library for the town. The
rugged materials—tile, brick,
and stone—the monumental
arched windows, and the
library's simple massing
bestowed grandeur on what
was actually a small building.*

"Public Library, Berkeley,
California."
N. J. Abbott & Son.

*The message on this card
reads, "Carnegie gave the
building and a Mr. Shattuck
the ground—his home is in
the grounds adjoining—a
pretty place full of trees,
flowers, and vines." The new
library was celebrated on
some of Berkeley's earliest
postcards. This particular
view was used by several
postcard publishers.*

"Public Library,
Berkeley, Calif."
Real-photo postcard,
Armitage, No. 21.

*Shortly after the library's
opening in January 1905,
construction began on the
Homestead Loan Association
Building next door to the
south. This beautiful little
bank was designed by
Charles W. Dickey, the
architect of the Claremont
Hotel. Over the years, it
was victim to several major
remodels and the building is
now unrecognizable.*

"City Hall, Berkeley, Calif."
Real-photo postcard,
A&W Photo, No. 45.

The Shattuck Building (A. H. Broad, Designer, 1897), also referred to as the "Free Library Building," on the northwest corner of Shattuck Avenue and Allston Way, housed two civic entities during its existence. When the building opened, the arched entry on Shattuck led to the newly formed (1895) Berkeley Public Library on the second floor. In 1904, after the Town Hall burned, city offices were moved into the building temporarily, hence the title of this postcard.

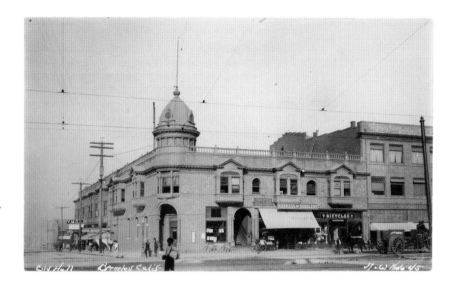

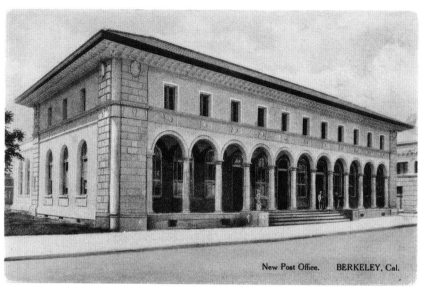

New Post Office. BERKELEY, Cal.

"Y.M.C.A. Building,
Berkeley, Cal."
The O. Newman Company,
No. W 22.

Berkeley's Y.M.C.A., founded in 1903, was presented with a challenge by Shattuck heirs Mr. and Mrs. W. E. Woolsey when, in 1909, they donated a site at the corner of Allston Way and Milvia Street upon the condition that $100,000 be secured at once to erect a building. Enough money was raised in a rousing eight-day campaign and the handsome Georgian style "Y," designed by Benjamin G. McDougall, was completed and dedicated on January 7, 1911.

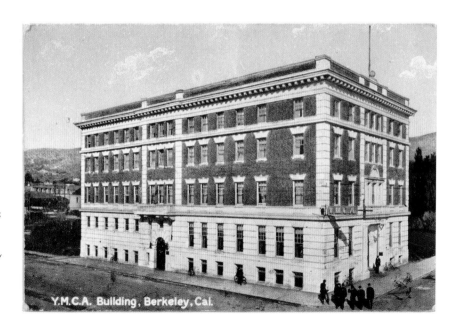

Y.M.C.A. Building, Berkeley, Cal.

"New Post Office.
Berkeley, Cal."
The Albertype Co.

Several small post office buildings had existed in downtown before this grand edifice was built in 1914 as a "cornerstone" for Berkeley's Civic Center. The design, with its arcaded loggia, red tile roof, and overhanging eaves, took its inspiration from Brunelleschi's Foundling Hospital in Florence. Variations of Berkeley's post office were built all over America during this time.

"Berkeley, Cal., Looking East from New City Hall."
Pacific Novelty Co., No. B. 24.

The blocks across from the new City Hall presented a ragtag appearance with lumberyards and vacant lots. In 1911, the City sponsored a plan for a civic center around the City Hall and the High School. Slowly, it began to take shape with the addition of other civic buildings, such as the Veterans Building, built to the east of the small white house in the picture. However, it was not until 1940 that the City was able to purchase the block at the right through a bond measure, and the Civic Center Park—designed by a committee including architects Bernard Maybeck, Julia Morgan, and Henry Gutterson—was dedicated in 1942.

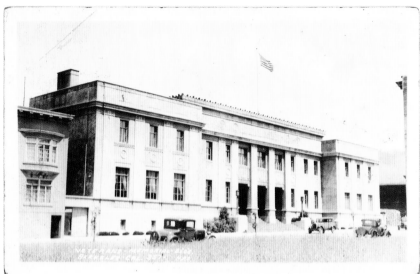

"Veterans Memorial Bldg., Berkeley, Cal."
Real-photo postcard, M.P.S., No. 357.

The construction of the Veterans Memorial Building in 1928 on Center Street helped to round out the slowly evolving Civic Center on its north side. Financed by a special tax levied by the county, the Memorial was designed by Henry H. Meyers in association with Mildred S. Meyers, his daughter, and George R. Klinkhardt. Organizations of veterans from the Civil War, Spanish-American War, and the First World War were housed in the building. Today, it is home to the Berkeley Historical Society's Berkeley History Center.

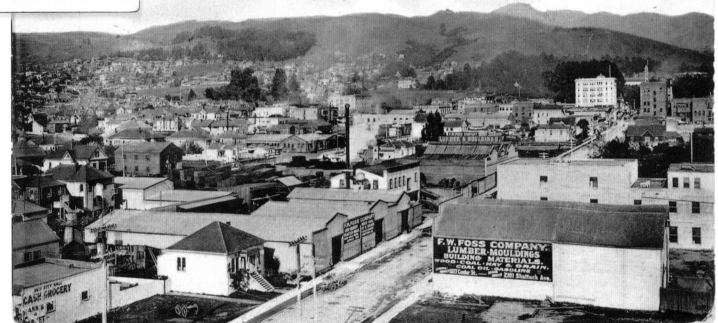

After its establishment in 1882, Berkeley's telephone exchange moved its small office four times along Shattuck Avenue. In 1905, this larger central office was built at 2112 Bancroft Way (A. A. Cantin, Architect) and was finished in time to meet the increased demand on the telephone system caused by the jump in population in the East Bay after the 1906 Earthquake. The yellow brick Telephone Building served the city until the present building was constructed next door in 1925.

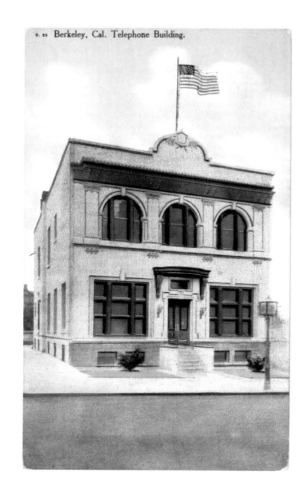

Berkeley, Cal. Telephone Building.

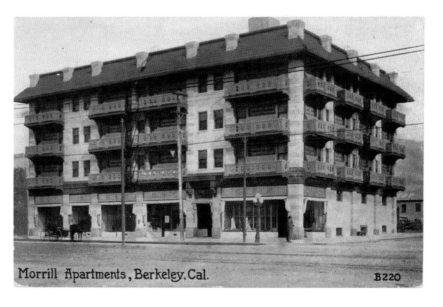

Morrill Apartments, Berkeley, Cal. B220

This odd-looking building (George F. King, Designer, 1911) survives to this day at the corner of Shattuck Avenue and Haste Street.

This handsome structure reminiscent of California's Mission architecture was designed in 1923 by Walter H. Ratcliff, Jr., for Armstrong Business College. It is tucked behind the Shattuck Hotel Building on one-block-long Harold Way.

**Tupper & Reed Building.
Real-photo postcard.**

*This charming building was
designed by W. R. Yelland in
1925, when quaint period
buildings were at the height
of their popularity. The Tupper
& Reed music store is still
in business next door, while
the piper, still perched atop
the chimney, recalls the
original second-floor business,
the "Sign of the Piper"
tea room.*

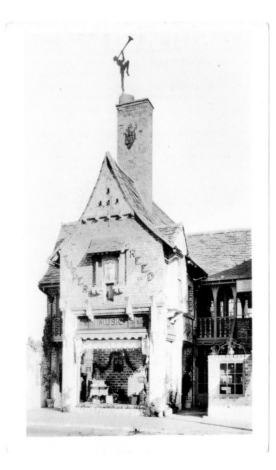

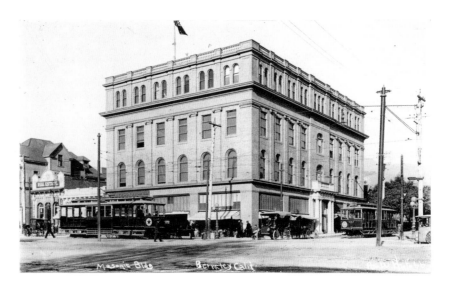

**"Masonic Bldg.,
Berkeley, Calif."
Real-photo postcard,
A & W Photo, No. 66.**

*Ground was broken for
the Masonic Temple on
December 2, 1905, and
construction of the steel-
framed structure with facing
of cream-colored brick and
granite trim progressed
during most of 1906. William
H. Wharff, the architect, had
been an active Mason since
1872 and was the designer
of three other downtown
classical buildings.*

**"Berkeley, Cal.
Masonic Temple."
Pacific Novelty Company,
"Quality Series" No. B. 28.**

*This printed color postcard
shows almost the identical
view as the photo version.
The granite pillars seen next
to the streetcar mark the
grand entrance to the lodge
rooms above. The ornate
entrance was a gift from
Rosa Shattuck in memory of
her husband, Francis Kittredge
Shattuck, who was a Mason
of high rank.*

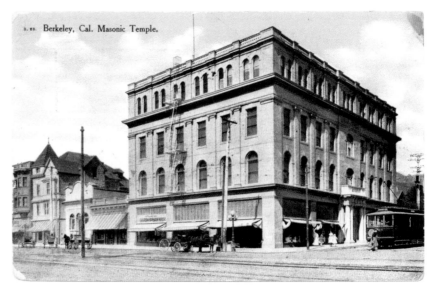

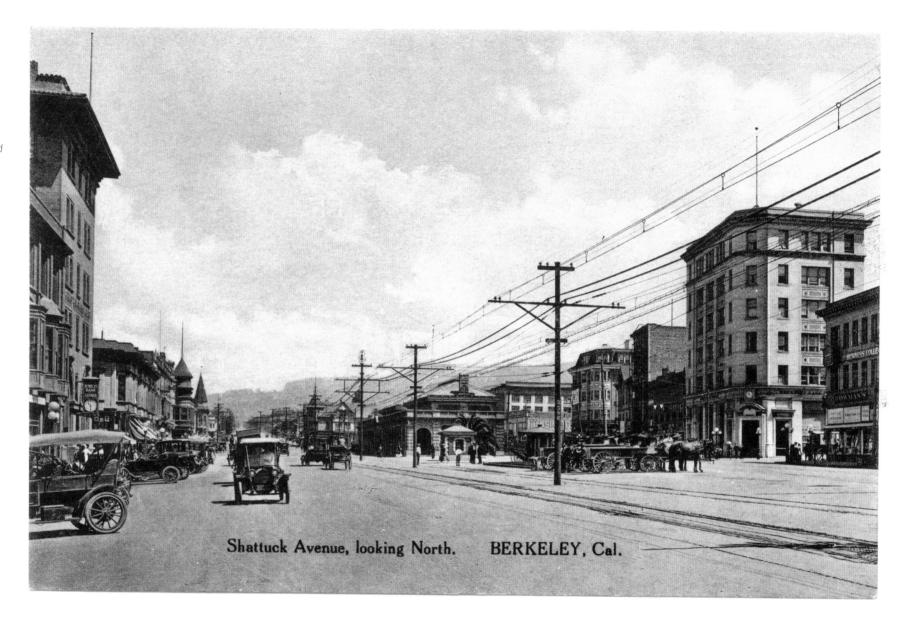

Shattuck Avenue, looking North. BERKELEY, Cal.

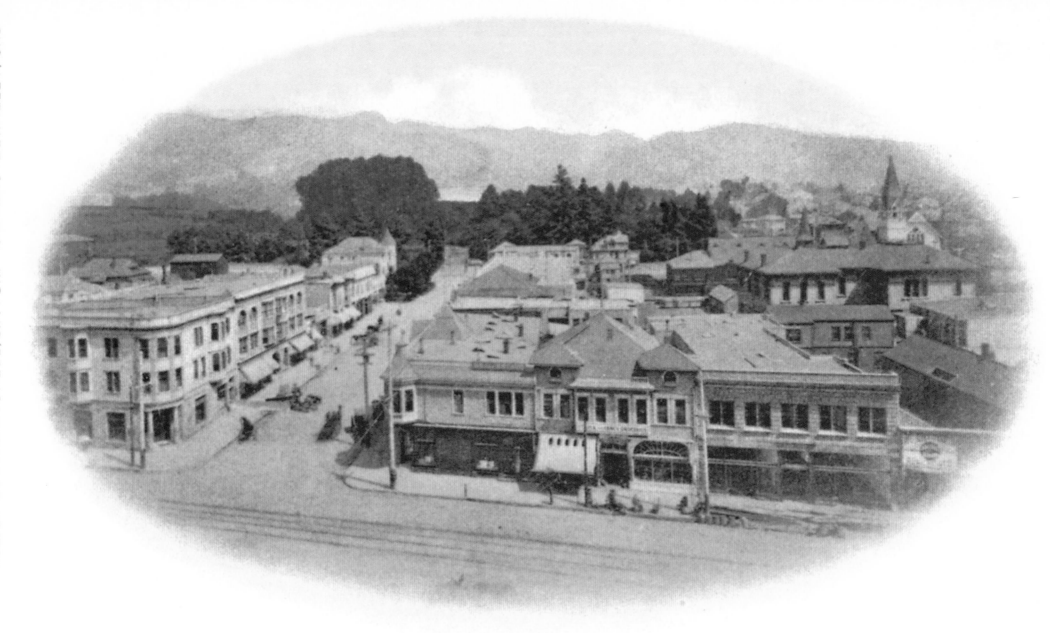

CENTER STREET, BERKELEY, CALIFORNIA

Ask Mr. Sadler

THE BRIEF IMPERATIVE, "ASK MR. SADLER," FOLLOWED BY A TELEPHONE NUMBER, WAS THE SIMPLE AND DIRECT advertisement that daily greeted readers of the *Berkeley Reporter* in the fall of 1907. Sadler's was one of several book stores in the vicinity of Berkeley Station that sold their own line of post-cards. N. J. Abbott & Son offered monochromatic gravure cards in blue or sepia, while Glessner, Morse & Geary was known for its photo postcards of University events. For his shop on Center Street, Frank E. Sadler commissioned Edward H. Mitchell, the largest publisher of postcards in the West, to pro-duce a beautiful and unusual "vignette" series in full color. These distinctive cards, with their undivided backs, are early and, unlike most postcards, their publication can be accurately dated. A postmark of December 1905 found on one card and, on another, a scene showing a building—begun in April 1905—nearing completion indicate that the cards were printed that year. The vignette technique not only produced an espe-cially attractive card, but, importantly, the surrounding white space left ample room for a message. Around the same time, Sadler's also published a full-color panoramic fold-out card and a black-and-white card of double thickness with a tab that, when pulled, revealed an accordion-fold of miniature views.

Although most of the subjects used on the vignette cards were standard—the Greek Theater, the Football Statue, the oaks—the images that were used seem to be unique to this series. The Sadler's postcards are also distinguished by the rare glimpse they provide of Stiles Hall (the University Y.M.C.A.) and several city views not found on other postcards. For instance, the view looking up Center Street shows the Wright Block, the corner building in the middle foreground with the large pink awning. This building, partially destroyed by fire in early 1906, was torn down and therefore missed being included on the other downtown postcards, the majority of which were published later. Sadler's main store was in this building at the time of the fire. The Marshall Block, shown in the Telegraph and Bancroft card, was completed in 1905 and was not promi-nently featured on other postcards. That this now-forgotten building made an appearance on the Sadler's cards is probably due to the fact that Sadler's had recently opened a branch there.

Sadler's was a thriving concern in Berkeley for about twenty years. Entering the shop, one could find books, college texts, periodicals, stationery, photographic supplies, and, incon-gruously but customary at the time, sporting goods (in 1906 Sadler's advertised "ping-pong or table tennis, fad of the season, sets available"). Engraving was offered as a service, and old issues of the University yearbook, *The Blue and Gold*, were "always on hand." Located at 2118 Center Street at Berkeley Station, Sadler's was on the well-traveled pedestrian route to and from

Ask Mr. Sadler

BERKELEY 29

Old issues of "Blue and Gold" always on hand. Prices given on application.

SADLER'S

2118 CENTER STREET

BOOKS, ENGRAVING
P R I N T I N G
SPORTING GOODS
S T A T I O N E R Y

Headquarters for
COLLEGE TEXT BOOKS AND SUPPLIES

The Best Goods and the Lowest Prices

PUB. BY EDW. H. MITCHELL. S.F. FOR "SADLER'S" BERKELEY, CAL.

TELEGRAPH AVENUE AND BANCROFT WAY, BERKELEY, CALIFORNIA.

the University campus. One wonders if their postcards were displayed on a rack near the door to tempt the passerby.

The year 1905 appears to have been a banner one for Sadler's and for Frank Sadler, the proprietor, and his wife Ella. Their business had doubled in size with the opening of the branch store; they had commissioned architect Julia Morgan to design their new home at 2619 Benvenue Avenue; and their memorable vignette postcards had just been published.

—Anthony Bruce

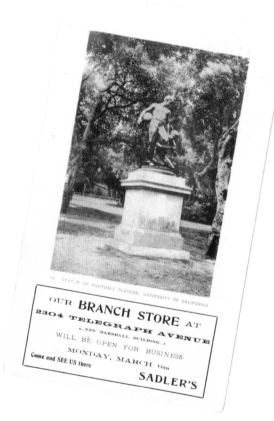

STATUE OF FOOTBALL PLAYERS, UNIVERSITY OF CALIFORNIA

OUR BRANCH STORE AT
2304 TELEGRAPH AVENUE
NEW MARSHALL BUILDING
WILL BE OPEN FOR BUSINESS
MONDAY, MARCH 6th
Come and SEE US there
SADLER'S

"Telegraph Avenue and Bancroft Way, Berkeley, California."

With the construction of the Marshall Block, designed by architect C. M. Cook for developer J. A. Marshall in 1904, a commercial building boom began on Telegraph Avenue south of Bancroft Way that transformed the street into the vibrant shopping center it is today. Sadler's branch store was an early tenant in the Marshall Block, which was demolished in 1948.

Advertising postcard.

A Channing Way resident received this postcard announcing the opening of Sadler's Telegraph Avenue branch store in March 1905.

"Deaf and Dumb Institute, Berkeley, California."

"Library, University of California, Berkeley."

"Chemistry Building, University of California, Berkeley."

The Chemistry Building was designed by architect Clinton Day in 1891. It is no longer standing, but its cupola sits as a historical remnant in the courtyard of the new chemistry building.

"Shattuck Avenue, Berkeley, California."

This view of the east side of Shattuck between Bancroft Way and Kittredge Street shows the large Wanger Block and a small Mission Revival style building built in the 1890s for the telephone company. Between them, the four-story brown structure is now the site of the fanciful Tupper & Reed Building.

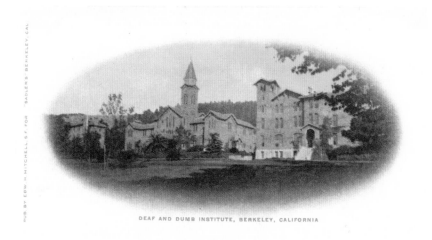

DEAF AND DUMB INSTITUTE, BERKELEY, CALIFORNIA

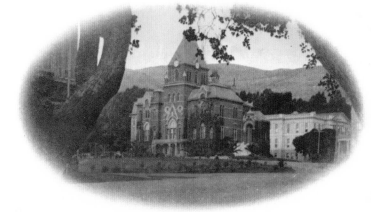

LIBRARY, UNIVERSITY OF CALIFORNIA, BERKELEY

CHEMISTRY BUILDING, UNIVERSITY OF CALIFORNIA, BERKELEY

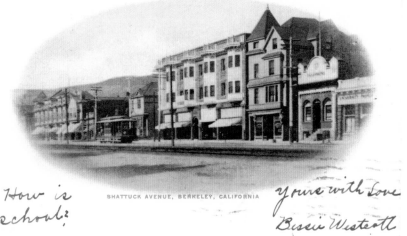

SHATTUCK AVENUE, BERKELEY, CALIFORNIA

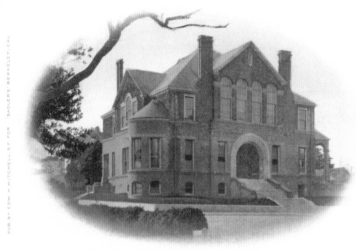

STILES HALL, UNIVERSITY OF CALIFORNIA, BERKELEY

RUSTIC BRIDGE, UNIVERSITY OF CALIFORNIA, BERKELEY

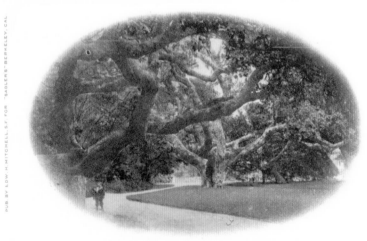

THE BERKELEY OAKS, UNIVERSITY OF CALIFORNIA

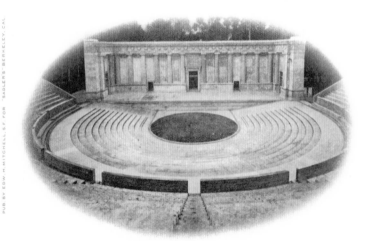

AMPHITHEATRE, UNIVERSITY OF CALIFORNIA, BERKELEY

"Stiles Hall, University of California, Berkeley."

Clinton Day, architect of Stiles Hall in 1893, designed many of the campus buildings constructed during the 1880s and 1890s, none of which remain. Stiles Hall, the University Y.M.C.A., stood on Allston Way just outside the Dana Street entrance to the campus.

"Rustic Bridge, University of California, Berkeley."

The "Rustic Bridge"— actually, there were several spanning Strawberry Creek, each resplendent in its own intricacy of design—was a very popular subject for postcard publishers.

"The Berkeley Oaks, University of California."

Eighteen of the Sadler's vignette postcards have been identified, including two views of the oaks. Perhaps there are others waiting to be discovered! See page 69 for the vertical "Strawberry Canyon" postcard in this series.

"Amphitheatre, University of California, Berkeley."

This is one of two different views of the Greek Theater published by Sadler's.

"Hearst Hall, University of California, Berkeley."

"University from South Hall, Berkeley, California."

The white form of the Hearst Memorial Mining Building, as yet unfinished, can be seen in the distance.

"Campus, University of California, Berkeley."

A set of Berkeley postcards from 1905 would be incomplete without one that showed the shining new California Hall.

"Faculty Club, University of California, Berkeley."

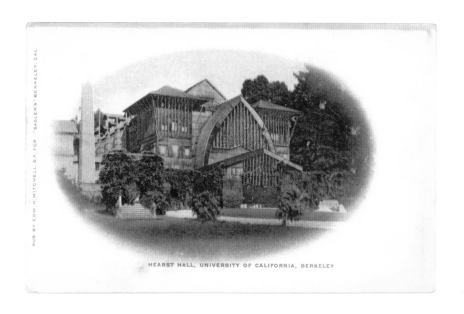

HEARST HALL, UNIVERSITY OF CALIFORNIA, BERKELEY

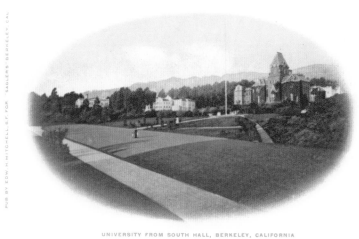

UNIVERSITY FROM SOUTH HALL, BERKELEY, CALIFORNIA

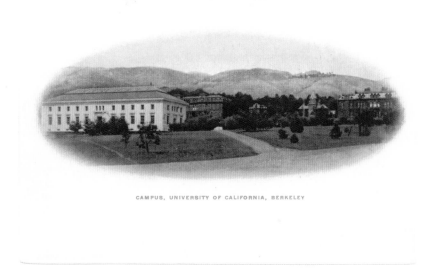

CAMPUS, UNIVERSITY OF CALIFORNIA, BERKELEY

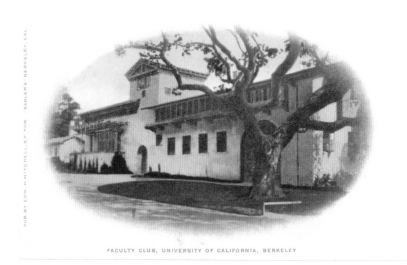

FACULTY CLUB, UNIVERSITY OF CALIFORNIA, BERKELEY

Water Falls, University Creek-Co. Ed. Canon. Berkeley, Cal.

Picturing the University of California

THE HISTORY OF POSTCARD DEVELOPMENT AND THE GROWTH OF THE UNIVERSITY OF CALIFORNIA RUN A parallel course. Both began in the last quarter of the nineteenth century and reached their "Golden Age" at the beginning of the twentieth. The picture postcard gives an interesting portrayal of the physical development of the University that supplements the written record.

On March 23, 1868, Governor Haight of the State of California gave final approval to the Charter, or Organic Act, a document drawn up to establish the University of California. The University was the result of an amalgamation of two academic institutions, the private College of California of Oakland, which had owned land for campus development since 1860, and a State technical school established in 1866–1867 as an "Agricultural, Mining and Mechanical Arts College" to take advantage of Federal land grant legislation. The merger proposed that the private college would donate its land, and that the State would sell its grant land for funds to build buildings.

The College of California site was a picturesque spot on Strawberry Creek in the quiet and peaceful countryside north of the town of Oakland. It had been selected "because of its abundant water supply, its mild climate, the absence of severe winds, the rolling landscape abundantly covered with oak,

sycamore and bay trees, the superb views to the Golden Gate and Sausalito mountains, the rather convenient but not pressing proximity of Oakland and San Francisco." To the founding fathers the reasons for the site choice were obvious. They believed proper education should be carried out in a wholesome and idyllic setting discreetly away from the temptations and distractions of city life—a setting that combined natural beauty and the virtue of a non-urban atmosphere.

The University of California had modest ambitions: it wished to be nothing more than "a College of Mines, a College of Agriculture and an Academic College," in that order, "with courses of instruction equal to those of Eastern Colleges."

There have been several master plans for the University's development—by Frederick Law Olmsted in 1866, by David Farquharson in 1873, by Emile Bénard for the Phoebe Hearst International Competition of 1899–1900, and by John Galen Howard in 1914.

Speaking generally, the physical development of the Berkeley campus that can be viewed on postcards falls into four broad categories:

- The **Romantic Phase**, the first decade when the rural character of the environment was preeminent, as envisioned by Olmsted.
- The **Picturesque Phase**, growing out of the Farquharson

plan that stressed the preservation of the natural features of the site.

- The **Classical Phase**, starting with the competition of 1899–1900 and the arrival of John Galen Howard from the East to supervise the realization of the winning Beaux-Arts plan for the University by Emile Bénard of Paris.
- The **Campus Places** that in all phases were developed by the activities and events of students, faculty, and the public.

THE ROMANTIC PHASE

In 1858, Professor Henry Durant, president of the private College of California in Oakland, selected a tract of 160 acres, at the base of the East Bay foothills and directly opposite the Golden Gate, to build an expanded campus with a residential area surrounding it. The site was dedicated in 1860. The Board of Trustees named their new town and its College after George Berkeley, the 18th century Bishop of Cloyne, leader in the field of education in new areas of investigation and research. Five years later the Trustees commissioned Frederick Law Olmsted, landscape architect and planner from Boston, to prepare a plan for the college and for residential lands of the College Homestead Association that were to provide funds from property sales for campus building construction.

A loose, organic planning respecting the contours of land was a prevailing mode for newly developing summer places along the Hudson River and the Atlantic shore. Andrew Jackson Downing's books sang the praises of rusticity, picturesque cottages rose on all sides, and Olmsted himself, with his project for Central Park in New York City, had introduced the idea of romantic landscapes even within urban settings where they might not be thought immediately appropriate.

His plan for the College of California was in this romantic spirit. Park-like residential areas surrounded the proposed campus, for which nothing more definite was envisaged than two "considerable buildings," one of brick to house the library, records, and scientific collections, the other of wood for classes, faculty offices, and a general assembly hall. These buildings were to be placed on an artificial plateau facing the Golden Gate. A formal avenue and two broad walks led to the head of the dell and the entrance to the campus. The straight axis to the Golden Gate, besides the magnificent open vista it helped focus, underlined the concern of the Board for the tactical position of the Golden Gate in the defense of the bay. Since officer training was made mandatory by a clause of the land grant, it was considered wise to keep units on the ready at this crucial point of the Pacific Coast defense in case of attack.

Olmsted insisted that each building for the proposed campus in the years to come be designed independently for the express purpose for which it was destined, rather than in accordance with a grand master plan. His idea was that there should be mutually independent colleges or schools contained in each building, on the model of English campuses and their imitators of the East Coast. Olmsted's plan called for a large green for athletics, park areas for the prospective town around the campus, and parkways to the bay and to Oakland.

The distance of the campus site from centers of population discouraged the buying of residential lots, and the lack of funds in turn prevented the Board from starting construction of College buildings.

"Inspection Day, California University, Berkeley, Cal." Pacific Novelty Company, No. B.32.

Spectators dressed in their Sunday best take pleasure in watching the drilling of the University Cadets.

"Campus Scene, University of California, Berkeley." Geo. C. Salch Co., No. 5214.

The red brick campus of North and South halls began to change with the addition in 1905 of the white granite California Hall. Note the barren hills.

"State University, Berkeley, Cal." Pacific Novelty Company, No. B.48.

East Hall and the Botany Building (Clinton Day, Architect, 1898) at center, right, of wooden construction, introduced the Classic style to the campus.

"In the California University Grounds, Berkeley, Cal." Pacific Novelty Company, No. B 28.

Virginia creeper vines added a picturesque quality to the red brick buildings.

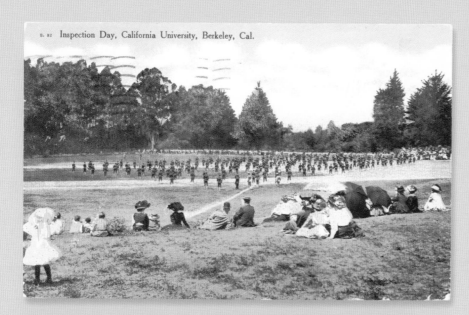

B. 82 Inspection Day, California University, Berkeley, Cal.

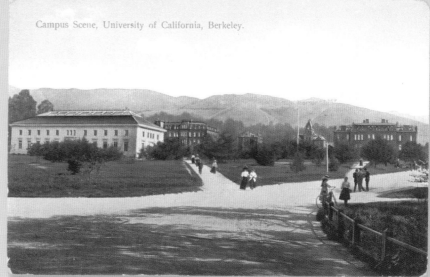

Campus Scene, University of California, Berkeley.

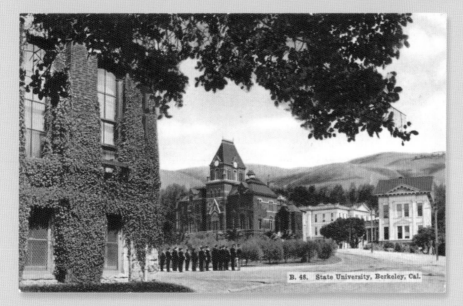

B. 48. State University, Berkeley, Cal.

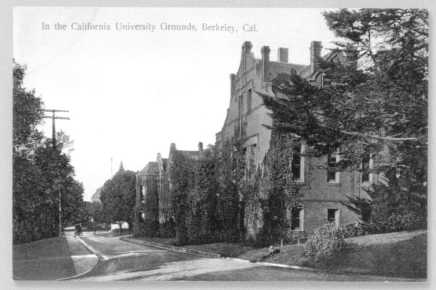

In the California University Grounds, Berkeley, Cal.

3107 - Trail to the "Big C" University of California, at Berkeley.

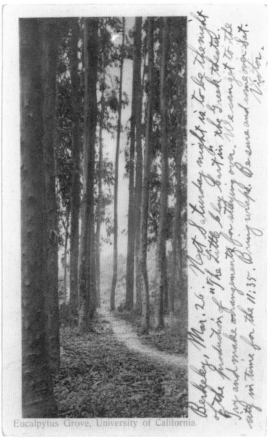

Eucalpytus Grove, University of California

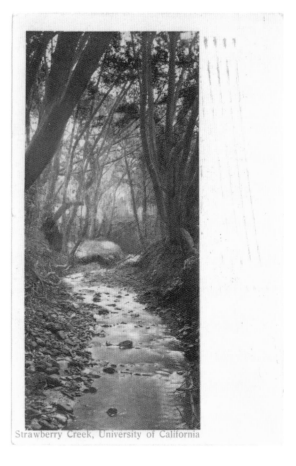

Strawberry Creek, University of California

"Trail to the 'Big C'
University of California,
at Berkeley."
Edward H. Mitchell,
No. 3107.

Note the barren hillside.

"Eucalyptus Grove,
University of California."
M. Rieder, No. 2891.

*The grove sheltered a track
field from the west winds.*

"Strawberry Creek,
University of California."
M. Rieder, No. 2892.

*Two branches of the creek
flow through the campus.*

"Founders Rock,
University of California,
Berkeley."
Students Co-operative
Society, No. 146.

*The rock lies obscured at
Gayley Road. and Hearst
Avenue.*

"Berkeley Oaks,
University of California,
Berkeley, Cal."
Geo. C. Salch Co.,
No. 5211.

*The original LeConte
memorial oak tree.*

"The Lily pool,
University of California."
Cardinell-Vincent Co.,
No. 743.

*The Conservatory and the
Lily Pool once dominated the
central valley of the campus.*

"University of California,
Berkeley, California—
The Conservatory."
Cardinell-Vincent Co.,
No. 783.

*Lord and Burnham,
Architects, 1891. The
Conservatory was removed
for the construction of
Haviland Hall in 1924.*

FOUNDERS ROCK.
UNIVERSITY OF CALIFORNIA. BERKELEY.

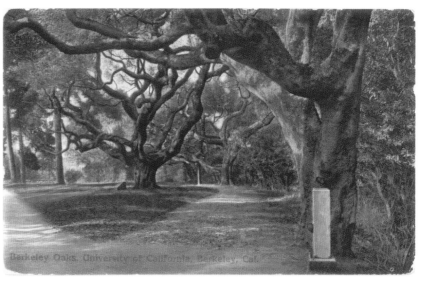

Berkeley Oaks, University of California, Berkeley, Cal.

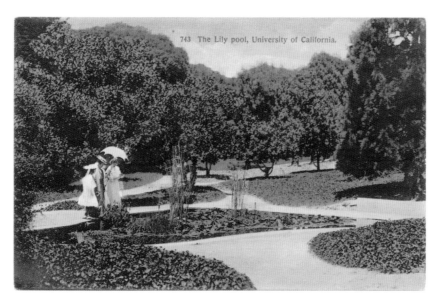

743 The Lily pool, University of California.

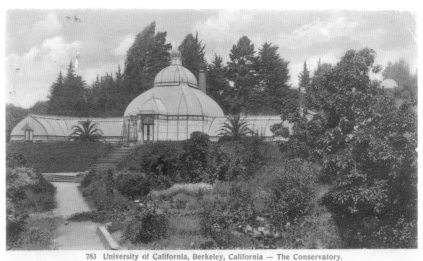

783 University of California, Berkeley, California — The Conservatory.

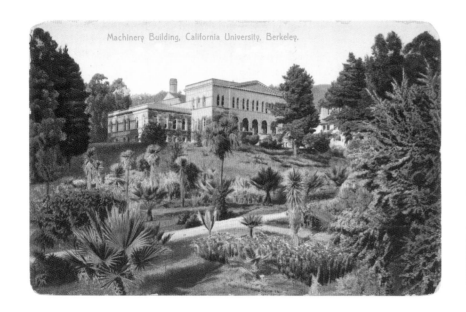

Machinery Building, California University, Berkeley.

"Machinery Building, California University, Berkeley."
Pacific Novelty Company, No. 692.

Here the Mechanical and Electrical Engineering building is seen through the Botanical Gardens. William Curlett, Architect, 1893.

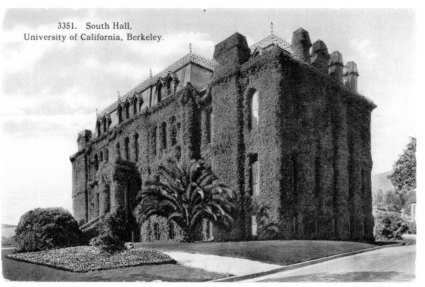

3351. South Hall, University of California, Berkeley.

"South Hall, University of California, Berkeley."
Cardinell-Vincent Co., No. 3351.

South Hall (David Farquharson, Architect, 1873) is the only remaining building of the Picturesque phase of the campus. In this view, the red brick walls and contrasting gray cast iron trim, sand painted to imitate stone, are completely hidden by Virginia creeper vines.

"The Palms, University of California, Berkeley."
Edward H. Mitchell, No. 354.

This tropical view shows a portion of the Botanical Gardens that once filled the central glade of the campus.

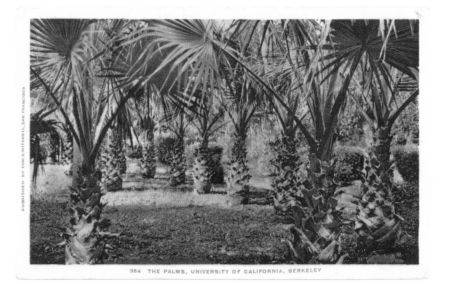

354 THE PALMS, UNIVERSITY OF CALIFORNIA, BERKELEY

"The Foot-Ball Statue, University of California."
I. Sheff & Bros., No. Cal. 75.

The statue was a prize awarded the University of California football team for its Big Game victories over Stanford University in 1898 and 1899.

"Path to North Gate, University of California, Berkeley."
Associated Students' Store, No. 106.

The path crosses the center of the Botanical Gardens that once filled what is now known as Memorial Glade.

"Mitchell Memorial Drinking Fountain. University of California."
Students Co-operative Society, No. 116.

John Galen Howard, Architect, 1905. The fountain memorializes John Mitchell, the armorer for the University Cadets from 1895 to 1905, and serves to recall the origins of military instruction on the campus, established under the provisions of the Morrill Land Grant Act of 1862.

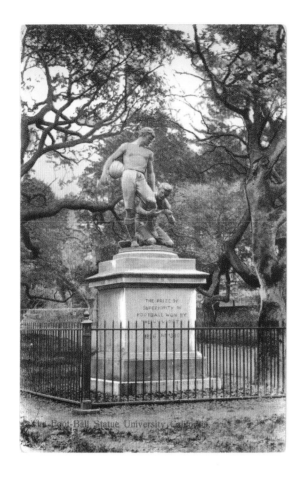

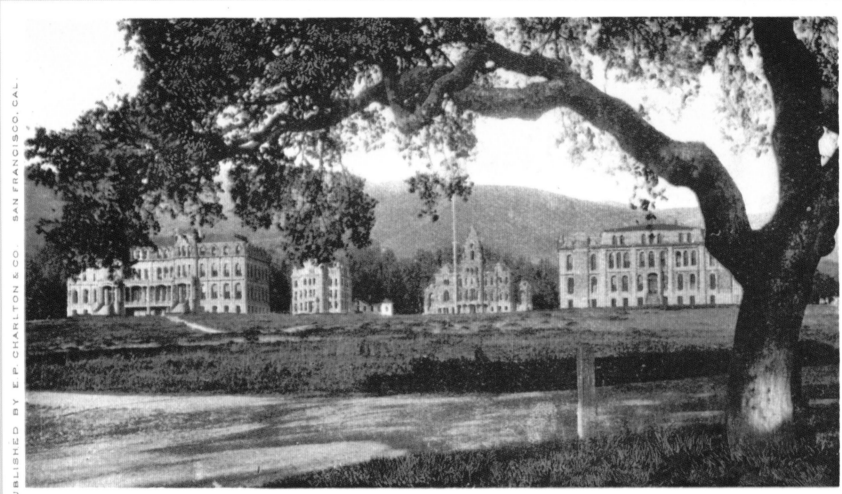

University of California, Berkeley, Cal.

THE PICTURESQUE PHASE

In 1866, the legislature established a land grant technical college, and a year later it proposed to build on a site about two miles from the College of California tract. The Board of Trustees of the College of California then decided, in the best interests of education, to merge their private institution with the new state college. The two formed the University of California under the Charter of 1868 and established a Board of Regents charged with the management of all University properties. The Committee on Grounds and Buildings was put in charge of all construction. The Board of Regents was also charged to adopt a general plan for the new campus, which "shall set aside separate buildings for separate uses, and yet group all such buildings upon a general plan, so that a larger and central building hereafter erected may bring the whole into harmony as parts of one design."

By 1870, the Regents had adopted plans for six "spacious and elegant buildings," to be known as the College of Agriculture, the College of Mechanic Arts, the College of Civil Engineering, the College of Mines, the College of Letters, and a focal structure to be known as the Hall of California. David Farquharson was selected as architect for the first two of these buildings, North Hall and South Hall, both completed in time for the University's opening in September 1873. They were located part way up the sloping site, approximately where Olmsted envisaged the placing of his "considerable buildings," overlooking the Golden Gate. And eight years later Bacon Hall, which housed the Library, was completed as the focal structure flanked by the two Halls. Of these only South Hall now survives. But the axial balance they formed prevailed in the following decades. The major cross-point today, once marked by Bacon, North, and South halls, is the axial crossing of

Campanile Way and the Campanile Esplanade. By the end of the century two more major buildings, the Civil Engineering and Mechanics buildings, joined this nucleus, while over a dozen lesser structures, mostly of frame construction, were scattered without much thought on the more level portions of the campus site. The central branch of Strawberry Creek, running through the middle of the campus site, was drained off to gain level ground for a running track and botanical garden.

"University of California, Berkeley, Cal."
E. P. Charlton & Co.

North Hall, Bacon Hall, and South Hall, arranged according to the modified Farquharson Plan of 1869, balance around the axis established by Olmsted. The flagpole stands where one day Sather Tower was to be erected.

"Strawberry Canyon, Near Berkeley, California."
Edward H. Mitchell for "Sadler's."

Two branches of Strawberry Creek meet in the western portion of the campus and flow to San Francisco Bay.

North Hall, California University, Berkeley, Calif.

North Hall, University of California, Berkeley, Cal. Aug 23/07
4166. Skidoo.

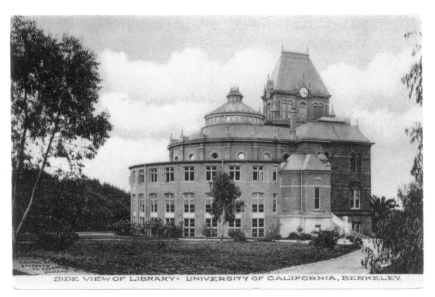

SIDE VIEW OF LIBRARY~ UNIVERSITY OF CALIFORNIA, BERKELEY.

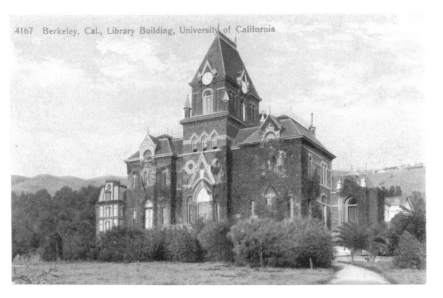

4167 Berkeley, Cal., Library Building, University of California

"North Hall, California University, Berkeley, Calif." Pacific Novelty Company, No. B 5.

David Farquharson, Architect, 1873. A wooden classroom building, North Hall was razed in 1917 after the construction of Wheeler Hall.

"North Hall, University of California, Berkeley, Cal." Paul C. Koeber Co., No. 4166.

The remaining concrete basement of North Hall was removed in 1937 to make way for the construction of Doe Library Annex.

"Side View of Library— University of California, Berkeley." Students Co-operative Society.

Bacon Art and Library, J. A. Remer, Architect, 1881.

"Berkeley, Cal., Library Building, University of California." Paul C. Koeber Co., No. 4167.

Bacon Hall stood at the head of the axis oriented to the Golden Gate of the Olmsted, Farquharson, and Howard plans.

"Hearst Hall."
Students Cooperative
Society.

Hearst Hall was built by
architect Bernard R. Maybeck
as a reception hall for
Phoebe Apperson Hearst.
In 1901 it was moved to the
campus from Channing Way.

"Chemistry Building."
Students Cooperative
Society.

Architect Clinton Day used a
Flemish-Gothic style for the
Chemistry Building in 1891.

"Philosophy Building, Calif.
University, Berkeley, Cal."
Pacific Novelty Company,
No. B.13.

A late nineteenth-century
wood building in the
Classic style.

"Harmon Gymnasium
University of California,
Berkeley, California."
Edward H. Mitchell,
No. 3068.

Built in 1879, Harmon
Gymnasium also functioned
as a concert and assembly
hall.

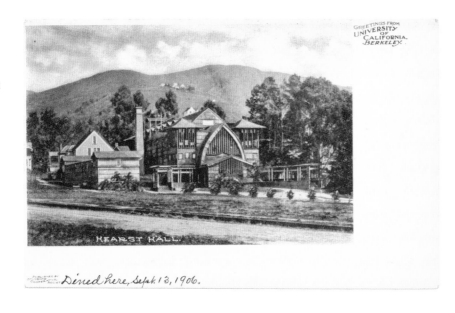

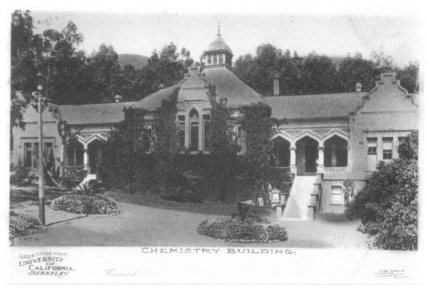

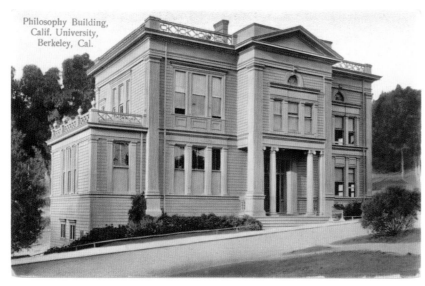

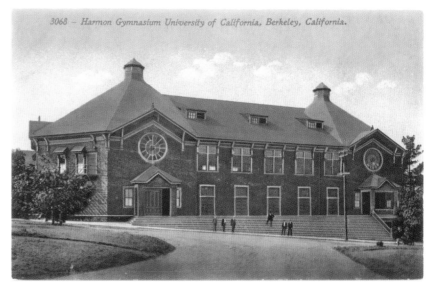

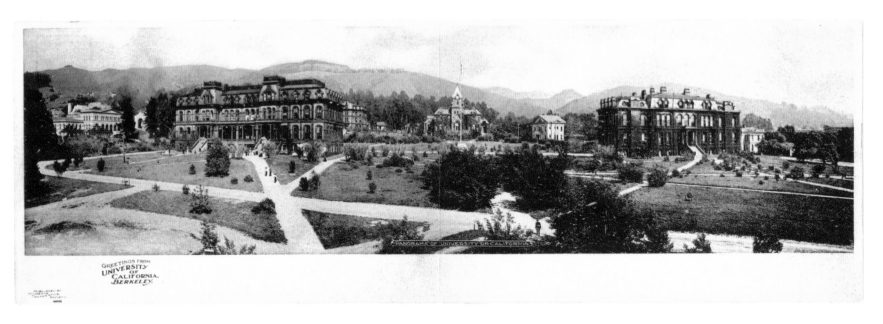

GREETINGS FROM
UNIVERSITY
OF
CALIFORNIA.
BERKELEY.

"Panorama of University of California."
Double card. Students Co-operative Society.

John A. Remer, Architect, 1881. The bell in the tower of Bacon Hall was removed in 1926 as an earthquake precaution.

"Stiles Hall, University of California. Berkeley."
The Albertype Company.

A Romanesque Revival brick building constructed in 1893 as the student center of the Young Men's Christian Society, Stiles Hall was constructed off-campus in the College Homestead Tract, land which the University later acquired for the men's physical education complex.

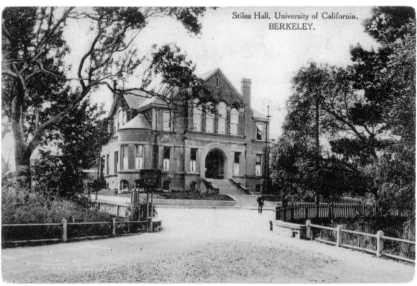

Stiles Hall, University of California.
BERKELEY.

"Botany Building,
University of California.
Berkeley."
Students Cooperative
Society, No. 145.

Clinton Day, Architect, 1898.

"East Hall, University of
California, Berkeley."
Students Cooperative
Society, No. 175.

*Clinton Day, Architect, 1898.
A wooden classroom building
introducing the Classic style
to the campus.*

"Civil Engineering Hall,
University of California.
Berkeley."
Students Cooperative
Society, No. 149.

*Alfred A. Bennett, Architect,
1879.*

"The Rudolph Spreckels
Physiological Laboratory,
University of California,
Berkeley."
Students Cooperative
Society, No. 148.

*John Galen Howard,
Architect, 1903. Renamed
the Spreckels Art Building
in 1935, it was destroyed
in 1955.*

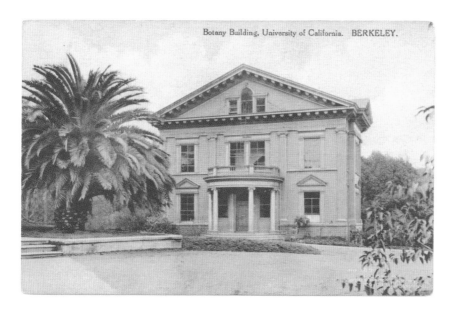

Botany Building, University of California. BERKELEY.

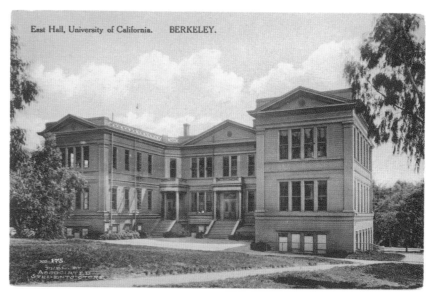

East Hall, University of California. BERKELEY.

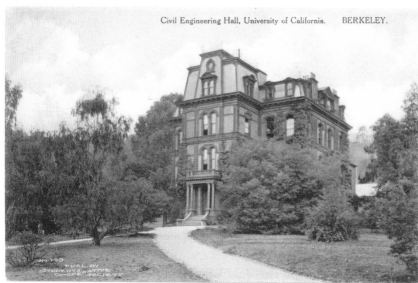

Civil Engineering Hall, University of California. BERKELEY.

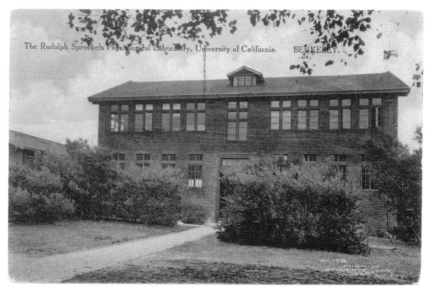

The Rudolph Spreckels Physiological Laboratory, University of California. BERKELEY.

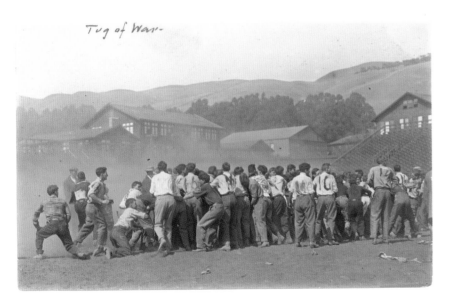

Tug of War.

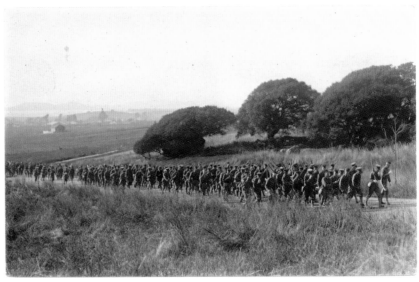

Berkeley, Cal. - University Cadets.

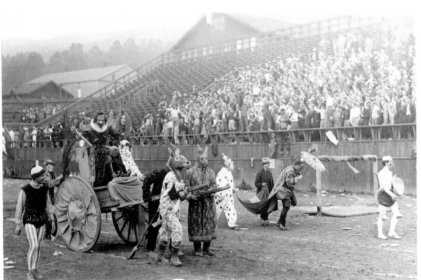

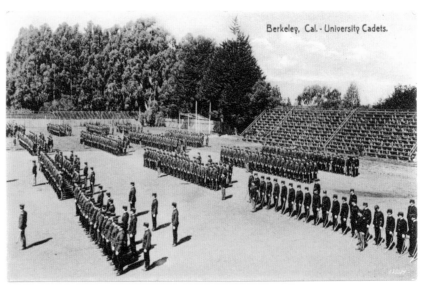

**"Tug of War."
Real-photo postcard.**

Sophomores and freshmen in a tug of war on a field south of the south fork of Strawberry Creek, the original boundary of the Picturesque phase of the campus.

**Untitled (University Cadets on hike).
Real-photo postcard.**

Note the scattered farms of Berkeley's flatlands.

**Untitled (Labor Day, 1912).
Real-photo postcard,
Glessner, Morse & Geary, Inc.**

Each leap year's February 29th was Labor Day, when the male students worked with picks and shovels in the morning hours to transform some corner of the campus, and the women students served a hearty lunch on California Field, followed by festivities in which all participated. Labor Day 1912 brought a royal procession, in which the "Kink" and Queen were played by Henry Stern, '13, and Gerald Kennedy, '12.

**"Berkeley, Cal.—University Cadets."
Pacific Novelty Company, No. 23.**

R. O. T. C. Cadets in parade on West Field, later to become the site of the Life Sciences Building.

"University of California and San Francisco Bay."
H. G. Z. & Co.

The Picturesque campus buildings of the Farquharson Plan, balanced around an axis pointing to the Golden Gate, are encompassed by the greenery of the north and south forks of Strawberry Creek.

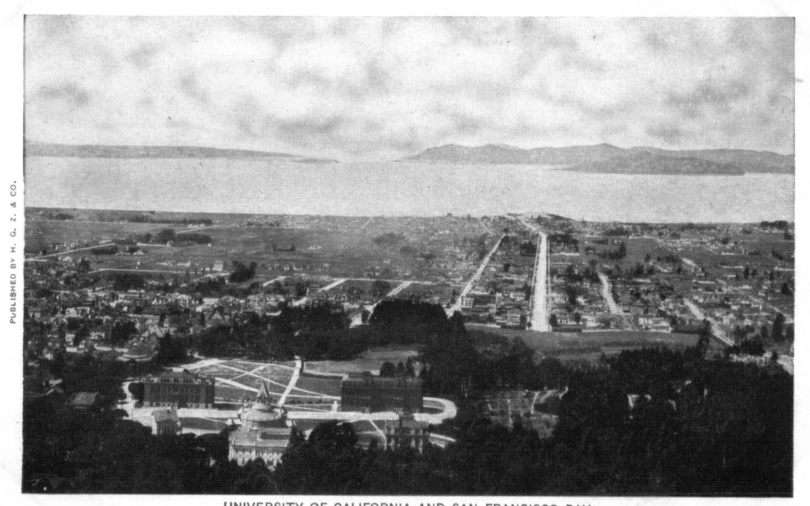

PUBLISHED BY H. G. Z. & CO.

UNIVERSITY OF CALIFORNIA AND SAN FRANCISCO BAY.

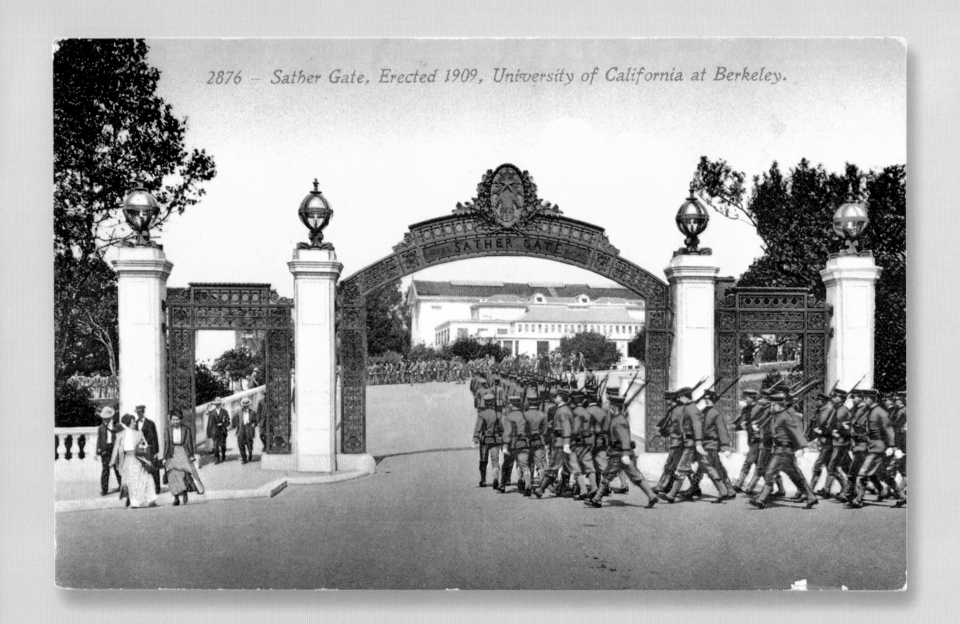

2876 – Sather Gate, Erected 1909, University of California at Berkeley.

THE CLASSICAL PHASE

In 1896, Regent Jacob Reinstein, influenced by the views of Bernard R. Maybeck, instructor in architectural drawing, urged the Board of Regents to adopt a long-range plan for the growth of the University of California. The Board was receptive and accepted Phoebe Apperson Hearst's offer to fund Maybeck's proposal that an international competition be held to obtain a physical plan for the University. A jury of five internationally known architects was chosen, and invitations were extended to architects throughout the world to compete. Bernard Maybeck was appointed as the competition advisor.

University requirements in the program guide for competitors included provisions for housing the administration, departmental offices, a library, a museum, an auditorium, a military establishment, gymnasia, dormitories to lodge 1,500 students, club houses, and an infirmary. Fifteen departments of instruction were to be accommodated, and all buildings were "to be so connected as to insure easy communication, both open and covered, between the groups of buildings, and to contribute to the stately aspect of the whole."

The jury unanimously chose as the winning design that of Emile Bénard, an eminent French architect. Bénard came to Berkeley to effect what revisions might be necessary to fit his plan more closely with actual conditions. Although it had been hoped that he would remain to supervise the execution of his plan, Bénard left the campus soon after he had completed the revision in 1900.

The Board of Regents adopted Bénard's revised plan as "The Phoebe A. Hearst Permanent Plan for the University of California," the official basis for building operations and landscape gardening of the campus. John Galen Howard of New York, who had placed fourth in the competition, was invited to come to Berkeley and supervise the execution of the Bénard Plan, and Mrs. Hearst, at the recommendation of Mr. Maybeck, selected Howard to design a memorial building to her husband.

Bénard's triumph was the triumph of the Beaux Arts, which since the 1880s had put an end to the picturesque ideals of Downing, Olmsted, and others. The Classical Chicago Fair of 1893 had swept the country and given rise to City Beautiful projects in East and West alike. The scale of the Bénard Plan was monumental, and fixed the placing of academic areas for the future. Bénard was sensitive to the peculiarities of the site, both natural and architectural. His grand axis scheme was designed with an axis from hills to bay as envisaged by Olmsted. His axis, however, shifted northward, skewed from that of Bacon, North, and South halls, which were to be demolished to make room for the new buildings. The shift brought the axis into harmony with the grid of the city of Berkeley.

John Galen Howard thought of the Bénard plan as nothing more than a preliminary sketch. By 1908, he had altered it enough to render the plan almost unrecognizable. Howard deviated from the Bénard plan in designing the Hearst Memorial

Mining Building in 1902. He respected the place Bénard had allocated to Mining, but he shifted the axis of the building to align it with Bacon, North, and South halls. His new axis reverted to the pre-Bénard position. It had the advantage of being in harmony with the existing major buildings of the Picturesque Phase that now were to be retained. But his axis was at an angle to the city street grid, and he arranged his buildings facing inward about it rather than outward toward the city.

After the start of the Hearst Memorial Mining Building (1902) came the Greek Theater (1902–1903). Not envisaged in Bénard's plan, its construction doomed his plan's implementation. Buildings constructed in the next years followed Howard's competition entry: California Hall (1903), Doe Memorial Library (1907), Sather Gate (1908), Boalt Hall (1908), Agricultural Hall (1910), and Sather Tower (1913). The Campanile became the landmark of a long east-west axis and the formal north-south esplanade. Howard incorporated all his new buildings in a general plan of 1914, called the "Phoebe Apperson Hearst Architectural Plan."

When building reached the edge of the campus and bordered city streets, in recognition of the city grid Howard designed buildings like Hilgard Hall (1916) in an odd polygonal shape, with a long facade that lined with Oxford Street to the west, while the short south facade lined with the axis of the campus. This doubtful practice of having peripheral buildings conform both to the campus axis and to the city grid was used in future buildings.

On several new buildings Howard was overruled. Memorial Stadium was built in 1923 at the mouth of Strawberry Canyon over his strenuous protest. In 1927, the Hearst Memorial Gymnasium, designed by Maybeck and Julia Morgan, a splendid Beaux Arts pile overlooking Bancroft Way,

aligned with the Howard axis, but the Maybeck-Morgan scheme, by the skillful use of terracing on the side toward Bancroft Way, met the city grid without mechanically lining up its mass with the street.

In 1927, George W. Kelham succeeded Howard as supervising architect. He proposed no new master plan, and the Howard scheme continued to serve as the guiding plan of the campus. Planning was taken from the supervisory architect and put in the hands of the Buildings and Campus Development Committee. Its first recommendation was the placement of the Men's Gymnasium on land outside the limits of the original campus, beyond its southwest corner. A track stadium and fields were added. This group of structures and the Hearst Gymnasium to the east extended the width of the campus southward by two city blocks.

In 1930, the University enrolled 11,200 students; the city of Berkeley had become a bustling town of 80,000 inhabitants. And, because of a growing concern with escalating enrollments and increasing land values, a large Life Sciences building was built to house all of the biological sciences rather than a group of small units as envisaged by the Howard plan. This decision marks the end of the Classical Phase.

"Bird's-eye view of 'Greater University of California' plans."
Needham Bros.

Emile Bénard's revised plan, 1900. Notice that the campus is bound on the north by Hearst Avenue and on the south by Allston Way. Only Bénard's physical education complex extends south to Bancroft Way.

"Hearst Memorial Mining Building—University of California, Berkeley."
Pacific Novelty Company, No. B 88.

John Galen Howard, Architect, 1902–1907. A building in the Free Classic Style.

"Air View University of California Campus, Berkeley."
Associated Students, Berkeley.

The heart of the Classical campus shows clearly, sited between the north and south forks of Strawberry Creek, indicated by the dark tree masses.

"Sather Gate, University of California, Berkeley."
Associated Students' Store, No. 187.

The Sather Gate entrance to the campus sits askew to Telegraph Avenue.

Bird's-eye view of "Greater University of California" plans

NEEDHAM BROS., BERKELEY

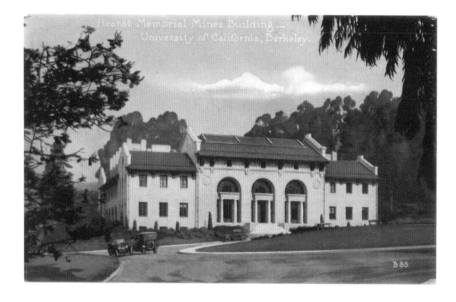

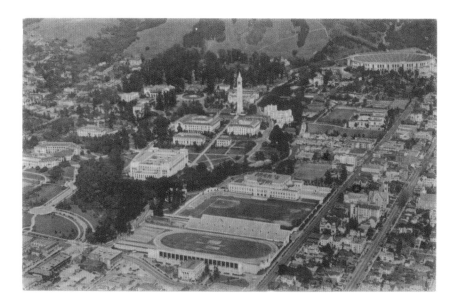

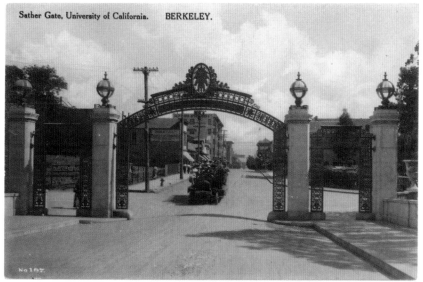

Sather Gate, University of California. BERKELEY.

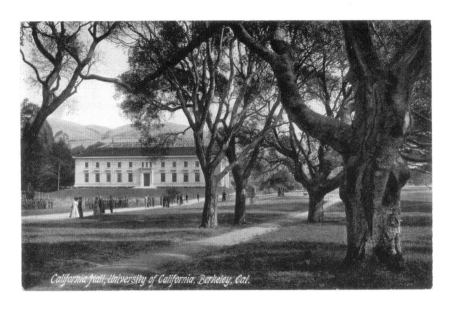

California Hall, University of California, Berkeley, Cal.

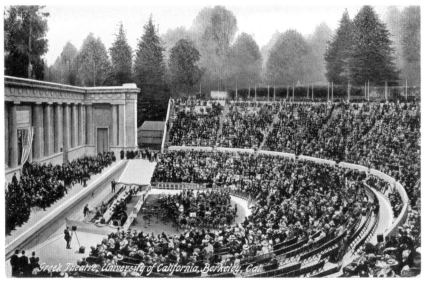

Greek Theatre, University of California, Berkeley, Cal.

3108 — Residence of President Wheeler, University of California, at Berkeley.

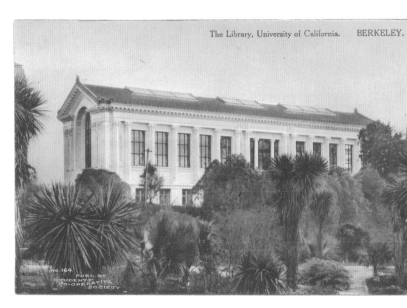

The Library, University of California. BERKELEY.

"California Hall, University of California, Berkeley, Cal."
Pacific Novelty Company, No. B. 37.

John Galen Howard, Architect, 1903–1905. California Hall was designed when Julia Morgan was working in the Howard office.

"Greek Theatre, University of California, Berkeley, Cal."
Pacific Novelty Company, No. O. 40.

John Galen Howard, Architect, 1902–1903. A gift of William Randolph Hearst.

"Residence of President Wheeler, University of California, at Berkeley."
Edward H. Mitchell, No. 3108.

Albert Pissis, Architect, 1901. This is the only building on campus sited according to the Revised Bénard Plan.

"The Library, University of California. Berkeley."
Students Co-operative Society, No. 164.

John Galen Howard, Architect, 1907–1911.

"Campus Scene, University of California, Berkeley."
Associated Students' Store, No. 310.

The Classic Campus. From left to right: California Hall, Doe Library, Boalt Hall, Wheeler Hall, and Sather Tower.

"The University of California, Berkeley, Boalt Hall of Law, California Hall."
Students Cooperative Society, No. 147.

John Galen Howard, Architect, 1908–1911, and 1903–1905.

"Agricultural Hall, University of California, Berkeley."
Associated Students' Store, No. 155.

John Galen Howard, Architect, 1910–1912.

Untitled (once Architecture, now North Gate Hall). Real-photo postcard.

John Galen Howard, Architect, 1905–1912. The building served as a combination Office of the Supervising Architect and the School of Architecture. The plaster casts ornamenting the walls were remnants from the Panama-Pacific International Exhibition of 1915.

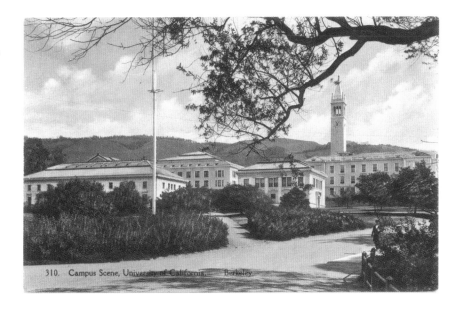

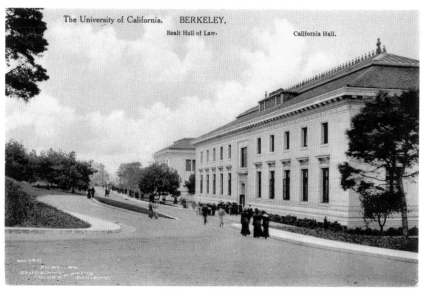

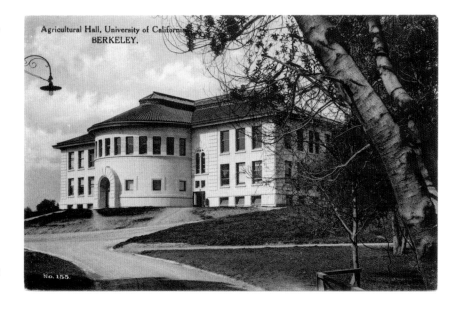

"Class of 1910 Bridge,
University of California,
Berkeley."
The Albertype Co.

*John Bakewell, Jr., and Arthur
Brown, Jr., Architects, 1911.
The bridge crosses Straw-
berry Creek and leads to
Faculty Glade, once known
as Co-ed Canyon.*

Class of 1910 Bridge, University of California. BERKELEY.

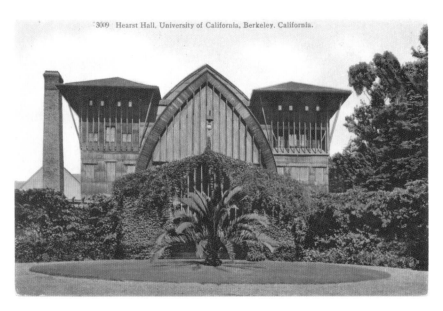

3009 Hearst Hall, University of California, Berkeley, California.

"Hearst Hall, University of
California, Berkeley,
California."
Britton and Rey, No. 3009.

*Bernard R. Maybeck,
Architect, 1899–1901. Mrs.
Hearst's Reception Hall was
moved to the campus where
it served as the Women's
Gymnasium. The shape of
the pairs of bolted wood
laminated arches, which
aided in the removal of
sections of the building to
the campus, dominate the
western elevation.*

"Berkeley, California,
Memorial Stadium,
University of California."
Real-photo postcard.

*John Galen Howard,
Architect, 1923. Howard
objected to the siting of the
stadium in the mouth of
Strawberry Canyon.*

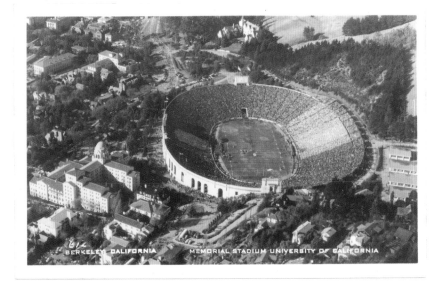

BERKELEY CALIFORNIA MEMORIAL STADIUM UNIVERSITY OF CALIFORNIA

"Faculty Club, University of California, Berkeley, California."
Edward H. Mitchell, No. 858.

Bernard R. Maybeck, Architect, 1902. The Faculty Club was Maybeck's first commission on the campus, although the Reception Hall that he had designed for Phoebe Hearst had been moved to the campus in 1901 to serve as a gymnasium and social hall for women students. It was destroyed by fire in 1922. Maybeck's later work, also a gymnasium, done in conjunction with Julia Morgan, was part of a grand scheme that was to include a large auditorium and is pictured in the following postcards. The marble decks and planting boxes surrounding the Main Pool were planned to be lobbies that would be used during intermissions by persons attending performances in the auditorium. The building complex was planned to terminate the north-south axis of the Campanile Esplanade.

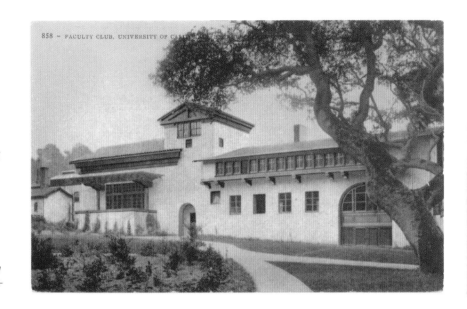

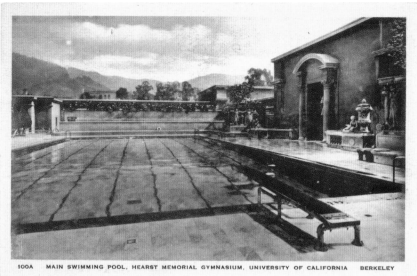

100A MAIN SWIMMING POOL, HEARST MEMORIAL GYMNASIUM, UNIVERSITY OF CALIFORNIA BERKELEY

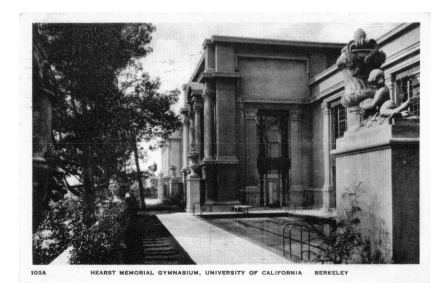

103A HEARST MEMORIAL GYMNASIUM, UNIVERSITY OF CALIFORNIA BERKELEY

"Main Swimming Pool, Hearst Memorial Gymnasium, University of California, Berkeley."
Associated Students, Berkeley, No. 100A.

Bernard R. Maybeck, and Julia Morgan, Architects, 1926–1927.

"Hearst Memorial Gymnasium, University of California, Berkeley."
Associated Students, Berkeley, No. 103A.

Bernard R. Maybeck, and Julia Morgan, Architects, 1926–1927.

"The Campanile, Height 307 feet, University of California. Berkeley." Associated Students' Store, No. 324.

John Galen Howard, Architect, 1913–1914.

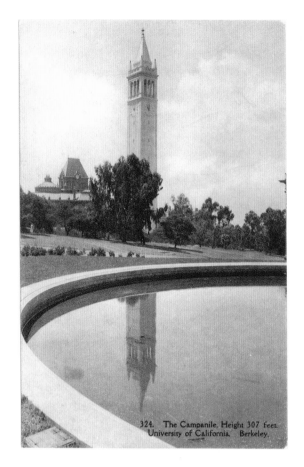

324. The Campanile, Height 307 feet. University of California, Berkeley.

"Benjamin Ide Wheeler Hall, University of California, Berkeley." Associated Students' Store, No. 309.

John Galen Howard, Architect, 1915–1917. The principal facade of Wheeler Hall faces south and recognizes a shift in campus orientation from the west to the south campus area where most students lived and shopped.

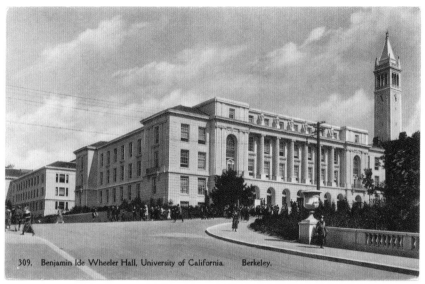

309. Benjamin Ide Wheeler Hall, University of California. Berkeley.

Untitled
(Life Sciences Building). Real-photo postcard.

George Kelham, Architect, 1929–1930. The building of groups of small buildings for related academic disciplines of the Bénard and Howard plans was abandoned in Kelham's large monolithic concrete structure for the life sciences.

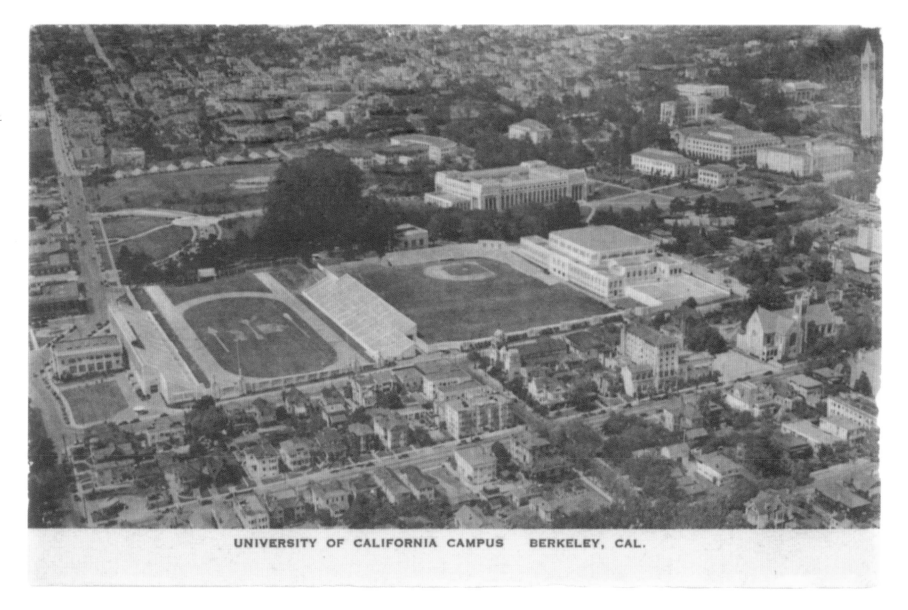

"University of California Campus, Berkeley, Cal." Associated Students, Berkeley.

Athletic fields replaced several blocks of the College Homestead Association Tract.

UNIVERSITY OF CALIFORNIA CAMPUS BERKELEY, CAL.

Senior Bench, University of California. BERKELEY.

CAMPUS PLACES

The commitment of students and faculty to intellectual development and to the world of everyday reality is much more than academic. To the distress of some and the excited enthusiasm of others, the campus has been a vital and sometimes impassioned center of social development. The evolution of a campus is not merely a matter of buildings built and buildings destroyed. A campus may be seen as a place whose character develops from the activities of its inhabitants as well as the alterations and additions to its parts.

Campus places were shaped by Henry Durant and Professor Joseph LeConte, Regent Reinstein, Phoebe Hearst, by President Benjamin Ide Wheeler and Coach Andy Smith, just as much as they were shaped by the ambitious master plans of Emile Bénard and John Galen Howard. The athletic competitions that students engaged in or watched, the rallies and bonfires, traditions begun and traditions forgotten, the hazing of freshmen, and the students excused from classes to construct walks and roads, all modified the environment as much as the constructions of the architects and contractors.

The Master Plans represented well-intentioned aspirations. None was followed faithfully or fully realized. This is natural. The physical development of any man-made environment can only partially be subjected to prescriptive plan. Places, being containers of human activity, grow less rigidly and predictably than we might like them to. They react to necessity and unforeseen financial limitations. They are prone to the impact of dynamic persons, of memorable events, of the temper of the times.

Remembrances of activities in, or on, the Big "C" trail, cadet drill fields, athletic stadiums, Faculty Glade, North and South Strawberry creeks, the eucalyptus grove, academic

processions, the Greek Theater, the Campanile, West Gate, North Gate, Sather Gate, and places with names now forgotten—all campus places pictured on postcards—may differ for those who knew them at differing times. But postcards, through their growth and development, reveal an aspect of the history of the University of California not recorded in other ways.

—Kenneth H. Cardwell

"Senior Bench, University of California, Berkeley." Associated Students' Store, No. 125.

A fixture of an early tradition, the Senior Bench was once located at the southeast corner of North Hall.

Untitled
(Labor Day, Feb. 29, 1912).
Real-photo postcard.

Traditional Labor Day, with students excused from classes to work on campus paths.

"University of California
World Famous Glee Club
Spring Tour."
Publisher unknown.

"University of California
Glee Club, en route to
New York."
Publisher unknown.

"The Joint, University of
California, Berkeley."
Associated Students'
Store, No. 189.

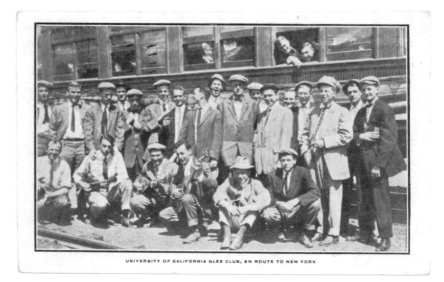

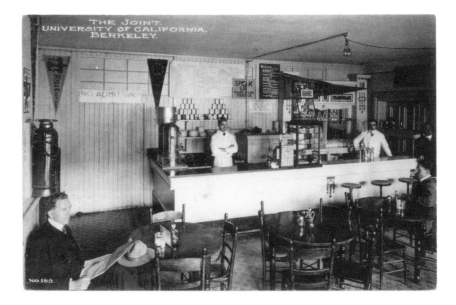

"Swimming Pool,
University of California,
Berkeley."
Edward H. Mitchell,
No. 156.

"1st and 2nd Winners
of Marathon Race
[illegible] Carnival."
Real-photo postcard,
Chas. Weidner, No. 01.

Untitled
(A.S.U.C. football players).
Real-photo postcard.

"Foot ball at University
of California."
Cardinell-Vincent Co.,
No. 674.

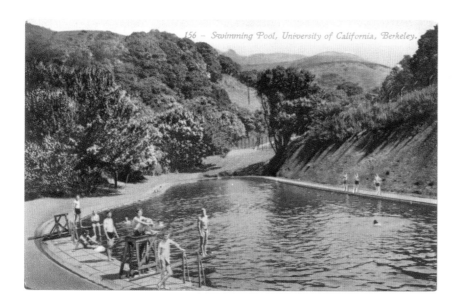

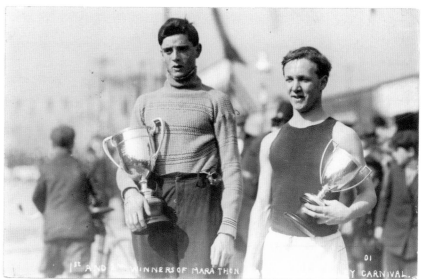

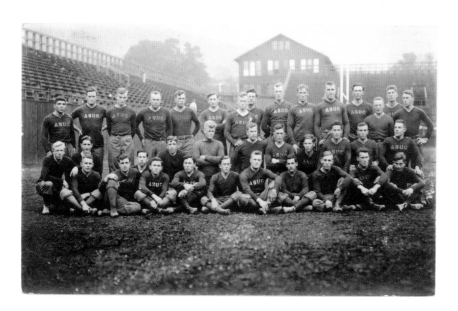

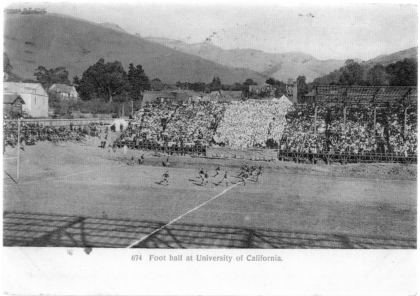

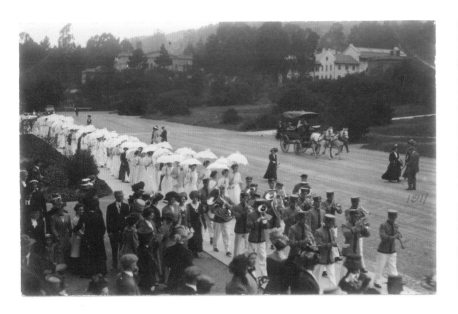

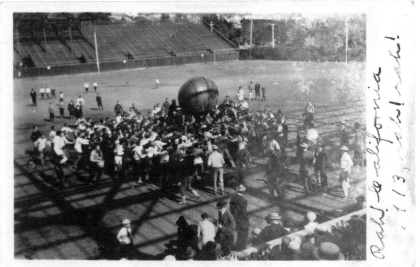

SENIOR HALL - UNIVERSITY OF CALIFORNIA, BERKELEY.

Senior Women's Hall, University of California BERKELEY.

Untitled
(Senior Pilgrimage, 1911).
Real-photo postcard.

Some traditions, such as the Senior Pilgrimage to favorite campus places, have waned.

Untitled (Push Ball Match).
Real-photo postcard.

Contests between freshman and sophomore classes have a long tradition at the University.

"Senior Hall—University of California, Berkeley."
Students Cooperative Society.

John Galen Howard, Architect, 1905. The redwood log cabin, also known as the "Golden Bear Lodge" was (and still is) home to the Order of the Golden Bear, a senior honor society.

"Senior Women's Hall, University of California, Berkeley."
Associated Students' Store, No. 180.

Julia Morgan, Architect, 1911. The building, Girton Hall, took its name from Girton College, the first residential college established for women at Cambridge University in 1869.

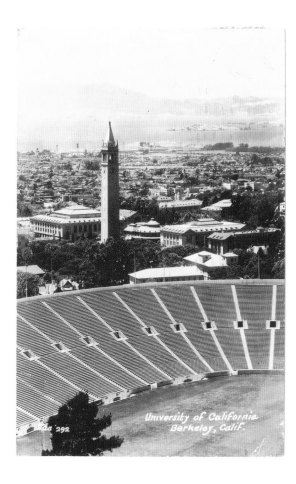

"University of California,
Berkeley, Calif."
Zan, No. 292.

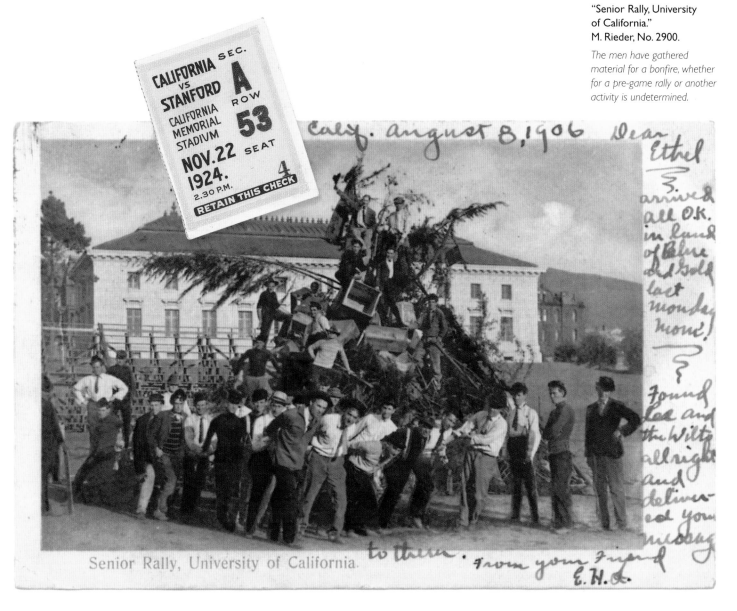

Senior Rally, University of California.

"Senior Rally, University
of California."
M. Rieder, No. 2900.

*The men have gathered
material for a bonfire, whether
for a pre-game rally or another
activity is undetermined.*

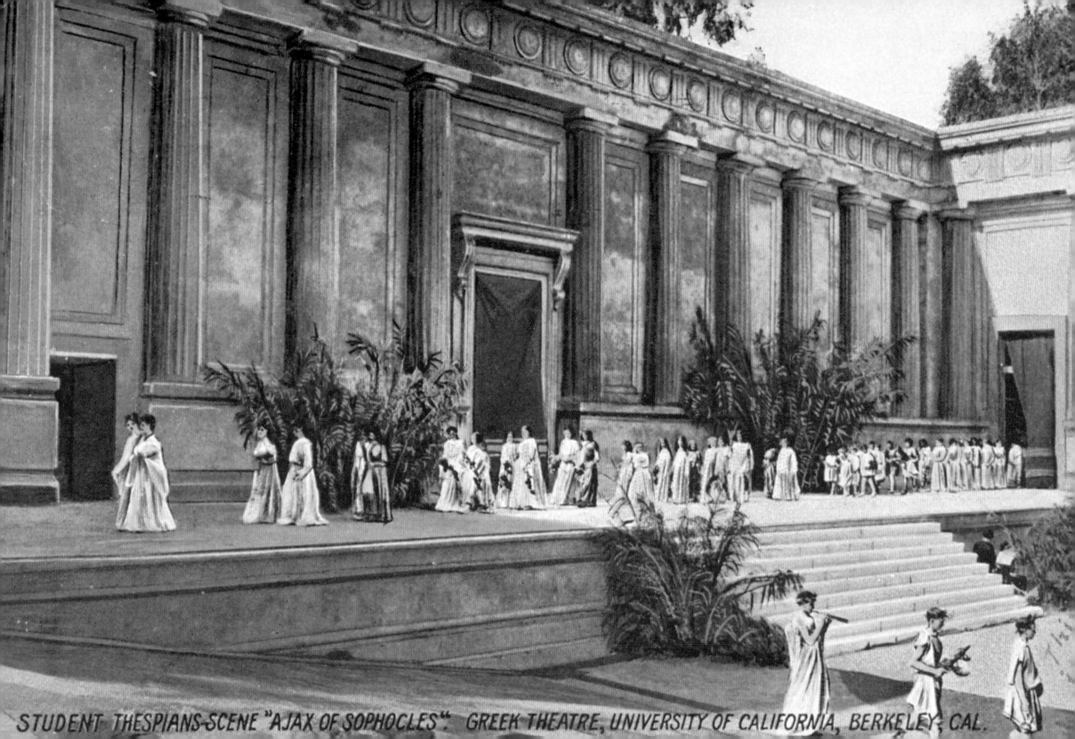

STUDENT THESPIANS-SCENE "AJAX OF SOPHOCLES". GREEK THEATRE, UNIVERSITY OF CALIFORNIA, BERKELEY, CAL.

From the time of its incorporation on April 1, 1878—in order to avoid annexation by the rowdier city of Oakland—Berkeley intended to be a city of culture and refinement. The establishment of a university in Berkeley ten years earlier attracted educated and professional people who also appreciated a "suburban" lifestyle removed from bustling San Francisco. The needs of a cultured class were served by merchants, artisans, and farmers of great diversity, giving Berkeley a cosmopolitan but genteel air. This development of the city into a cultural mecca is reflected in the popularity of postcards depicting institutions such as churches, clubs, and theaters as well as those commemorating important civic and historic events.

THE GREEK THEATER

The most popular Berkeley postcard subject in the early 1900s was the Greek Theater. Designed by John Galen Howard and modeled after the Greek amphitheater at Epidaurus, it was one of the first outdoor amphitheaters to be built anywhere in the world since ancient times. It was a symbol of culture in a state just emerging from its dusty frontier past.

The first ceremony in the Greek Theater was the presentation of an honorary Doctorate of Law to President Theodore Roosevelt by University President Benjamin Ide Wheeler. On May 14, 1903, the headline of the *Berkeley Daily Gazette* proclaimed "Town and Gown Combine to Give the Chief Executive of the Nation a Royal Rousing Welcome…. Thousands Throng the Theater," and "Children Welcome President." A company of African-American soldiers led the parade that accompanied President Roosevelt's party to the theater. The theater was not yet completed, but, the article continued, under the "able direction of Architect John Galen Howard and Miss Julia Morgan the open-air theater will present a beautiful appearance. The sixteen pillars and most of the stage will be entirely draped in white. Along the outer rim of the amphitheater will be placed a double row of supporting festoons and wreaths of laurel and roses."

The official opening took place some months later on September 24, 1903. Again, the *Berkeley Daily Gazette* reported the event in detail: "Before an audience numbering nearly 8,000 persons, the new open-air theater on the University of California campus was dedicated this afternoon with the presentation of Aristophane's 'Birds,' a comedy twenty-four hundred years old, by men students of the University, who are engaged in the study of classics. It was the first time that an old Greek comedy had been given in the West."

For over a decade after its official opening, the theater was an important tourist destination. Postcards were sold by the

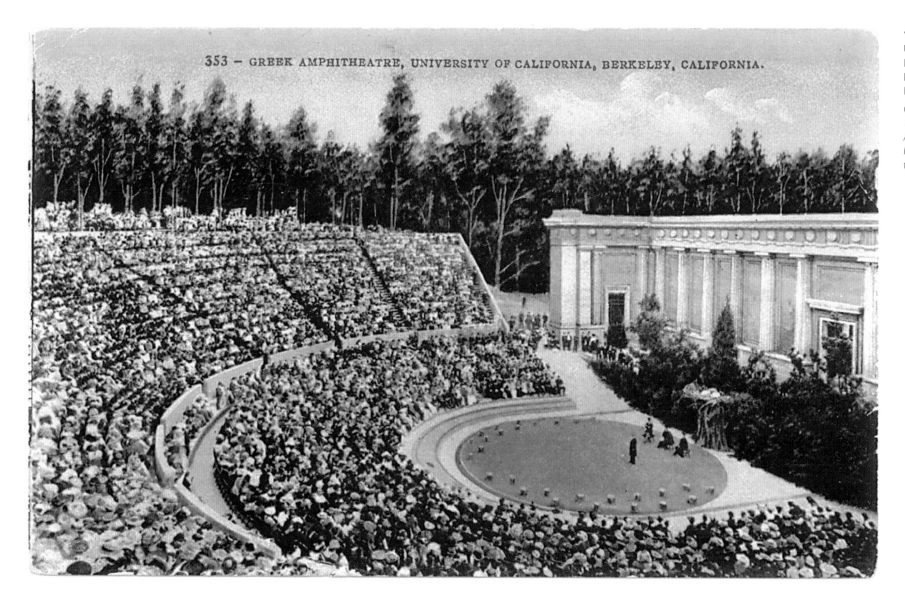

353 – GREEK AMPHITHEATRE, UNIVERSITY OF CALIFORNIA, BERKELEY, CALIFORNIA.

"Greek Amphitheatre, University of California, Berkeley, California." Edward H. Mitchell, No. 353.

Official opening, September 1903, "The Birds" by Aristophanes. Note the large eggs in a nest behind the student actors.

"Greek Theatre, University of California, Berkeley, Cal." Pacific Novelty Co., No. B. 41.

President William Howard Taft's 1909 visit to Berkeley.

"Greek Theatre, University of California, Berkeley, California." Edward H. Mitchell, No. 2253.

"M. Sarah Bernhardt, Greek Theatre." Pillsbury Picture Co., No. 1019.

"An Artistic Triumph is Scored by the Noted Parisian who Appears on Cement Stage in the Open Air," stated the Berkeley Reporter *on May 17, 1906.*

Program for the "Ajax of Sophocles," Greek Theater, October 13, 1904.

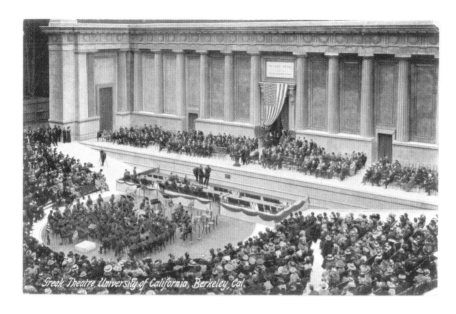

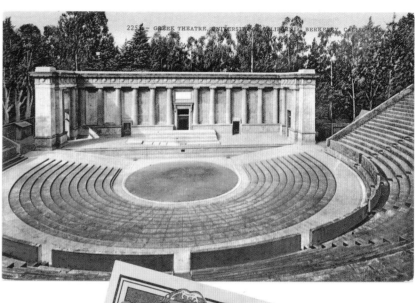

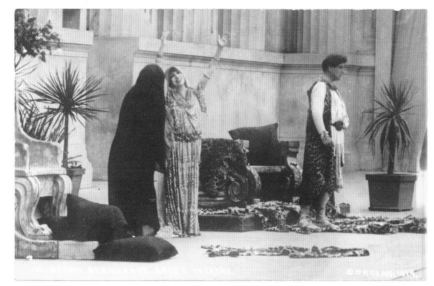

thousands, helping to spread Berkeley's growing reputation as the center of learning, the "Athens of the West." Well-known performing artists appeared before sold-out audiences. In an era before movies, San Franciscans crossed the bay by ferry where the Southern Pacific train waited to take them to downtown Berkeley. From there it was a pleasant walk through the sylvan campus to the Greek Theater. On the way home after the performance, there might be time to buy a few postcards at the stores on Center Street or at the train station kiosk.

TEMPLE OF WINGS

In 1911, Florence Treadwell Boynton asked Bernard Maybeck to design a home that would enhance a Hellenic lifestyle. They developed a roofed open-air pergola that became known as the "Temple of Wings."

In 1996, the Berkeley Historical Society held an event within the courtyard of the Buena Vista Way home, where Professor Kenneth Cardwell described the original structure:

> The Temple of Wings was erected without walls. Thirty-four Corinthian columns of concrete were poured on site, and supported canvas awnings between them. A central fireplace, having four openings, and a flagstone floor heated with hollow earthen tubes took off the chill of winter nights. To Florence Boynton, who conceived the roof as "a pair of sheltering wings," the new home captured the spirit of "Athens of the West," as Berkeley was then known. The Temple was badly burned in the 1923 Berkeley Fire, but was rebuilt by Edna Deakin, who installed permanent stucco walls instead of canvas.

Isadora Duncan, a devotee of free-flowing dance, was a Boynton family friend. The Boynton family lived in the house for almost seven decades, and for much of that time, the girls and boys of the community learned modern dance at the Boynton Temple of Wings. Ironically, Duncan herself never gave a professional performance at the Temple home, or at the Greek Theater of the University.

CLUBS

Civic and social clubs were formed as the town's population expanded. African-American women in Berkeley and Oakland who wanted to pursue cultural interests and provide charitable services founded the Fanny Jackson Club in 1899, the oldest Black club in the state. Other clubs were the Mother's Charity Club, founded in 1905, and the Phyllis Wheatley Club of the East Bay, founded in 1914; both of these clubs advocated racial solidarity in a statewide network of Black women's clubs. In 1928, the East Gate Lodge 44 of the Prince Hall Masons was organized as a Black men's organization.

Meanwhile, women in north Berkeley started the Hillside Club in 1899 to protect the hills of Berkeley from unsightly grading and "unsuitable and disfiguring houses." They were influenced by the ideas of architects Bernard Maybeck and John Galen Howard and poet Charles Keeler, all of whom joined the Club when membership was later opened to men. The Club produced a booklet in 1905, given to prospective purchasers of Berkeley lots, which discouraged "additions to the natural hills which may detract from their beauty."

Women also were influential in organizing civic and cultural groups, including the Twentieth Century, Town and Gown, Berkeley Piano, and Berkeley City clubs.

"Temple of Wings." Real-photo postcard.

The Boyntons sent this postcard to friends at Christmas. It shows the temple as rebuilt after the 1923 Berkeley Fire.

Untitled (Temple of Wings). Photo by Ron Delaney.

Isadora Duncan's influence on dance is very much in evidence today. Mary Sano, dancer and founder of the Isadora Duncan Heritage Society of Japan, performed at the Temple of Wings for a Berkeley Historical Society event in 1996.

Untitled (Isadora Duncan, c. 1915). Photo by Arnold Genthe, courtesy of The Bancroft Library, University of California, Berkeley.

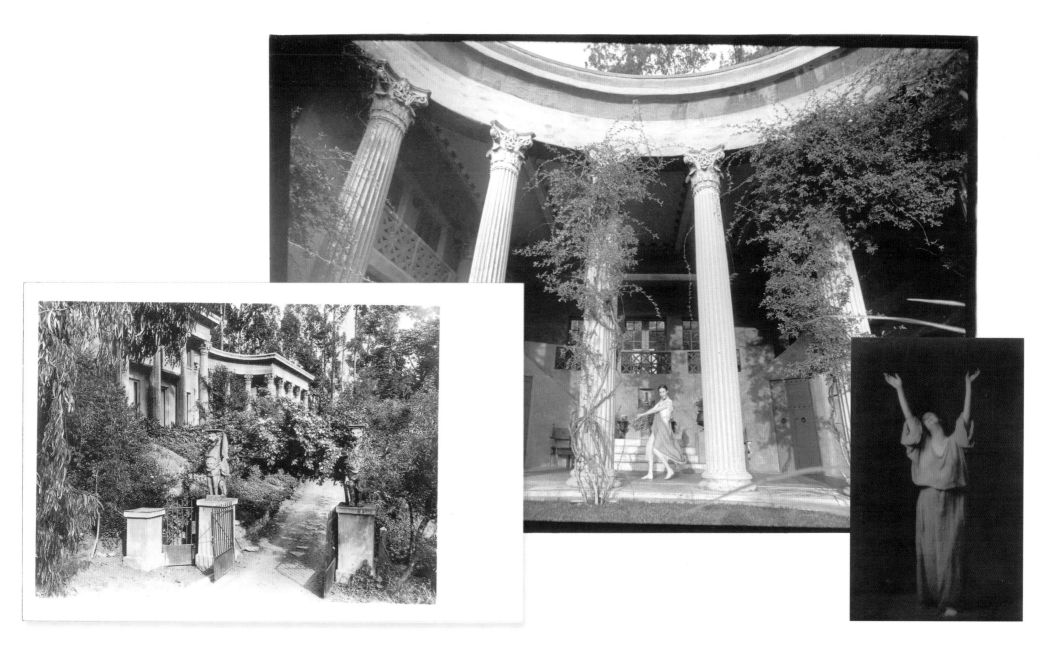

"Athens."
Real-photo postcard,
Dooley photographer.

*Charles Daniel offered
piano, voice, violin, and
dancing performances as
well as lectures on Art.
The Berkeley Daily Gazette
featured an article about
the Club's opening in 1908:
"BERKELEY HOME TO BE
TEMPLE OF GREEK GODS.
Each of Nine Rooms to
Be Dedicated to a Muse,
While Other Goddesses
Will Be Scattered About."*

**Untitled (College
Women's Club).**
Real-photo postcard.

*A structure of eloquent and
graceful design, the College
Women's Club, 2100
Bancroft Way at College
Avenue, was designed in
1928 by architect Walter T.
Steilber. He had worked
previously in Julia Morgan's
office and was a student
of John Galen Howard. The
Club was founded in 1920
to promote new educational
opportunities. Its accomplish-
ments include establishing
the first cooperative day
nursery in the county,
working on the first Braille
translations, forming a
foreign student hospitality
organization (which inspired*

*the Rockefeller Foundation to
build International House in
Berkeley), and promoting the
hiring of the first police-
woman in Berkeley.*

"A Monterey Road."
Invitation postcard.

*The Town and Gown Club
still meets in its handsome
and trendsetting brown-
shingle clubhouse designed in
1899 by architect Bernard
Maybeck at the corner of
Dwight Way and Dana
Street. The card announcing
an exhibition of paintings by
University professor of art
Eugen Neuhaus is post-
marked 1914.*

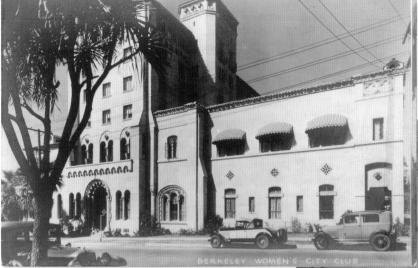

"Berkeley Women's
City Club."
Real-photo postcard,
Morton and Co.

*With its Gothic arches and
interior garden courtyards,
the Berkeley City Club
(as it is called now) at
2315 Durant Avenue stands
even today as a masterpiece
of design by architect
Julia Morgan.*

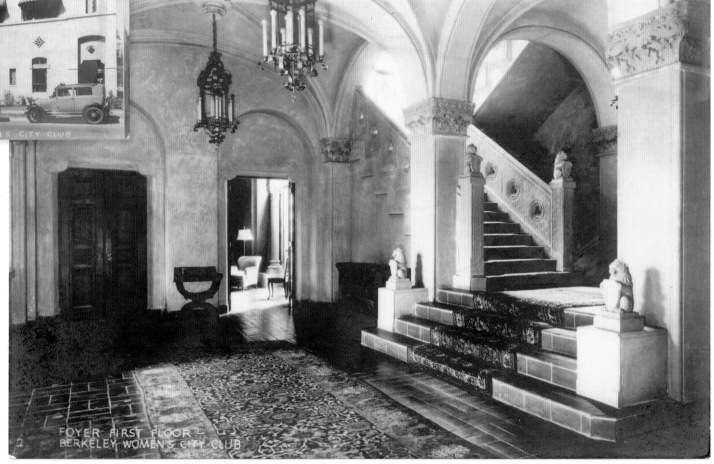

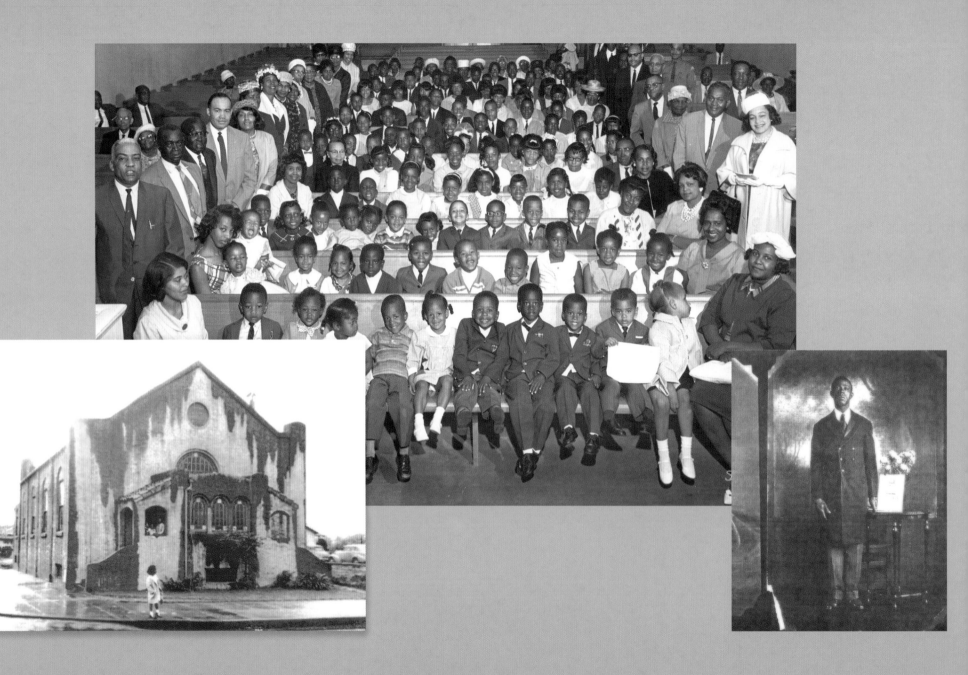

"Sunday School at
McGee Avenue
Baptist Church."
Photo, c. 1950.

Untitled (Mt. Pleasant
Baptist Church).
Real-photo postcard.

"The Reverend Silas
Lincoln Tillman."
Photo, 1918.

CHURCHES AND SYNAGOGUES

Berkeley attracted people from all ethnic and cultural heritages. There were New Englanders, Italians, Finns, Chinese, Irish, Blacks, Japanese, Germans, Jews, Mexicans, and English. Places of worship played an important cultural role in the social life of this diverse community, since the laws and customs of the time segregated certain groups from the larger civic life. Many religious and ethnic groups commissioned real-photo postcards to honor their families and institutions. These often hand-painted color postcards are especially interesting; they document Berkeley's architectural heritage in an era before color photography.

Saint Joseph's Catholic Church was constructed by 1883 and soon became the center for the Irish, Italian, and small Latino communities that lived in West Berkeley. Among these were some of the rancheros who had raised cattle on the Peralta Ranch, the 48,000-acre Spanish land grant that had comprised most of the East Bay but that by 1853 had been reduced to only 300 acres. Many stayed in the area to become landowners or farmers, while newer Mexican arrivals found employment in local factories. After the 1910 Mexican Revolution, church membership increased as a Mexican intellectual and professional class migrated to Berkeley and established newspapers, small businesses, and restaurants.

Chinese began to settle in the 1870s, and many Chinese families moved to Berkeley after the 1906 Earthquake. The Berkeley Chinese Community Church was founded in 1900. It had evolved from a Sunday School for the Chinese in the basement of the Congregational Church at Dana Street and Durant Street. When the church moved to its first permanent site at 1919 Addison Street, it became the social and cultural center for the city's Chinese residents and offered lessons in English.

In 1918, the Reverend Silas Lincoln Tillman from Mount Pleasant, Mississippi, founded the Mount Pleasant Baptist Church on Bonita Avenue to serve the growing community of African-Americans in Berkeley, who were employed primarily as waiters, cooks, Red Caps, and porters on the transcontinental trains. The church moved to its present site in 1934, and the name was later changed to McGee Avenue Baptist Church.

No historic postcards document the important cultural contribution of Berkeley's Jewish community. Only recently has the Judah L. Magnes Museum begun to publish historic photos in postcard format. Nevertheless, many Jewish families did come to Berkeley at the turn of the last century. They were attracted in part by the educational opportunities provided by Berkeley's outstanding high school and University. Rabbi Jacob Voorsanger founded the Semitics Department at the University in the late 19th century. San Francisco's leading Jewish families also encouraged their children to attend the University at Berkeley; Zellerbach, Haas, Lilienthal, and Stern are family names familiar today for their philanthropy to the University. In 1909, Rabbi Martin Meyer founded the First Hebrew Congregation of Berkeley, which became Congregation Beth Israel in 1924.

SCHOOLS

Postcards of the many and diverse schools were published, spreading Berkeley's reputation worldwide as the "Athens of the West." By 1915, Berkeley High School had students from the Philippines, China, Japan, Mexico, and Central and South America.

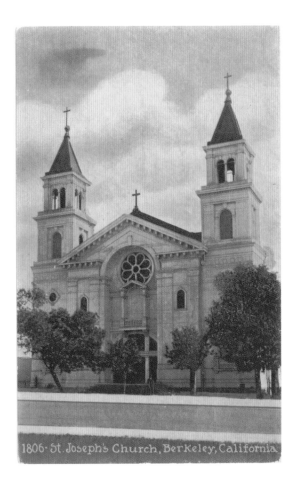

1806· St. Joseph's Church, Berkeley, California.

"Unitarian Church at Berkeley, California." N. J. Abbott & Son, hand-colored.

The small, shingled Unitarian Church is one of Berkeley's most architecturally significant buildings. Designed by A. C. Schweinfurth in 1898, it exemplifies the "building with nature" philosophy as applied to an institutional structure. Note the trunk of a redwood tree used as a corner column. The building is now used as a dance studio on the University campus, Bancroft Way at Dana Street.

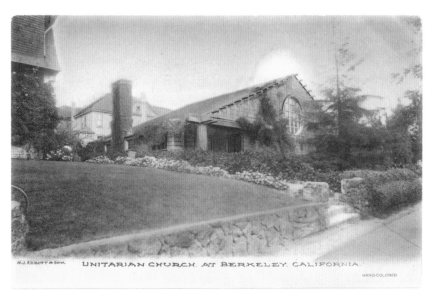

N. J. ABBOTT & SON. UNITARIAN CHURCH, AT BERKELEY, CALIFORNIA. HAND-COLORED

"Beautiful California. The Unitarian Church, Berkeley." Pacific Novelty Company, "Glosso Series" No. 3542.

The south porch is visible here; the two porches symmetrically flank the round window in the west gable. Amber glass lights the interior.

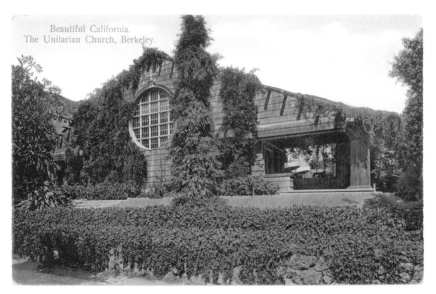

Beautiful California. The Unitarian Church, Berkeley.

**"Berkeley, Cal.
Congregational Church."
Pacific Novelty Company,
"Quality Series" No. B. 31.**

*The spire of the
Congregational Church can
be seen in early bird's-eye
views of Berkeley. The
building was designed by
architect Clinton Day in
1883 and was replaced by
the present edifice in 1925.*

**Untitled
(First Baptist Church).
Real-photo postcard.**

*The original First Baptist
Church was built in 1890 on
Dwight Way near Shattuck.
In 1898, the structure was
moved to Allston Way
between Shattuck Avenue
and Oxford Street and
remodeled by architect
William Knowles. Although
still used by the congregation,
the rear of the building
served as additional space
for Berkeley High School, as
evidenced by the message
on this postcard. In 1922, the
building was converted to the
Playhouse Theater, a leading
experimental theater under
the direction of Irving Pichel.
It was replaced with an office
building in 1938.*

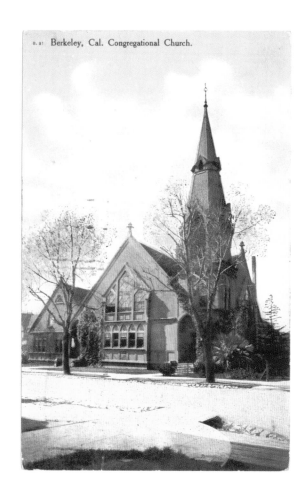

Berkeley, Cal. Congregational Church.

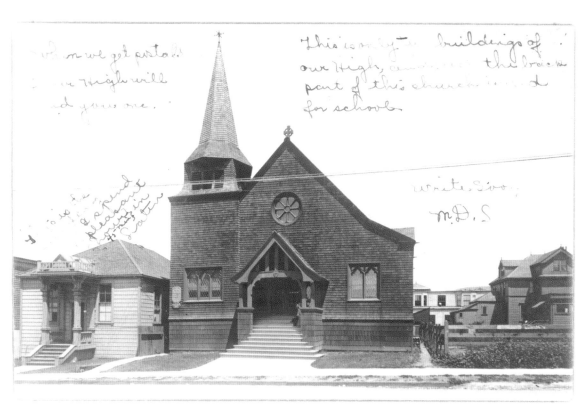

"The First Presbyterian Church, Berkeley, California."
Edward H. Mitchell, No. 2281.

The tower of the Presbyterian Church was a landmark on the Berkeley skyline from its completion in 1907 to its demolition in 1973. This was the second Berkeley church designed by architect Charles W. Dickey.

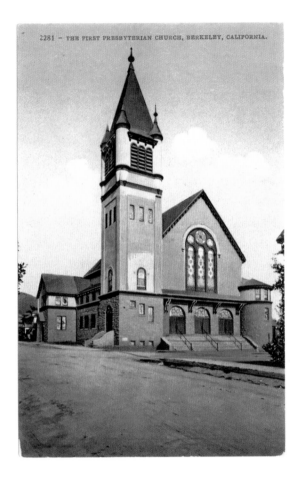

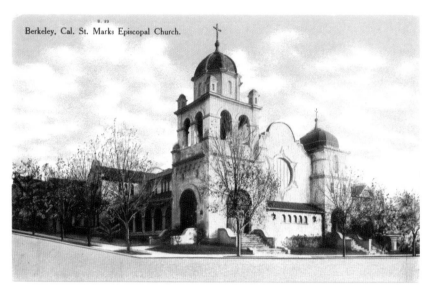

"Berkeley, Cal. St. Marks Episcopal Church."
Pacific Novelty Company, "Quality Series" No. B. 23.

One of the earliest Mission Revival style buildings in Berkeley, St. Mark's was designed by architect William Curlett in 1899 and constructed in 1901. The history of St. Mark's in Berkeley extends from its first service in 1877, held in a rented room, to the recent completion of a major restoration project.

"Epworth M. E. Church, Telegraph Avenue, Berkeley, California."
Edward H. Mitchell, No. 2255.

Designed in 1904 by Charles W. Dickey, architect of the Claremont Hotel, the Epworth Church at the corner of Durant and Telegraph avenues lasted only twenty years at this location before being replaced by the present bank building. The congregation displayed its progressive and humanitarian spirit when the Right Rev. C. H. Phillips, Bishop of the African Methodist Church, was invited to be guest preacher in August 1909. He was the first Black clergyman "to occupy a pulpit in an East Berkeley church," according to the Berkeley Reporter.

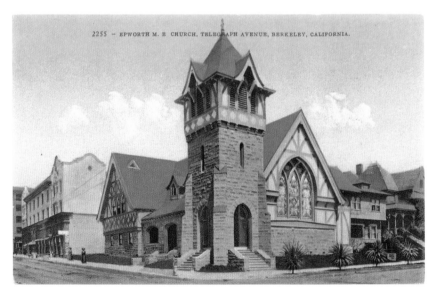

**"First Church of Christ Scientist. Berkeley, Cal."
The Albertype Co.**

Plants were an integral part of architect Bernard Maybeck's 1910 design for Berkeley's First Church of Christ, Scientist. The innovative building was constructed with heavy timber trusses supported by hollow piers of reinforced concrete. Industrial materials such as cement-asbestos board cladding and factory steel sash were used in novel and artistic ways. This card pictures the church several years after the wisteria vines on the trellises had begun to soften its outline.

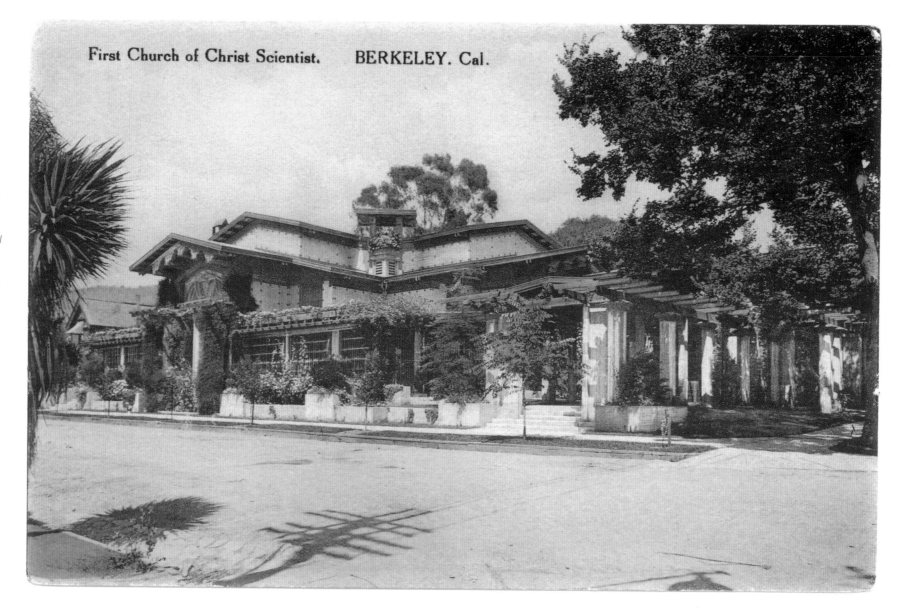

First Church of Christ Scientist. BERKELEY. Cal.

"Christmas Greetings from Rev. Stanley Armstrong Hunter."
The Albertype Co.

St. John's Presbyterian Church (Julia Morgan, Architect, 1908–1910) reflects the Arts and Crafts tradition with natural redwood interior exposed beams and supports. Rev. Stanley Hunter played a major role in the direction of the Church from 1924 until his retirement in 1954. The Julia Morgan Theater now occupies this landmark building.

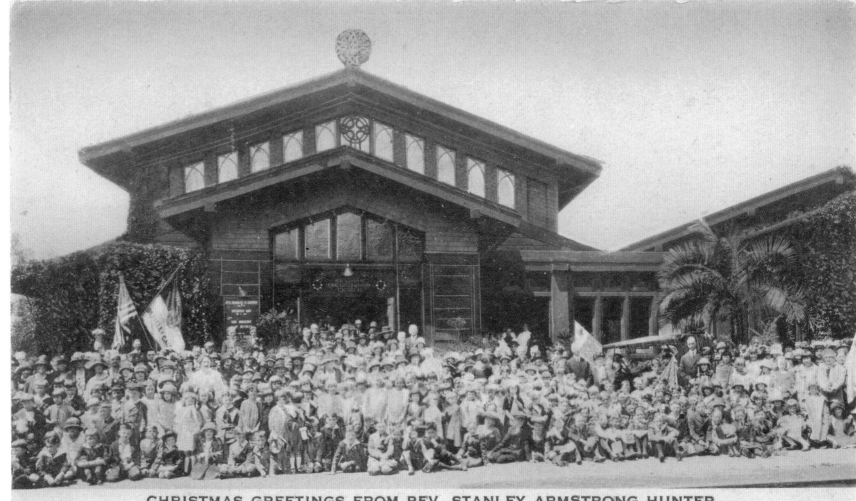

CHRISTMAS GREETINGS FROM REV. STANLEY ARMSTRONG HUNTER,
ST. JOHN'S PRESBYTERIAN CHURCH, 2640 COLLEGE AVENUE, BERKELEY, CALIFORNIA.
PRESENTATION OF AUTOMOBILE TO DR. J. B. DUNLAP OF SIAM.

"The House by the Side of the Road."
The Albertype Co.

Westminster House, still in active use at the corner of College Avenue and Bancroft Way, was designed by architect Walter H. Ratcliff, Jr., in 1926 as a Presbyterian student center next to the University campus.

"F.E.L. Church. June 23, 1912. Berkeley, Cal. E. J. Aalto, Designer & Builder."
Real-photo postcard.

The former Finnish Evangelical Lutheran Church, designed by Eric J. Aalto, was one of two West Berkeley churches constructed in 1912 at the corner of Allston Way and Byron Street.

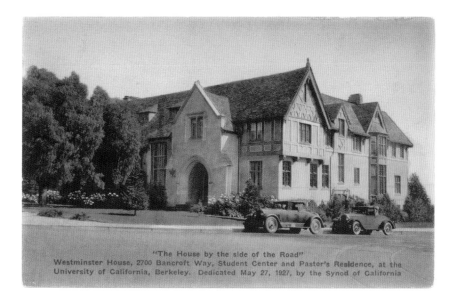

"The House by the side of the Road"
Westminster House, 2700 Bancroft Way, Student Center and Pastor's Residence, at the University of California, Berkeley. Dedicated May 27, 1927, by the Synod of California

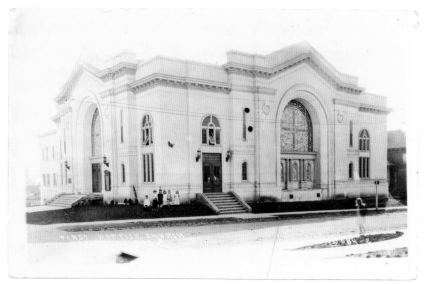

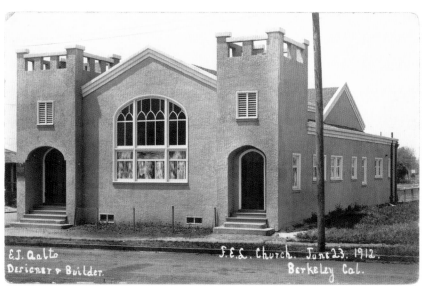

E.J. Aalto
Designer & Builder.

F.E.L. Church. June 23. 1912.
Berkeley Cal.

"First Baptist Church, Berkeley, Calif."
Real-photo postcard, No. S-584-2.

The Baptists moved from their small, shingled church on Allston Way to this impressive classically-inspired edifice at the corner of Dana and Haste streets in 1915.

"Young Men's Hebrew Association, 1902."
Judah L. Magnes Museum, 2000.

"SHARE, c. 1915."
Judah L. Magnes Museum, 2000.

This postcard is taken from an original by the Jewish Relief Campaign.

"Jewish Wedding, late 19th Century."
Judah L. Magnes Museum, 2000.

This charming painting by A. Trankowsky was sold by Kathe and Rudolf Neustader in 1938 to help finance their move from Germany to California. Years later, Dr. and Mrs. Fritz Schmerl bought the painting in New York and donated it to the Magnes Museum. By coincidence, the Neustader daughter and grandchildren had moved to a house on Russell Street in Berkeley, near the museum. The painting that once hung on the family's Berlin living room wall was now the museum's most popular painting, on view just a short walk from their new house.

"A happy New Year!"
Williamsburg Postcard Co.

A typical New Year's greeting card, in Yiddish and English, sent and received in Berkeley in the 1920s.

"Miss Head's School, Berkeley."
Real-photo postcard.

Miss Head's School for Girls opened in 1887 in a small house. That a large parcel was purchased at Channing Way and Bowditch Street soon after in 1892 and a three-story building erected, is evidence of the success of Miss Head's teaching methods. Channing Hall, shown on the right—the first building in what was to become a complex of interconnected shingled buildings—was designed by Anna Head's cousin, architect Soule Edgar Fisher "after old Dutch models," according to accounts of the day. It is believed to be the first of the many brown-shingle buildings for which Berkeley is famous. The University acquired the site in 1964, and although the buildings still stand, the school moved to Oakland and is known today as Head-Royce.

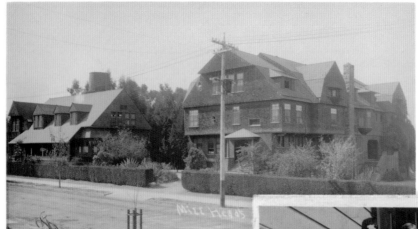

Untitled (Whittier School).
Real-photo postcard, Barr, photographer.

The Whittier, Columbus, and LeConte schools, designed by A. H. Broad, were built in 1892 with the proceeds from the same bond issue, and all three buildings were identical. Here, the third grade of the Whittier School posed for a class picture in 1908 on the steps of their school. For posterity, all pertinent information was written on photographer "Barr's" camera case and photographed along with the children.

"St. Joseph's Academy, Peralta Park, Berkeley, California. Boarding School for Boys." Edward H. Mitchell, No. S-745.

St. Joseph's Academy, one of Berkeley's numerous private schools of the era, was housed in a spectacular building that had started out as the Peralta Park Hotel (Gustav Behrnd, Architect, 1888). The hotel was intended as the centerpiece of the sylvan, creekside Peralta Park subdivision, a similar role to that given to the Claremont Hotel many years later. The area—north of Hopkins Street—was too far from the center of town; only a handful of houses were built and the hotel closed its doors within the year.

"Christmas Sale of Craft-work." Students Club, C.S.A.C.

The California College of Arts and Crafts, located in Oakland since 1926, was founded in 1907 as the California School of Arts and Crafts in the Studio Building at Shattuck Avenue and Addison Street. When this postcard was printed, the school had already moved to the old Berkeley High School property east of Shattuck, which was leased from the School Board.

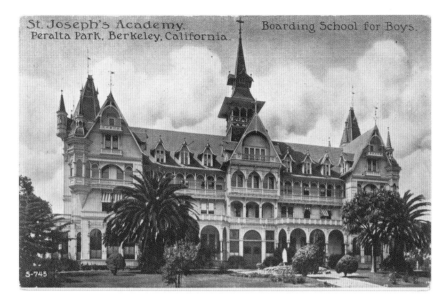

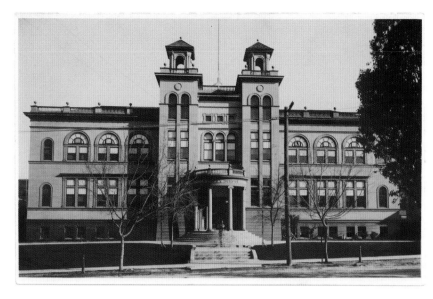

Untitled (McKinley School). Real-photo postcard.

The Dwight Way School was designed in 1896 by Cunningham Bros. and stood a half-block west of Telegraph Avenue. In April 1902, with "impressive and patriotic" ceremony, two English elms were planted at the entrance, a bronze bust of the late President McKinley and a bronze tablet honoring Col. Robert Shaw and his Black Civil War regiment were dedicated, and the name of the school was changed to "McKinley." In his speech, Superintendent S. D. Waterman explained that, "This tablet is intended to help perpetuate the memory of the heroism and valor of a colored regiment and its gallant leader, but more than this—to keep before the people of the country the fact that more than 36,000 negro soldiers gave up their lives in defense of the Union." When the school was razed in 1970, the tablet and bust disappeared. All that remain are the two elms.

**"High School,
Berkeley, Cal."
Pacific Novelty Compnay,
"Glosso Series," No. B. 9.**

In 1901, Berkeley High
School moved from Center
Street to its new 16-room
building (Stone & Smith,
Architects) at Allston Way
and Grove Street, diagonally
across from the old Town
Hall. It was one of the few
structures in Berkeley to be
seriously damaged in the
1906 Earthquake. The
subsequent investigation
found the main culprit to
have been an inferior mortar
that had been laid on too-
dry bricks. Most of the upper
walls were rebuilt of wood.

**"High School,
Berkeley, California."
Edward H. Mitchell,
No. 2878.**

The 1901 building was soon
bursting at the seams, and,
in 1907, Stone & Smith
were again commissioned,
this time to design the
Science Building and domed
Auditorium fronting on Allston
Way. This postcard shows the
new Beaux Arts ensemble.
The two 1907 buildings were
constructed of reinforced
concrete.

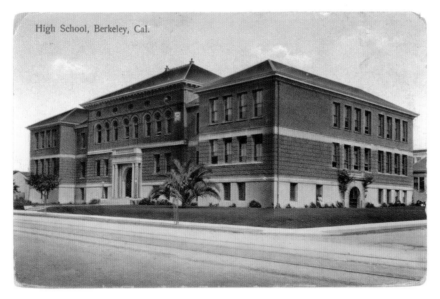

High School, Berkeley, Cal.

2878 High School, Berkeley, California.

BERKELEY CONTINUATION HIGH SCHOOL, BERKELEY, CALIF.

30595

**"Berkeley Continuation
High School, Berkeley,
Calif."
Western Notion &
Novelty Co., No. 30595.**

Not even rebuilding in 1906
could save Berkeley High
School's doomed 1901
building at Grove and Allston.
A new four-story Academic
Building was constructed in
1920 to replace it. Before
the 1901 building was razed
in 1934 as an earthquake
hazard, it had been painted
gray and was used for
evening and continuation
classes.

"The Deaf, Dumb and Blind Institute, Berkeley, California."
Newman Company, No. W. 24.

In 1867, 130 acres were purchased for the California Institution for the Education and Care of the Indigent Deaf and Dumb, and the Blind. The "surpassing loveliness" of the location appealed to the director, Warring Wilkinson, who noted, "It lies directly in front of the Golden Gate." That same year, six years before South Hall on the University campus was completed, the architectural firm of Wright & Saunders was commissioned to design the first structure, a large Gothic style building of sandstone quarried nearby. Destroyed by fire only eight years later, the stones were salvaged and used in 1901 to construct the wall that still surrounds the site.

"State Institute for Deaf and Blind. Berkeley, Cal."
The Albertype Co.

After the fire, Wright & Saunders designed a group of unconnected brick buildings in Romanesque style to house the school. In 1906, these buildings were some of the few in Berkeley that were severely damaged by the

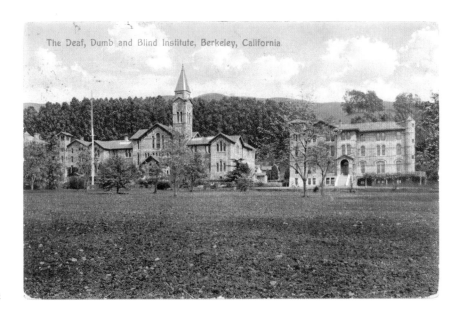

The Deaf, Dumb and Blind Institute, Berkeley, California.

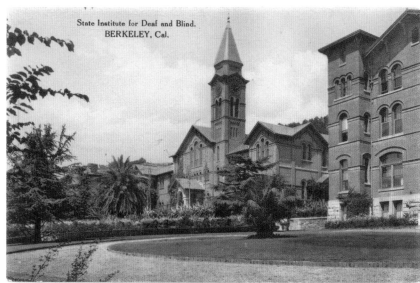

State Institute for Deaf and Blind.
BERKELEY, Cal.

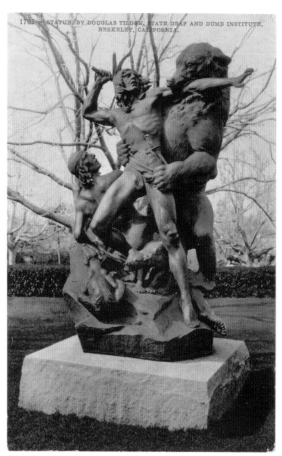

1705 STATUE, BY DOUGLAS TILDEN, STATE DEAF AND DUMB INSTITUTE, BERKELEY, CALIFORNIA.

Earthquake. Even though the buildings were repaired and towers were removed or shortened, a new building program was begun in the 1920s, which, by the 1950s, had replaced all the 19th-century structures. Today the site is the University's Clark Kerr Campus.

"Statue, by Douglas Tilden, State Deaf and Dumb Institute, Berkeley, California."
Edward H. Mitchell, No. 1705.

Douglas Tilden's monumental bronze statue "The Bear Hunt" was a startling and dramatic presence on the grounds of the Institute from its placement there in 1895 until both it and the school were removed to Fremont in 1980. Tilden was a graduate of the School for the Deaf and taught there for eight years, before leaving Berkeley for New York and Paris. He was one of California's most well-known sculptors; "The Football Players" on the University campus is his, as is the Mechanic Monument on Market Street in San Francisco. Later in life Tilden maintained a studio in Berkeley.

Berkeley, Cal. Refugee Camp University Grounds

THE UNIVERSITY AND THE 1906 SAN FRANCISCO EARTHQUAKE AND FIRE

As word spread around the world of the 1906 San Francisco Earthquake and Fire, postcard publishers in Germany hastily printed cards for an eager market: "State University of California Berkeley Destroyed by the Earthquake on 18 April 1906." In reality, Berkeley's damage was slight. Refugees from San Francisco found a safe haven on the University campus. A rare postcard shows the refugee tent camp set up in the field near Harmon Gym.

In the 1906 *Blue and Gold* yearbook, Professor Henry Morse Stephens recalls April 18, 1906:

In the stillness of the morning hours, produced by the cessation of all traffic, it could be seen that, while chimneys of Berkeley had suffered and particularly that the High School had been badly rent, the buildings of the University stood intact. So sound did the University appear that attempts were made to hold classes during the eight o'clock period and it was not until later in the morning that the seriousness of the situation in San Francisco began to be appreciated.

Professor Stephens describes the help provided by the student body:

If the men students of the University had their opportunity in helping to guard the city, the women students expressed their energies in the help that they gave to the refugees. Hearst Hall was turned into a lying-in hospital, and the kindly administration of the women students will long be gratefully remembered...it was no slight work to provide for those thousands of scared beings, and though the citizens of Berkeley did nobly in throwing open their houses and providing food and clothing, it was the women students who took upon themselves the kindly care of the relief camps...Perhaps a defense of co-education may be found here.

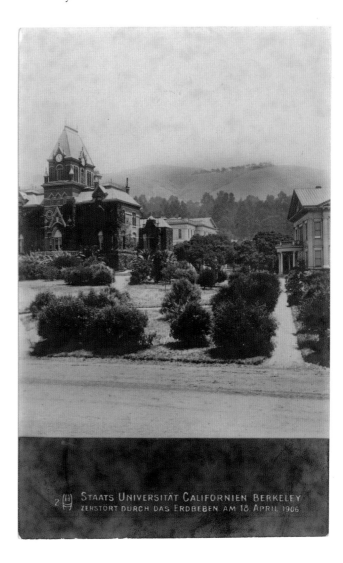

This little booklet [...]
pared that the wi[...]
hearts. the mothers [...]
at home may know [...]
the boys of the Navy [...]
in their achievement[...]

Berkeley's Greeting
TO THE
Fleet

BERKELEY

· THE PROGRAM ·

WELCOME
to our
FLEET

MAY. 1908.

COMPLIMENTS OF

St. Francis
Renovatory

GREAT WHITE FLEET

A million spectators lined the shores of San Francisco Bay to welcome the Great White Fleet, Teddy Roosevelt's Peace Voyage of the U.S. Navy, on May 14, 1908. The frenzy of excitement was unparalleled for the times, and postcard photographers and publishers were quick to take advantage of the historic occasion.

Postcard publishers started to print cards as soon as the fleet left the East Coast and headed to South America. Once through the Straits of Magellan, the Fleet entered the Pacific. Daily newspaper reports kept the reading public informed of its progress. In every port along the way, the sailors were hosted with parades, banquets, tours, and dances. In Lima, Peru, a bullfight was given in their honor.

No one seemed to notice that Congress never approved the Peace Voyage. President Teddy Roosevelt used his discretionary funds to finance the Fleet as far as the Philippines. Once it was halfway around the world, as Roosevelt correctly surmised, funds were approved to bring the Fleet home.

"Elaborate Plans for Decoration of Town," the *Berkeley Reporter* announced on March 3, 1908.

The preparations for "Berkeley Day" in honor of the visiting battleship fleet are making rapid progress. At a meeting of the Souvenir and Decoration Committee last night, Chairman Charles Keeler appointed a subcommittee consisting of the following well known architects Messers. Howard, Plowman, Maybeck and Ratcliff. The high standing of these gentlemen in the profession of architecture gives assurance that Berkeley will have something striking in the decoration line. One of the prettiest and most unique ideas adopted by the Committee was for the use of Chinese lanterns by all those taking part in the reception. The startling and beautiful effect of thousands of Chinese lanterns through the trees on the campus after dark is one which should be long remembered by the visiting sailors.

As the arrival day approached, thousands of people poured into San Francisco and the other bay cities to "see the fleet come in." Hotels were filled to capacity. Every steamer from north and south was packed with passengers, and a number of special trains were added, one coming from Utah and several from the north.

"Children Running from Home to See Fleet," the *Berkeley Reporter* proclaimed on May 9, 1908.

The police are receiving urgent message from anxious parents asking them to be on the lookout for runaway children who are headed for this city to view the ships. Hundreds of children are said to be headed this way. The police department has several men especially detailed to watch the visitors from boats plying between the Sacramento and San Joaquin rivers.

After the welcoming reception in Berkeley on May 14, the sailors moved to California Field to witness various athletic events. That evening a magnificent "spread" of home-cooked food was prepared by the women of Berkeley. More than 10,000 souvenir view books, showing the beauties of Berkeley, were distributed to the sailors to send to their families and sweethearts. The books contained eighteen different views of this city and were elaborate in every detail. A tiny American flag clasped the folder for mailing.

—Burl Willes

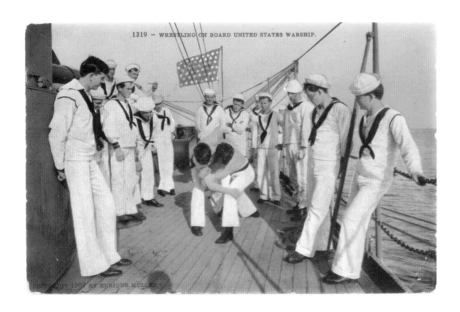

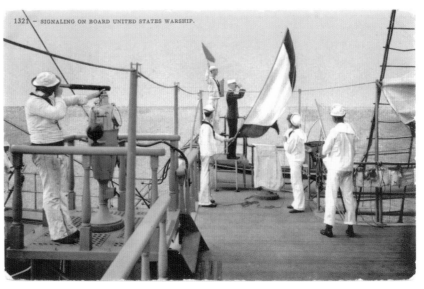

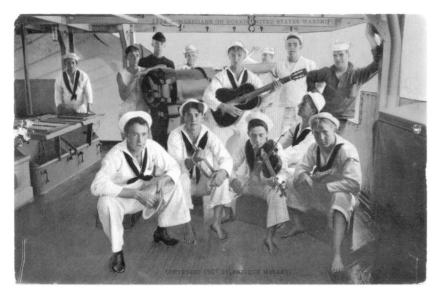

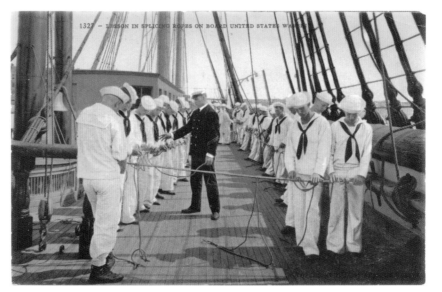

"Wrestling on Board United States Warship." Edward H. Mitchell, No. 1319.

"Signaling on Board United States Warship." Edward H. Mitchell, No. 1321.

"Musicians on Board United States Warship." Edward H. Mitchell, No. 1324.

"Lesson in Splicing Ropes on Board United States Warship." Edward H. Mitchell, No. 1327.

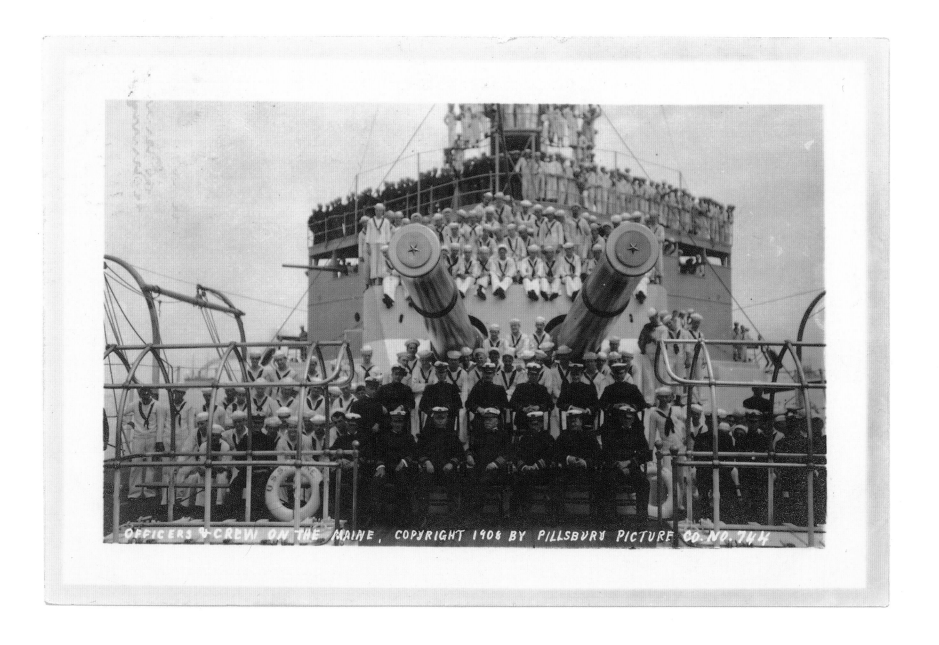

OFFICERS & CREW ON THE MAINE, COPYRIGHT 1908 BY PILLSBURY PICTURE CO. NO. 744

OTHER NOTEWORTHY EVENTS

"The Morrell Airship."
Photo.

*This 1908 photo shows the airship
before takeoff on Kittredge Street
at Grove Street (now Martin
Luther King Jr. Way).*

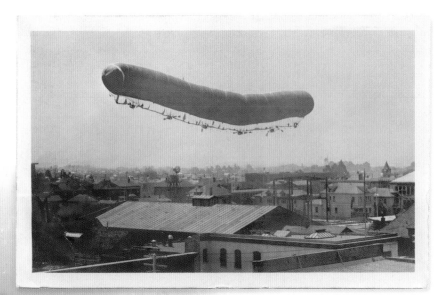

Unititled (Morrell
Airship Disaster).
Real-photo postcard.

*On May 23, 1908, a 450-
foot-long balloon collapsed
and exploded near Berkeley
High School. It was the first
airship disaster in U.S.
history. John Morrell had
wanted to create dirigible
service between San
Francisco and Asia. Morrell
and his crew boarded the
balloon, but it was untied
unevenly from the ground,
causing one end to rise
faster than the other. The
pressure on both ends
became unstable and the
balloon burst shortly after
takeoff. It fell to the ground
injuring nine people; the crew
and Morrell survived.*

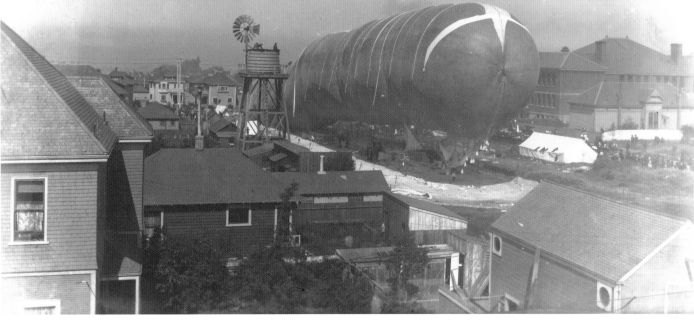

"Celebration 50th Anniversary of Berkeley, Cal., May 24, 1916." Real-photo postcard, No. 304.

Mayor Irving proclaimed May 24, 1916, a public holiday for all of Berkeley to commemorate the 50th anniversary of the naming of the city. Over 25,000 people turned out to cheer the parade and to witness the dedication—complete with speeches and a chorus made up of 100 schoolchildren singing "America"—of the liberty pole and flag raising at the intersection of Shattuck Avenue and Center Street. The tile-roofed Romanesque style building in the background was the site of Edy's ice cream parlor.

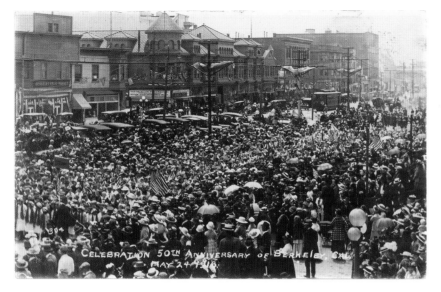

"Celebration 50th Anniversary of Berkeley, Cal., May 24, 1916." Real-photo postcard, No. 296.

All automobile owners in Berkeley were requested to decorate their vehicles for the big day. The Shattuck Hotel car, pictured here, which was one of 300 featured in the "Grand Automobile Procession," won first prize in the "Best Decorated Family Auto" section. In the driver's seat is William E. Woolsey, owner of the hotel.

"Celebration 50th Anniversary of Berkeley, Cal., May 24, 1916." Real-photo postcard, No. 294.

"How typical of Berkeley was the parade," reported the Berkeley Courier. "Every float and banner characteristic of Berkeley, her activities, her culture, her homes, her people and her work. The University float was warmly applauded along the entire line of march. It was one of the few floats that contrasted the past and present; it was imposing and well arranged and received special mention from the judges."

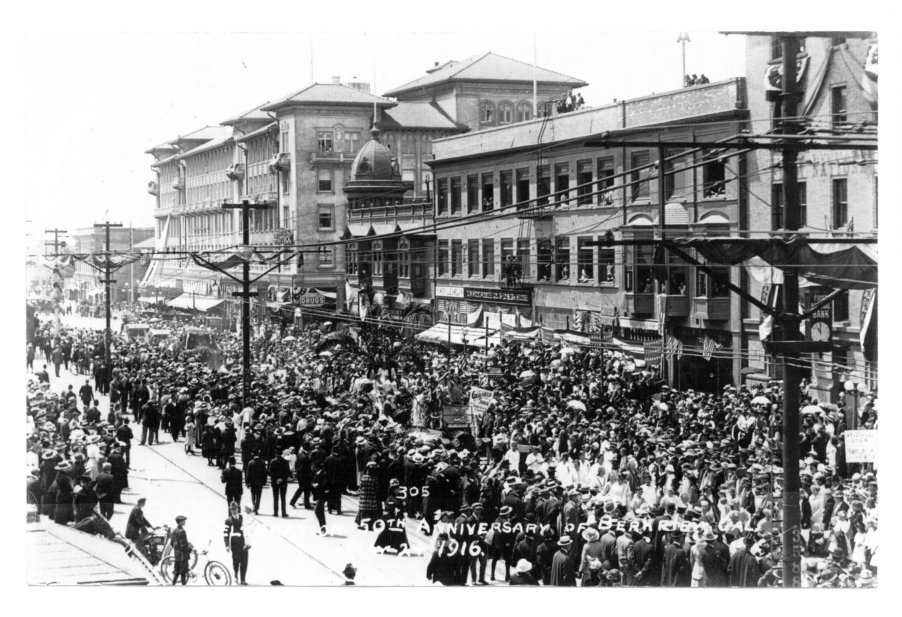

Businesses closed and schoolchildren "were turned loose" to enjoy the festivities, which included parades, games, and music. "Formality of every sort has been laid aside all day and the throngs have mingled as one great big happy family on pleasure bent," reported the Berkeley Gazette.

Untitled (Idora Park).
Real-photo postcard.

As Berkeley grew into a city during the age of postcards, Berkeleyans bemoaned the dearth of parks and playgrounds available to its citizens. Although the parklike University grounds were in the center of town, City Planner Werner Hegemann commented on the "entire absence of parks in Berkeley" in his 1915 report. But Berkeleyans did find outdoor entertainment available outside the city limits. North of town were the open spaces long used as picnic grounds, and just over the border in north Oakland was Idora Park. Developed by the Realty Syndicate, this amusement park was an immensely popular attraction for Oakland and Berkeley families, from its opening in 1903 until it was replaced by a housing subdivision in the late 1920s. In this postcard, a family poses for a studio portrait in 1908 in front of a painted backdrop of the Idora Park skating rink.

Untitled.
Real-photo postcard.

"Sleep under the big oaks at Knight's Ferry, blankets only." This bus departed from Shattuck and University avenues on June 17, 1922.

Untitled.
Real-photo postcard.

Pictured here, in January 1912, is a Berkeley family, in their stylishly painted car, on the last leg of a return trip from San Jose to their home at 109 Hillcrest Road in the Claremont district. Motor trips like this were undertaken by Berkeleyans even long before 1912 according to the reports in local newspapers, and one wonders how they managed on the primitive roads of the day. But, as "Kitty C." writes to her friend in New York on the reverse of this card, "You must come out some summer and take a trip with us. It is more fun than anything on earth!"

3078 – Residences on Telegraph Avenue, Berkeley, California.

City of Homes and Neighborhoods

"Residences on Telegraph Avenue, Berkeley, California."
Edward H. Mitchell, No. 3078.

This view along Telegraph Avenue, looking north from Stuart Street, creates the impression of a grand boulevard lined with stately homes. The large corner house (Cunningham Bros., Architects, 1900) and the one next to it (C. M. Cook, Architect, 1904) were built for cement contractor J. A. Marshall. The concrete pylons and retaining walls served extra duty as a form of advertisement for his work. The third house was the home of realtor Joseph Mason of the Mason-McDuffie Company, and it was designed in 1907 by architect Julia Morgan. The two Marshall houses are today a bed-and-breakfast; the Mason House has been torn down.

It is the home, however, that preeminently distinguishes Berkeley. People come here to live. Here they find an equable climate which is enjoyable for 365 days in the year; where indoors and outdoors is almost equally agreeable; …where the beauty of the landscape has an ever present charm; where the bounties of nature, in fruits, in all varieties of food, in flowers, make life healthy and pleasant; where the streets are well paved and well lighted; where the municipal government is efficient and clean; where the social life is simple and delightful; where the intellectual life affords a constant stimulus to mental improvement; where, above all, the moral atmosphere invites and tolerates only the best.

But the striking feature of the city is the number of individual private residences, with lawns and gardens full of flowers blooming at all seasons of the year. Here one may find ideal homes for rent or purchase and magnificent building sites. Or he may tell an agent what he wants, and a house will be constructed for him, of size, style and location to suit his taste.

—Berkeley, California, A City of Homes, 1905, Conference Committee of the Improvement Clubs of Berkeley

BERKELEYANS BESTOWED UPON THEIR TOWN THE SOBRIQUET "A CITY OF HOMES." THE CITY PRIDED ITSELF ON BEING livable, free of the noise, dirt, and congestion of the metropolis across the bay. Early real estate promotions were often aimed at San Franciscans who supposedly yearned to leave behind the hustle and bustle and reside in peace and tranquility in Berkeley. Even as early as the latter part of the nineteenth cen-

tury, there were those who commuted to San Francisco while preferring to live in Berkeley.

The residential tone of Berkeley was set by the founders of the private College of California, which evolved into the University of California. Berkeley's first exclusively residential subdivision was commissioned by the College Trustees and called the Berkeley Property. This residential district was part of the plan developed between 1864 and 1866 for the new college grounds by Frederick Law Olmsted, who would become known as the "father of landscape planning in America" and the primary force in the creation of garden suburbs across the United States and Canada.

Olmsted was already famous for his design for Central Park in New York, but his plan for the Berkeley Property was his first for a residential subdivision to become a reality. Olmsted's plan differed from the grid pattern that was the standard way of laying out towns in the United States in the nineteenth century. He created Piedmont Avenue as a wide, divided boulevard, with rounded corners, that gently curved along the undulating hillside. Olmsted linked the Berkeley Property with the earlier College Homestead Tract of 1864, which was laid out in a grid.

As well as creating an aesthetic, the founders of the College also set a moral tone for the city. After all, they had

selected the rural expanse of Berkeley for the college site in order to escape the influence of the saloons and dance halls of downtown Oakland! The envisioned town of Berkeley was to be different. The most tangible legacy of this time was the "one-mile limit." Well into the mid-twentieth century, the sale of liquor was forbidden within one mile of the University. "This patent purity of the community makes the place an ideal spot for a wholesome and well ordered home," claimed the promotional brochure quoted at the beginning of this chapter.

PIEDMONT WAY AND THE BERKELEY PROPERTY

The wide, divided boulevard that Olmsted designed is Berkeley's most beautiful and historically important residential street, Piedmont Way (later, Piedmont Avenue), the centerpiece of the Berkeley Property Tract. In a report Olmsted sent to the Trustees in 1866, he outlined his theories and vision for the "establishment of a neighborhood of refinement and tranquility adjacent to a respectable college of scholarship." Olmsted designed Piedmont Way "to make the most of the natural features, while preserving their completely sylvan and rural character, being carried with frequent curves in such a way as to make the best use of the picturesque banks of the arroyos and the

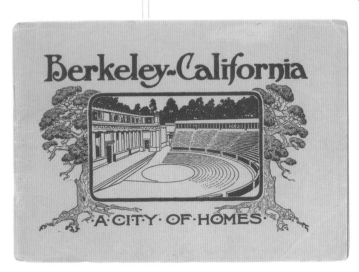

"Berkeley, California, A City of Homes." Cover, advertising brochure, Conference Committee of the Improvement Clubs of Berkeley, 1905.

existing trees upon them…allowing [the road] to divide into two parts."

Olmsted also suggested that the homes to be built here should express the "manifestations of a refined domestic life," with "garden set backs" enhanced by sidewalks lined with plantings that were "thick, intricate, luxuriant, rich and graceful, completely sheltering the visitor from the sun." The Berkeley Property was meant to provide a respite from "the heated, noisy life of a large town."

The Berkeley Property Tract was not built up immediately. During the 1870s and 1880s a number of impressive Victorian homes were built in the vicinity of Bancroft and Piedmont ways on the large "villa" lots that Olmsted had created. But it was not until after 1900 that the neighborhood became fully built. In 1900, Olmsted's design was formalized by Town Engineer Charles L. Huggins, who regraded the street, redefined the planted median, and replaced some of the elderly street trees. A new generation then built grand homes, designed by architects such as Julia Morgan, the Greene Brothers, and Walter Ratcliff, which stood side-by-side with those of their Victorian predecessors.

Soon Piedmont Way became the residential boulevard that Olmsted had envisioned. The wide and curving divided street was lined with a profusion of flowering shrubs and shaded by a bower of trees, and the homes and gardens of the neighborhood became a very photogenic subject for a series of postcards.

*The planted median can
be seen at the right in this
view of the northernmost
block of Frederick Law
Olmsted's residential
boulevard. Left to right are
the Professor Samuel
Christy House (circa 1880),
the Walter Kellogg House
(Julia Morgan, Architect,
1909), and the Charles
Noble House (William
Knowles, Architect, 1909).
Although the houses are
now used for University
offices, the street appears
very much the same today.*

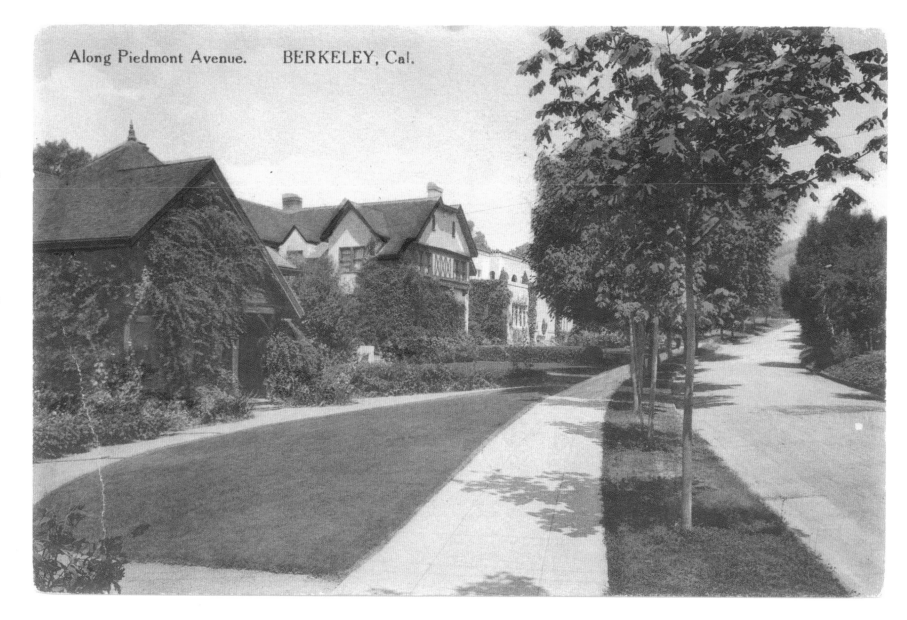

Along Piedmont Avenue. BERKELEY, Cal.

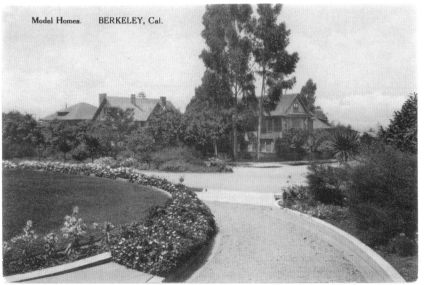

This is one of at least four postcards of the highly photogenic Piedmont Avenue issued by this publisher. The view is from the driveway of the Hicks House looking west to the intersection with Durant. Three houses designed by Julia Morgan are visible. At the left, the roof of the Greenleaf House (1905) can be seen, and next to it the gables and chimneys of the Tasheira House (1914). On the corner behind the tall eucalyptus trees is the shingled house built for Professor Charles Mills Gayley in 1905.

**"Residence District, Berkeley, Cal."
The Albertype Co.**

Julia Morgan designed the imposing house on the right in 1906 for Lewis Hicks, a partner in the cement-contracting firm that built the Greek Theater, on which Julia Morgan also worked. The Hicks House was built of reinforced concrete, making this one of the earliest residential uses of this material. To the left is the Thorsen House, designed by Greene & Greene for a lumber magnate. This is the one Berkeley residence by the famous Pasadena firm, and its extensive use of wood, both inside and out, made it the perfect complement to its neighbor.

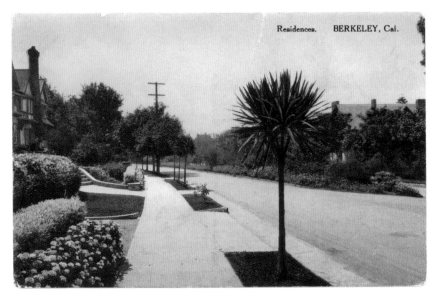

**"Residences. Berkeley, Cal."
The Albertype Co.**

In 1900, residents watched the removal of the old walnut trees along Piedmont Avenue, as the dirt road with its cobblestone gutters, the original manifestation of Olmsted's design, was soon to be regraded. The work was completed in March 1901 when "a carload of trees and shrubs" arrived from San Jose. When this view looking south from the Thorsen House was taken in 1915, the median was overflowing with flowering plants, and the trees were beginning to "embower" the street once again.

"Residences, Berkeley, California."
Edward H. Mitchell, No. 1838.

These residences, long ago destroyed, stood at the corner of Piedmont Avenue and Haste Street and were designed by a little-known architect, Albert Dodge Coplin. The Hathaway House at the right was built in 1902 and was one of the largest houses in Berkeley; only a small portion is visible here. The Mission Revival house, seen in the distance, was constructed with steel netting, diagonal sheathing, and reinforced chimneys and foundation in the summer of 1906 for a Mrs. Ramsey, who specified an "earthquake proof" house.

"Channing Way, from Warring Street", Berkeley, California."
American Industrial Photo Co., No. 1009 E.

The shingled house at the left was designed in 1905 by Julia Morgan for William Colby, an early Sierra Club member, who, with John Muir, founded the Club's annual high trip into the Sierra in 1901.

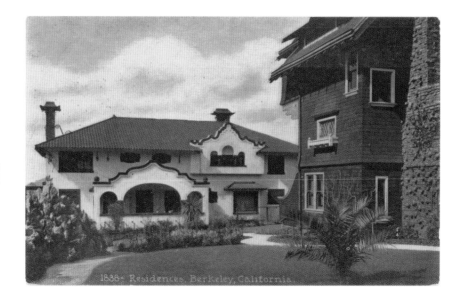

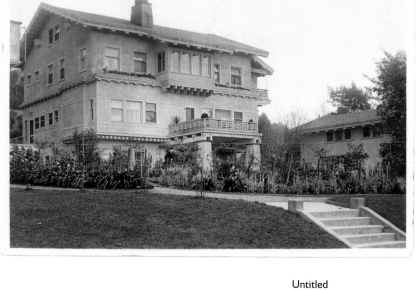

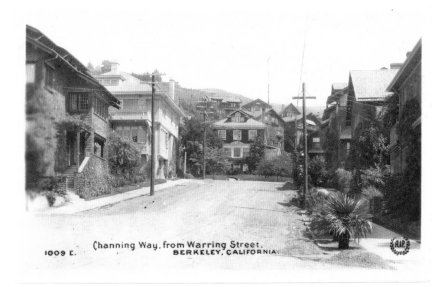

Untitled
(S. O. Johnson House).
Real-photo postcard.

In 1908, San Francisco capitalist S. O. Johnson erected a "palatial mansion" designed by Louis Christian Mullgardt on an enormous piece of property running between Piedmont Avenue and Warring Street at Channing Way. The following year he hired his contractor to build a second house of similar style next to it (shown here) for his mother. Mullgardt's original concrete barn and garage of 1908 is to the right.

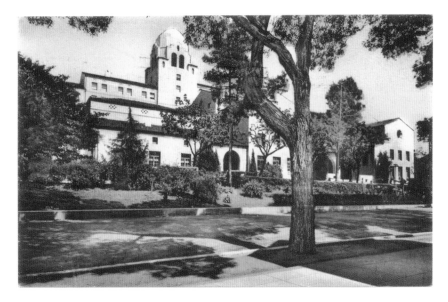

"Berkeley, California,
A City of Homes
by the Golden Gate."
Cover, advertising
brochure, Berkeley
Chamber of Commerce,
1908.

"International House,
University of California,
Berkeley."
Associated Students.

*Several old residences were
removed to make way for
the University's Memorial
Stadium (completed 1924)
and the International House
(George Kelham, Architect,
1928), but Piedmont Avenue
managed to remain a
verdant, lushly planted
boulevard until recent years.*

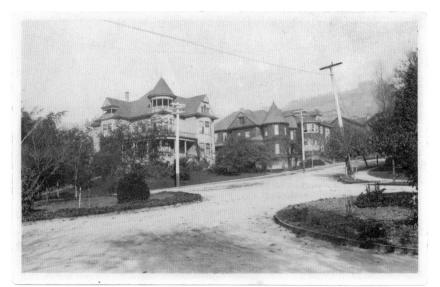

Untitled (Piedmont Avenue
and Channing Way).
Real-photo postcard.

*Olmsted's planted medians
are visible in the foreground
on Piedmont Avenue, while
in the background, looking
east on Channing Way, are
the Hill House (Cunningham
Bros., Architects, 1894), the
Haven House (Frederick Esty,
Designer, 1897), and the
Chandler House (Fred
Soderberg, Architect, 1902).
Only the latter is still
standing.*

This idyllic scene is Dwight
Way, one of Berkeley's elm-
lined thoroughfares, looking
east toward Piedmont
Avenue. The trees were
planted in the late
nineteenth century.

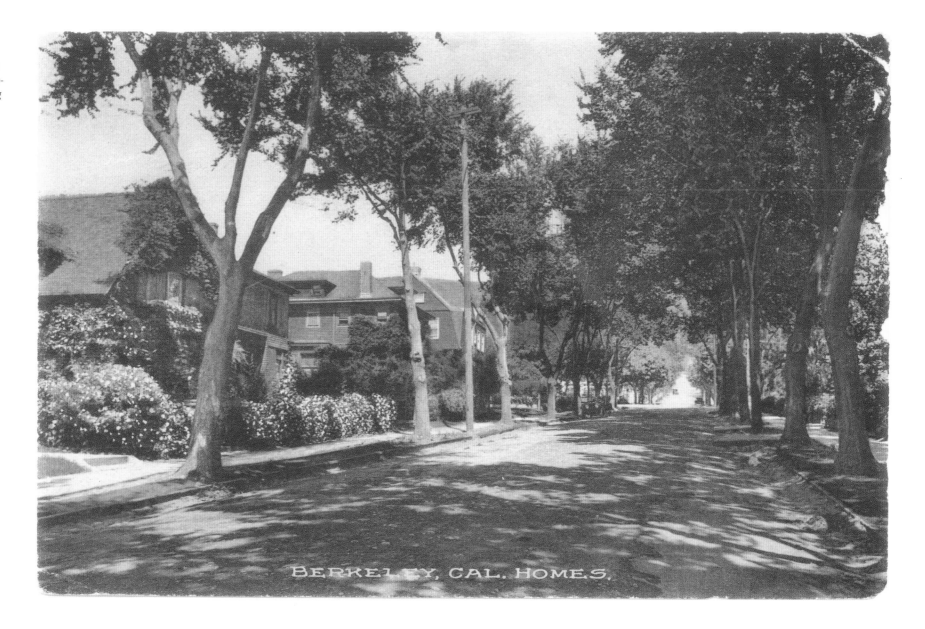

BERKELEY, CAL. HOMES.

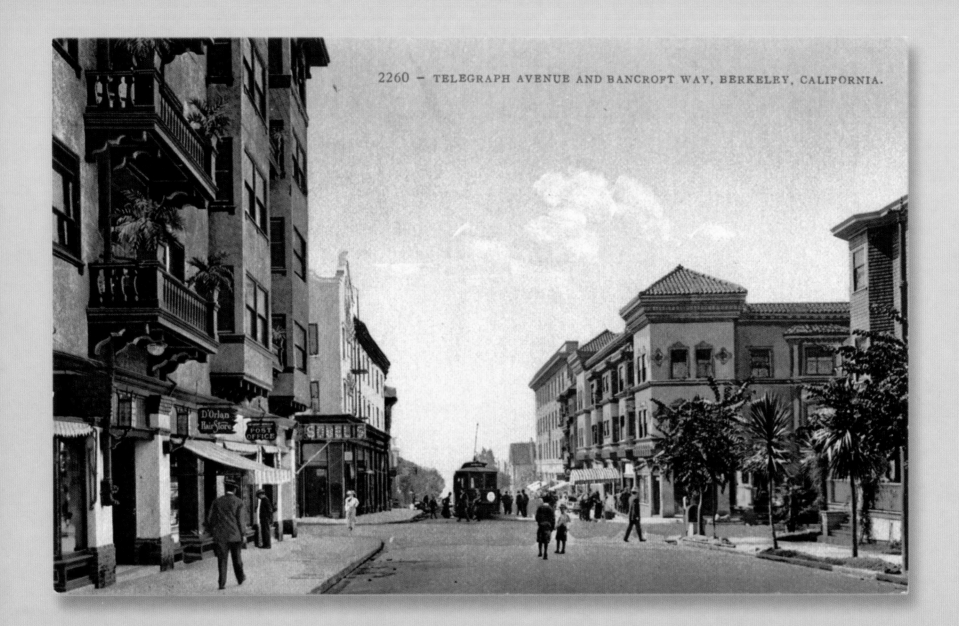

2260 — TELEGRAPH AVENUE AND BANCROFT WAY, BERKELEY, CALIFORNIA.

TELEGRAPH AVENUE AND SOUTHSIDE

When the University opened in Berkeley in 1873, the campus grounds extended no further south than Strawberry Creek. The entrance to the campus was over a wooden bridge at the end of Telegraph Avenue, where it met Allston Way. The earliest commercial buildings were clustered near the entrance to the campus on Telegraph Avenue.

The College Homestead Tract (Allston Way to Dwight Way, College Avenue to Fulton Street), which had been subdivided in 1864, provided a framework for development, and by the early 1900s a neighborhood had been built that included family homes, churches, student "house clubs," and a few apartment houses. The retail district north of Bancroft then expanded south along Telegraph Avenue. The five-block shopping district rivaled downtown, and the new business blocks and hotels were quick to make their way onto postcards. A convenient network of streetcars served the area.

As the campus and the city grew, and a streetcar line was established on College Avenue, development moved even further south. Beginning in 1900, the area south of Strawberry Creek to Bancroft Way was slowly incorporated into the campus, and by 1960 all the commercial and residential buildings north of Bancroft Way, except for one church, had been replaced with University buildings.

WEST BERKELEY

Berkeley's first American pioneers settled at the shore of San Francisco Bay near the mouth of Strawberry Creek in the early 1850s. They called their settlement Ocean View because the Pacific Ocean could be seen through the Golden Gate. Before the advent of the railroad in 1869, transportation around and across the bay was by water, and Ocean View's bayside loca-tion attracted a variety of businesses and manufacturing plants. Both the business owners and workers lived near their work, so West Berkeley was a residential neighborhood as well. This mix of commercial and residential buildings still exists today. Postcards of West Berkeley are rare, and most of them are real-photo postcards of homes and businesses.

SOUTH BERKELEY

In the years before the coordinated expansion of the train and streetcar lines, roughly from 1876 to 1903, residential neighborhoods were located near the Southern Pacific train stations, leaving much of the land within the town limits sparsely settled. The steam train passed through an unincorporated area along Adeline Street on its way to Berkeley Station. The two stops, at Alcatraz Avenue and at Ashby Avenue, were called Lorin Station and Newbury Station. Transportation made it possible for this outlying suburb of Oakland and Berkeley to develop early with homes and a few businesses. Much of the land west of Adeline Street was owned by Edward Dana Harmon, who, between 1872 and 1891, built over forty ornate Victorian speculative houses, most of which are still standing. In 1891 and 1892, Newbury and Lorin were annexed to Berkeley, and the area became known as South Berkeley. Commercial development had already occurred at the two train stops, but after 1903, as in other parts of Berkeley, the area experienced a boom as new transportation routes were added. Home building continued unabated for several years, as rows of Colonial Revival houses created harmonious residential streets. Adeline Street was graced with many fine new business blocks, the most striking being the South Berkeley Bank, designed by University Architect John Galen Howard.

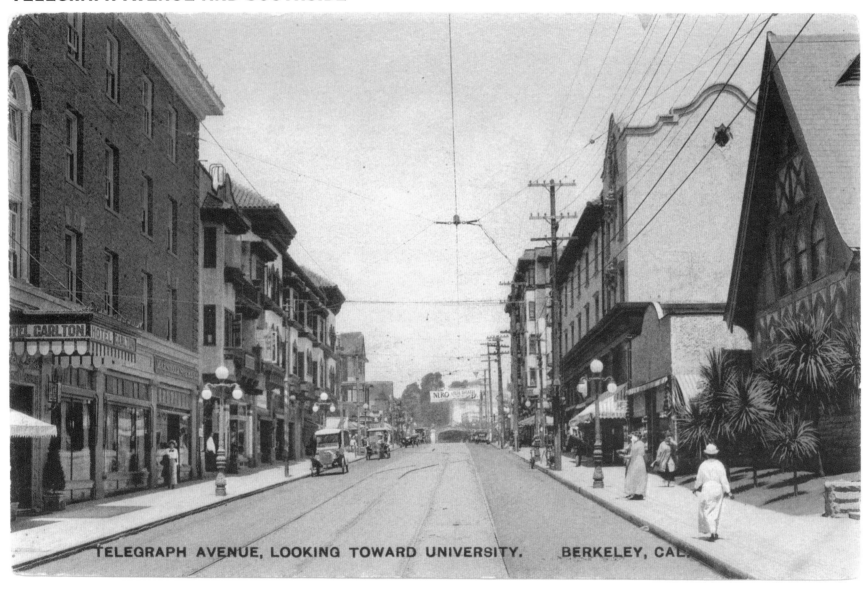

TELEGRAPH AVENUE, LOOKING TOWARD UNIVERSITY. BERKELEY, CAL.

"Telegraph Avenue,
Looking Toward University.
Berkeley, Cal."
The Albertype Co.

*Sather Gate can just barely
be seen at the end of
Telegraph Avenue in this
circa 1915 view from Durant
Avenue. To the left is the
Carlton Hotel; the west gable
of the Epworth Methodist
Church can be seen at
the right.*

"Berkeley, California—A view at Bancroft Way and Telegraph Avenue." Cardinell-Vincent Co., No. 787.

The Granada Building (Meyers & Ward, Architects, 1905) to the left is the only one of these buildings still standing. Its Mission gables and cast concrete ornamentation were removed in the 1950s, but have been faithfully replicated in a recent restoration of the building undertaken by descendants of the original owner.

"Looking South from Sather Gate. Berkeley, Cal." The Albertype Co.

"Berkeley, which has long been known for its artistic homes is now achieving renown for its beautiful apartment houses," claimed the Berkeley Reporter in 1907. Several of the most noteworthy can be seen in this view from about 1915.

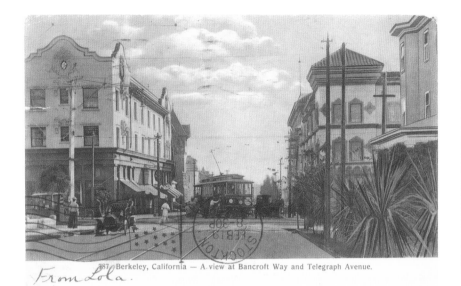

287 Berkeley, California — A view at Bancroft Way and Telegraph Avenue.

From Lola.

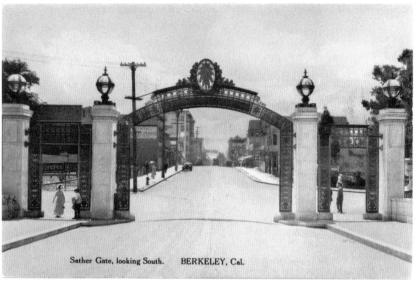

Sather Gate, looking South. BERKELEY, Cal.

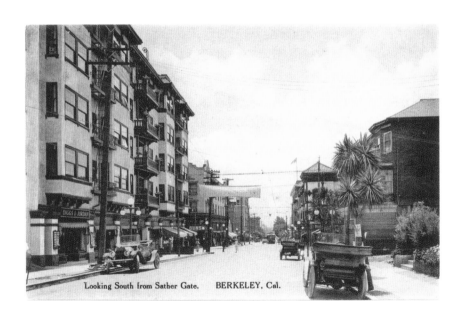

Looking South from Sather Gate. BERKELEY, Cal.

"Sather Gate, looking South. Berkeley, Cal." The Albertype Co.

Before Sproul Plaza and the Student Union Building were built to the south of Sather Gate in the late 1950s, this was the entrance from Telegraph Avenue to the University campus.

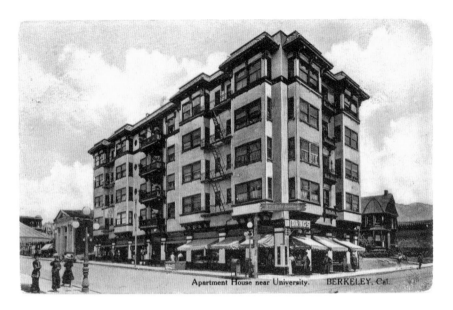

Apartment House near University. BERKELEY, Cal.

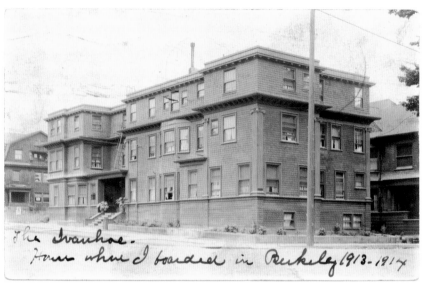

The Ivanhoe. From where I boarded in Berkeley 1913-1914

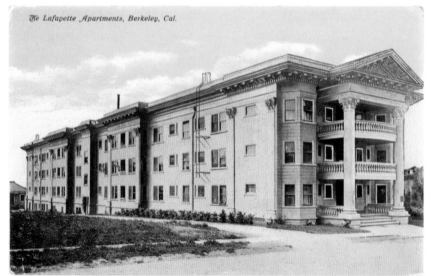

The Lafayette Apartments, Berkeley, Cal.

"Apartment House near University. Berkeley, Cal."
The Albertype Co.

The five-story Alta Vista Apartments, built by developer J. A. Marshall, stood sentinel at the northeast corner of Bancroft Way and Telegraph Avenue, near the entrance to the University, from 1907 until its demolition in 1946. The plans by C. M. Cook called for a roof garden with pergola, but this amenity was not realized.

Untitled (The Ivanhoe).
Real-photo postcard.

The Ivanhoe, at 2400 Durant Avenue, was designed and built by architect John Conant as "eight double flats" in 1902. It was replaced in the 1960s by a University dormitory complex.

"The Lafayette Apartments, Berkeley, Cal."
Pacific Novelty Co.,
"Glosso Series" No. B45.

"Structure Will be Entire Block in Length," exclaimed the Berkeley Reporter in 1906. The Newsom brothers, architects of the Lafayette Apartments, stated that this building was "the longest for which they have ever drawn plans, outside of one erected at the Midwinter fair." Located between Dana and Ellsworth, one side faced Dwight Way and the other faced Haste Street. The building was owned and operated for many years as Barrington Hall by the independent University Students Cooperative Association.

"Hotel Carlton, Berkeley, California."
Edward H. Mitchell, No. 2257.

The clinker brick Carlton Hotel, designed by architects Meyers & Ward, is still standing at Telegraph and Durant. Construction began before the 1906 Earthquake, and soon after that event developer Carlton Hall reported, "It was our intention to make an office building, but the San Francisco fire has shown that Berkeley is sorely in need of more hotels. We will rush our building to completion as rapidly as possible."

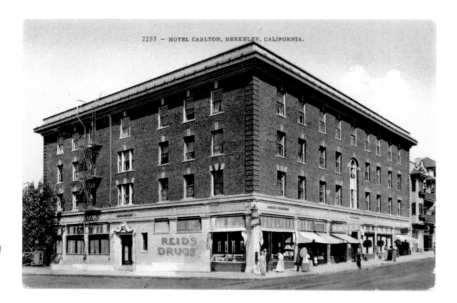

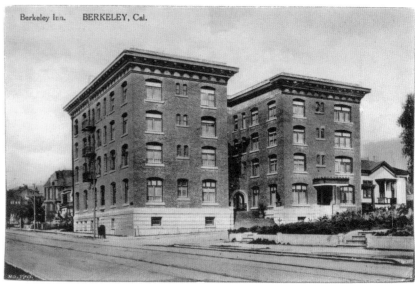

"Corner of Dining Room, Hotel Carlton, Berkeley, Cal."
M. Rieder, No. 20052, "handcolored work."

Berkeley's first modern hotel was built on Telegraph Avenue in an area that began to compete as Berkeley's sophisticated commercial district. The Carlton's dining room was the setting for lavish holiday feasts for the hotel guests. To insure that the hotel would be "a center of social life in Berkeley," Mrs. W. F. Morris, lease holder and manager, specified polished maple floors to accommodate bimonthly dances.

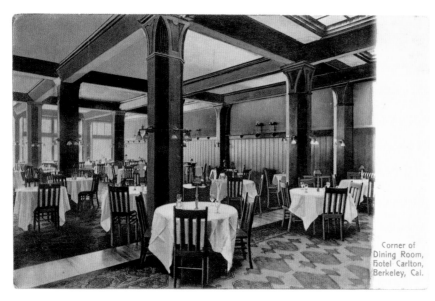

Corner of Dining Room, Hotel Carlton, Berkeley, Cal.

"Berkeley Inn. Berkeley, Cal."
The Albertype Co., No. 170.

The Berkeley Inn was designed in 1911 by architect J. Cather Newsom in what he called "Renaissance style." It stood at the corner of Haste Street and Telegraph Avenue until destroyed by fire in 1990. To the right is the John Woolley House of 1876, which still stands.

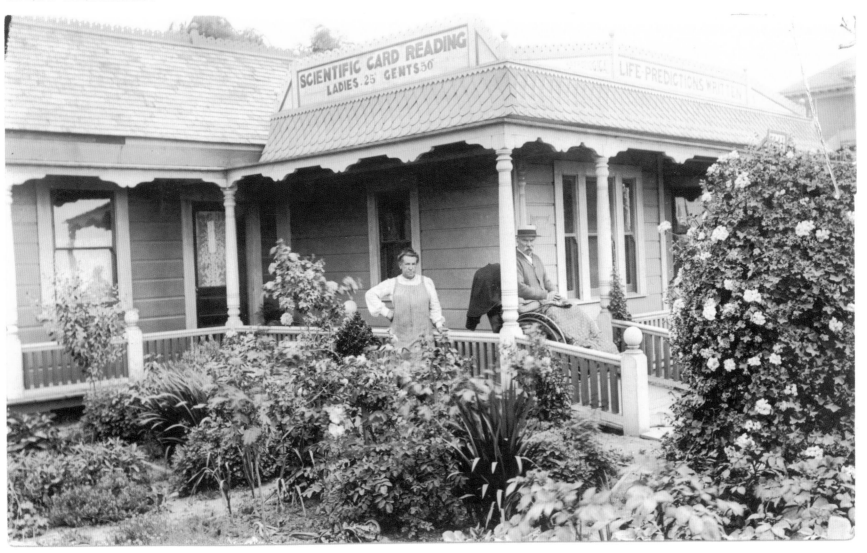

Untitled (a West Berkeley business). Real-photo postcard.

"Scientific Card Reading, Ladies 25¢, Gents 50¢" and "Astrological Life Predictions Written" proclaim the signs on this intriguing West Berkeley business, which stood at 1641 San Pablo Avenue. Note the well-tended garden and the ramp at the entrance to the veranda, presumedly for the wheelchair occupant.

Facing page:

Untitled (Wotton House). Real-photo postcard.

The home of Charles Wotton, plumber, on Hearst Avenue east of San Pablo Avenue, appeared bleak in its stark and barren landscape, with Mr. Wotton's advertising billboard on the adjacent vacant lot and his large work shed rising behind the house. Today the Wotton House sits primly tucked behind a cottage garden on a tree-lined street of bungalows.

"Heywood Lumber & Supply Co." Real-photo postcard.

One of the early businesses that helped to establish West Berkeley as an industrial center was the lumber yard

started by Zimri Brewer Heywood in 1856. By the 1860s, a wharf had been built at the foot of Hearst Avenue for lumber transport. Grandson Charles D. Heywood, listed as manager on the postcard, was mayor of Berkeley in 1913.

"Santa Fe Depot, Berkeley, California."
Edward H. Mitchell, No. 1805.

Still standing at University Avenue and West Street, the depot was designed by Santa Fe company architect Charles Whittlesey and completed in 1904 with a "Santa Fe Day" celebration to welcome the first train. Announced as being "in the old Spanish style of the padres," this Mission Revival building's most striking feature is its central dome topped by a massive finial.

Untitled (a West Berkeley cottage).
Real-photo postcard, Golden Rod Photo Co.

This neat and trim West Berkeley cottage was moved from 837 Addison Street to 847 Addison in 1926 to make way for construction of the West Berkeley Day Nursery on 6th Street. The house was then used by the Berkeley Welfare Society.

1805-Santa Fe Depot, Berkeley, California.

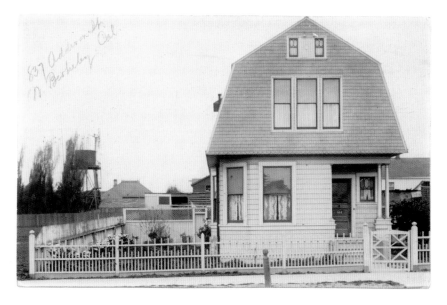

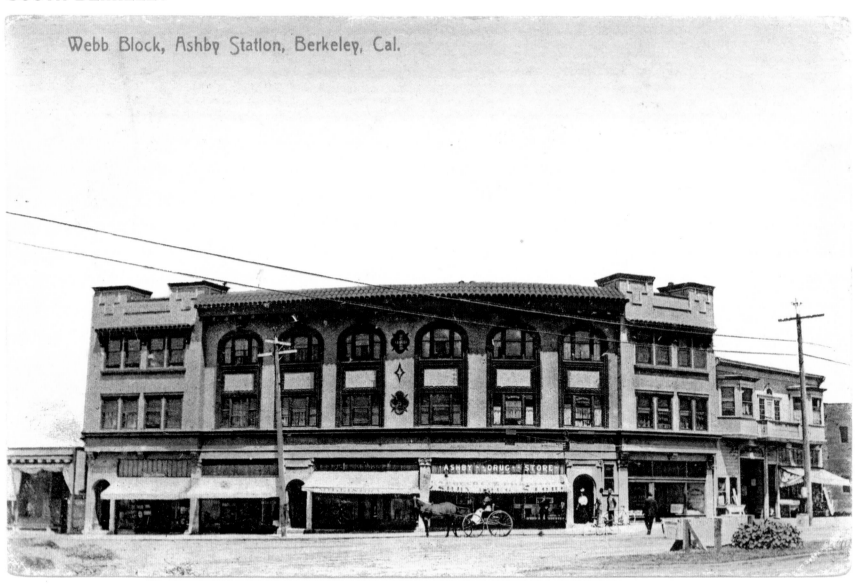

Webb Block, Ashby Station, Berkeley, Cal.

"Webb Block, Ashby Station, Berkeley, Cal." Pacific Novelty Co., No. B 14, "published for Caldecott's Pharmacy, Berkeley."

The Webb Block (Charles W. McCall, Architect, 1905) is a Mission Revival style building with a curved front that follows the broad curve of Ashby Avenue and Adeline Street. An early tenant was a pharmacy run by Thomas Caldecott, who was later elected president of the Alameda County Board of Supervisors. The Caldecott Tunnel, which connects Alameda and Contra Costa counties, was named for him.

Facing page:
**Untitled
(Louis Johnson House).
Real-photo postcard,
Golden Rod Photo Co.**

The Colonial Revival style still predominates on the residential streets of South Berkeley. This postcard, labeled on the back "our flats," shows a raised-basement cottage at 1732 Ward Street owned in 1909 by carpenter Louis Johnson.

Untitled (Wyckoff House). Real-photo postcard.

The Jacob Wyckoff family's home at 1812 Fairview Street was typical of the first wave of development in the Lorin district. Although many of the Queen Anne cottages remain, the Wyckoff House, with its distinctive paneled front gable and roof cresting, was replaced by City-sponsored housing in the 1970s. The turret is said to have been an 1895 addition.

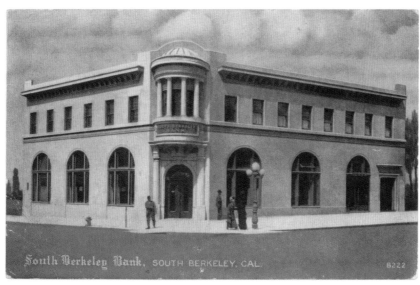

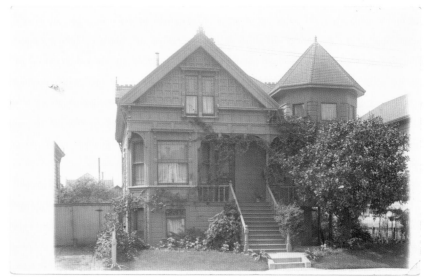

"South Berkeley Bank, South Berkeley, Cal." Advertising postcard. Pacific Novelty Co., B222.

One of the architectural gems of the South Berkeley business district is this bank building at Adeline Street and Alcatraz Avenue, designed in 1906 by University Architect John Galen Howard. It is the only commercial building of his remaining in Berkeley.

Calendar postcard.

Images of well-known advertising figures Buster Brown and his dog "Tige" grace this postcard promoting Charles T. Cox's dry goods store at 3240 Adeline Street, between Harmon and Fairview streets.

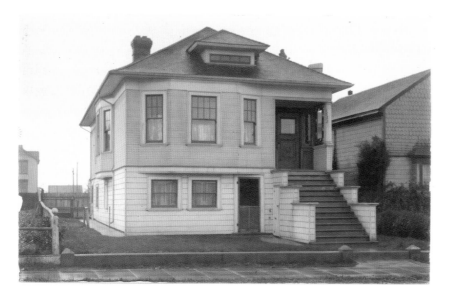

South Berkeley Bank, SOUTH BERKELEY, CAL. B222

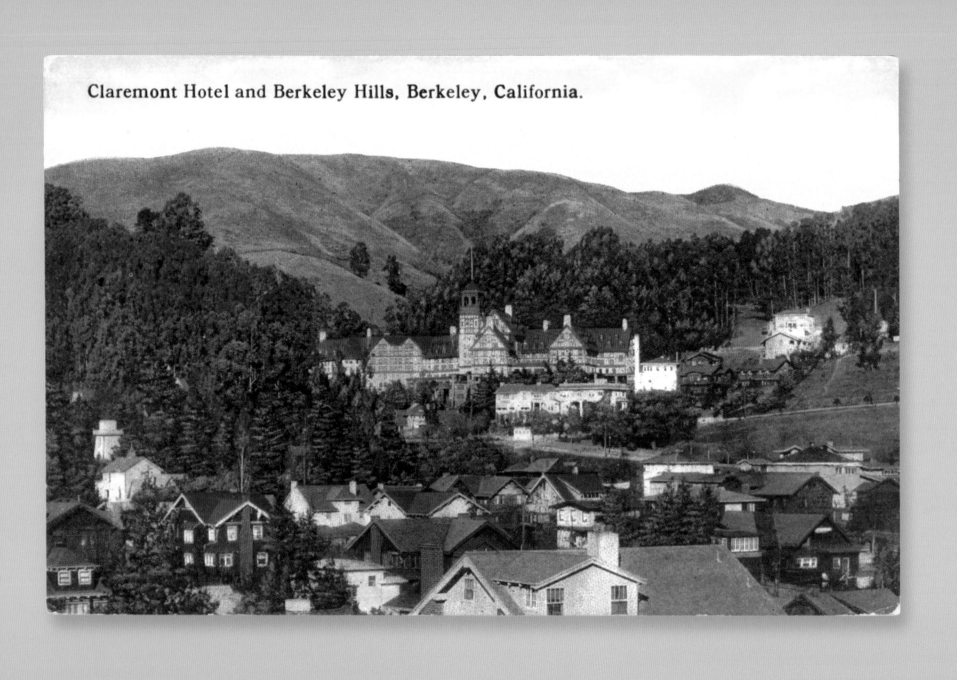

Claremont Hotel and Berkeley Hills, Berkeley, California.

CLAREMONT

When the Claremont development opened in 1905, the Mason-McDuffie Company promoted it as the only "private residential park" in Berkeley and the most beautiful in California as well. The centerpiece for the residential subdivisions that were established in the Claremont district was the Claremont Hotel, also planned in 1905.

The creators of Claremont, who were familiar with the suburban movement across America, envisioned a romantic naturalistic subdivision of family homes in a parklike setting. For the main entrance at Claremont and The Uplands, John Galen Howard, who had recently been named University Architect, designed a bold native-stone gateway, topped with lanterns and featuring stone pavilions and a bridge over Harwood Creek. Utilitarian amenities included paved roads and concrete sidewalks and curbs. Claremont was a single-family residential development where commercial establishments and rooming houses were forbidden. The attractive residences and tree-lined streets built in Claremont and the neighboring Claremont Court were featured on postcards.

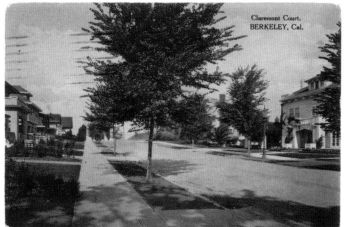

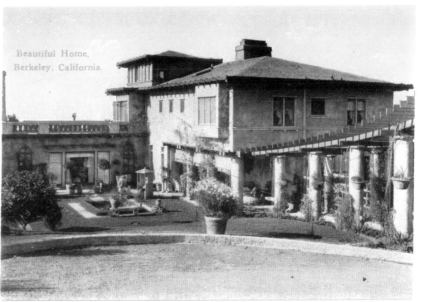

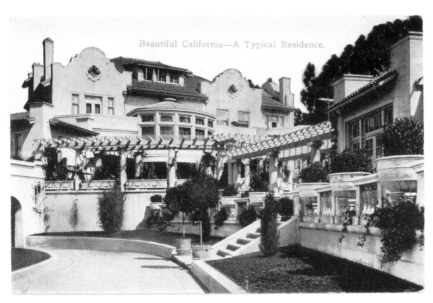

Beautiful California—A Typical Residence.

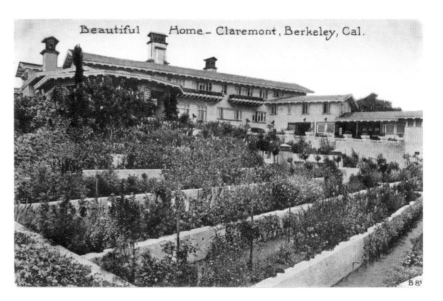

Beautiful Home – Claremont, Berkeley, Cal.

"A Hillside Residence in Berkeley, California."
Edward H. Mitchell,
No. 2902.

Along Tunnel Road, which led east to the open country of Contra Costa County through the first tunnel of 1903, the quiet, rural nature of this place lent itself to the creation of large country houses on spacious parcels. Pictured here, perched high above the road, is such a house, designed by architect Charles S. Kaiser in 1908. It was later home to the Ghirardelli family.

"Beautiful Home, Berkeley, California."
The O. Newman Co.,
No. W. 26.

The carriage entrance at the rear of the Ghirardelli home reveals a pergola leading to the house and a sheltered garden where guests could relax around an ornamental fish pond.

"Beautiful California—A Typical Residence."
Pacific Novelty Co.,
No. C. 1144.

The immense Mission Revival style Hart House on Alvarado Road behind the Claremont Hotel was anything but typical; it was on such a large scale that it could vie with the nearby

Taylor House in size. Designed in 1909 by the hotel's architect, Charles W. Dickey, the Hart House, built for a Klondike millionaire, was another casualty of the 1930s. The chauffeur's quarters and remnants of the garden pergola remain.

Facing page:

"Beautiful Home— Claremont, Berkeley, Cal." Pacific Novelty Co., No. B 81.

The sprawling, Tibetan style Taylor House sat on a knoll above The Uplands near Tunnel Road and was reached by a monumental brick stairway flanked by cascading terraced gardens. Built in 1908, this was the masterwork of architect Louis Christian Mullgardt, but it survived only into the Depression years, when it was demolished, with its stairway and ballroom wing alone remaining.

This page:

"Panoramic View from Hotel Claremont." Folded postcard, front and back views.

This folded postcard was evidently printed for the long-awaited opening of the Claremont Hotel in 1915. The east-west street seen in the center is Russell Street,

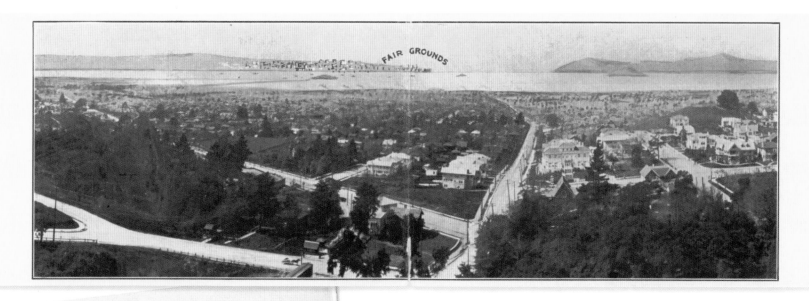

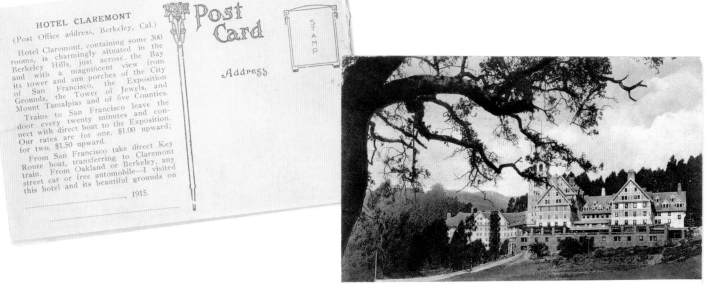

HOTEL CLAREMONT
(Post Office address, Berkeley, Cal.)

Hotel Claremont, containing some 300 rooms, is charmingly situated in the Berkeley Hills, just across the Bay and with a magnificent view from its tower and sun porches of the City of San Francisco, the Exposition Grounds, the Tower of Jewels, and Mount Tamalpias and of five Counties.

Trains to San Francisco leave the door every twenty minutes and connect with direct boat to the Exposition. Our rates are for one, $1.00 upward; for two, $1.50 upward.

From San Francisco take direct Key Route boat, transferring to Claremont train. From Oakland or Berkeley, any street car or free automobile—I visited this hotel and its beautiful grounds on

_____ 1915.

Post Card

Address

STAMP

1307 Claremont Hotel, Berkeley, California.

with the grand homes of Claremont Court visible to the right. In the foreground is Domingo Avenue, today bustling with retail activity. The Key Route train ran through the center of the block from Claremont Avenue to the hotel grounds. Notice that at this early date Ashby Avenue was not yet connected to Tunnel Road.

"Claremont Hotel, Berkeley, California." Cardinell-Vincent Co., No. 1307.

This enticing view shows the hotel framed by the branches of one of Berkeley's famous oaks.

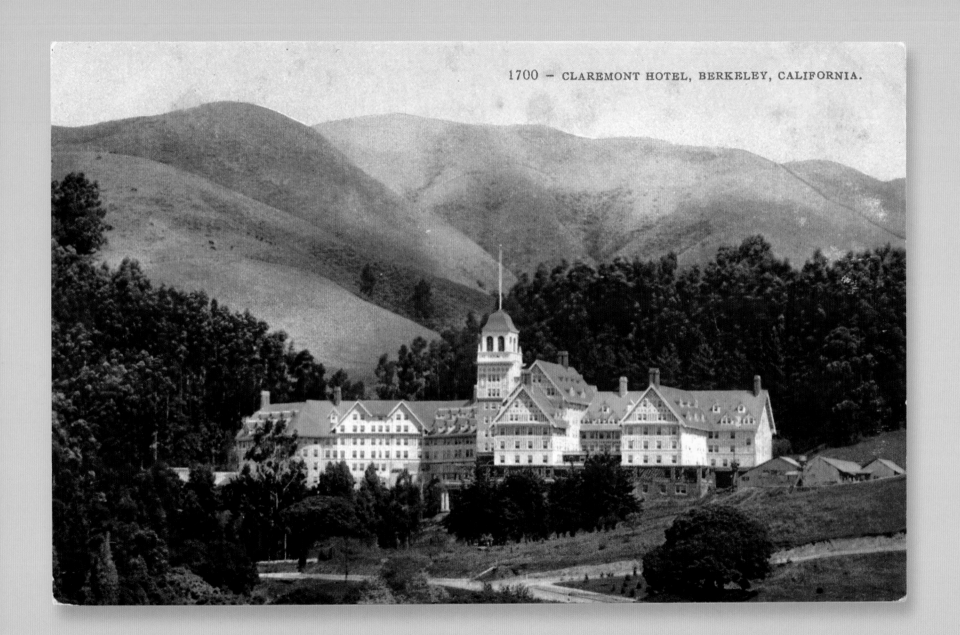

1700 — CLAREMONT HOTEL, BERKELEY, CALIFORNIA.

THE CLAREMONT HOTEL

One of the most "picture-perfect" views is that of the Claremont Hotel, and postcards of it and its luxuriant grounds are numerous and varied. Conceived in 1905 as a destination for one of the Key Route electric interurban lines, the hotel finally opened in 1915, just in time for the Panama-Pacific International Exposition. The postcards of the Claremont are a chronicle of time and change. Early postcards show the hotel nestled against rolling, grassy, unbuilt hillsides surrounded by a forest of eucalyptus trees; others show a garden in front of the hotel with native stone walls edging the pathways. A bit later, in 1917, the Berkeley Tennis Club and its ten tennis courts appear.

The hotel property had once been the gardens of a large country house that was destroyed by fire in 1901. This desirable tract of land was soon purchased by Francis Marion "Borax" Smith, Frank C. Havens, and John Spring, who had together formed the Realty Syndicate and were actively buying up land in the outlying districts of Oakland and Berkeley. The Realty Syndicate was allied with the Key Route transit company, and, hand in hand, they planned to make this land in the East Bay hills attractive to San Francisco businessmen and their families. The resort hotel was to be the nucleus of the development of the surrounding Claremont District. The local newspaper described the property at the time that construction began on the hotel thusly: "The grounds themselves are surpassingly beautiful with a garden of fourteen acres that has been lovingly cultivated for a period of forty years. A wild overgrown creek, huge old pines and oaks, and numberless rare trees, shrubs, and flowers combine with the broad lawns to present a most perfect setting."

An important architectural feature of the hotel is its massive stone foundation. Its walls rise a full two stories and

visually, as well as physically, anchor the massive structure to the hillside. The foundation walls once culminated in a trellis-covered verandah, which stretched along much of the west front of the building, offering sweeping views of the city and bay. Arrivals and departures were important, and three entrances to the building, depending on mode of travel, were conceived: a porte-cochere at the base of the tower for carriages; another porte-cochere at the south to accommodate automobiles entering from Tunnel Road; and a covered walkway to allow visitors alighting from the trains at the foot of the property to enter the hotel in all weather.

The hotel changed hands in 1937, and, in preparation for the 1939 World's Fair on Treasure Island in San Francisco Bay, the exterior was painted brilliant white, ensuring that it could be seen by fairgoers. Still white today, its form can be easily distinguished against the hills when seen from as far away as the Golden Gate Bridge.

Notwithstanding its Berkeley address, the Claremont Hotel and its grounds are actually in the neighboring city of Oakland. When the unincorporated Claremont District was annexed to Berkeley in 1906, the hotel property was not included, and now it is surrounded on three sides by Berkeley. Since the beginning, the perception of the general public was that the hotel was in Berkeley, and postcard publishers seemed to agree. You will notice that only one card refers to the hotel's location as Oakland.

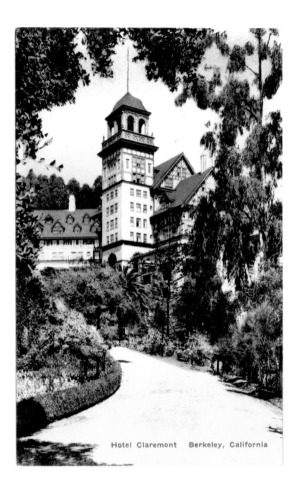

Hotel Claremont Berkeley, California

"Hotel Claremont, Berkeley,
California."
The Albertype Co.

"Hotel Claremont."
Cover, rates sheet, and
illustrations from advertising
brochure, circa 1920.

Hotel Claremont

THE BEAUTY SPOT OF CALIFORNIA
BERKELEY, CALIFORNIA

EUROPEAN PLAN
ROOM AND DETACHED BATH

1 person	$2.00 and $2.50 per day
2 persons	3.00 and 3.50 per day

ROOM AND BATH

1 person	$3.00 to $5.00 per day
2 persons	4.00 to 7.00 per day

SUITES

2 rooms and bath	$5.00 to $ 8.00 per day
3 rooms with 2 baths	8.00 to 12.00 per day

AMERICAN PLAN
ROOM WITH DETACHED BATH

1 person	$4.50 to $5.50 per day
2 persons	8.00 to 9.00 per day

ROOM WITH BATH

1 person	$5.50 to $ 8.00 per day
2 persons	9.00 to 12.00 per day

ATTRACTIVE PERMANENT RATES

R. H. CROSS, MANAGING DIRECTOR

POST OFFICE ADDRESS
BERKELEY, CALIFORNIA
TELEPHONE BERKELEY 9300

The Palm Room

HOTEL
Claremont

BERKELEY, CALIFORNIA
20 MINUTE SERVICE TO SAN FRANCISCO

The North Veranda

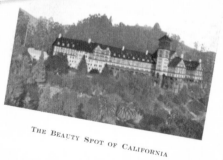

THE BEAUTY SPOT OF CALIFORNIA

Facing page:

"Beautiful California—
Claremont Hotel Grounds,
Berkeley."
Pacific Novelty Company,
"Glosso Series" No. 3548.

*The photographer of this intimate
view of the romantically overgrown
grounds recorded, as well, a sign
in his composition. It reads,
"Visitors must not pick flowers,
break shrubs or trees, or walk on
the grass. No dogs allowed inside
the grounds. Claremont Hotel Co."
The property would have been
almost deserted at this time, as
the hotel awaited completion.*

"Hotel Claremont,
Berkeley, Cal."
Pillsbury Picture Company,
No. 7, "copyright 1907."

*So impressive was the new hotel
that postcards began to appear
while it was still under construc-
tion. This early view shows the
James Palache House from the
1870s on the neighboring estate.
A few months after this picture
was taken, the Palache and
adjacent Garber lands were
combined and subdivided as
"Claremont Court." The Palache
House was moved and survives
in a much-altered state.*

"Claremont Hotel, Berkeley,
California."
Britton & Rey, No. 3014.

*This picture, retouched in a very
painterly way, shows the Palache*

apricot orchard in full leaf and the house already removed. The commission for the design of a hotel was won in early 1906 by architect Charles W. Dickey, a native Californian who also practiced extensively in Honolulu. Dickey designed a rambling half-timbered Elizabethan structure, whose peaked roofs, tower, and massing followed the contour of the hills.

"Claremont Hotel, Berkeley, Cal."
Newman Post Card Co., No. W. 21.

After the Earthquake in April 1906, work was pushed forward on the hotel, and the massive concrete and stone foundation was completed in August. It was expected that the hotel would be ready for occupancy by November, but increased building activity after the Earthquake caused a scarcity of materials, and the framework was by then only up to the top of the second story. A planing mill was erected on the site—and the building was finally enclosed by the end of the year. However, before the interior could be finished, the company found itself in financial straits due to the Panic of 1907. Work was halted.

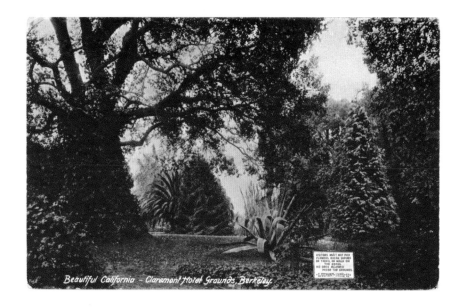

Beautiful California – Claremont Hotel Grounds, Berkeley.

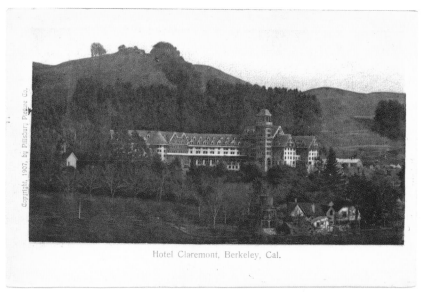

Hotel Claremont, Berkeley, Cal.

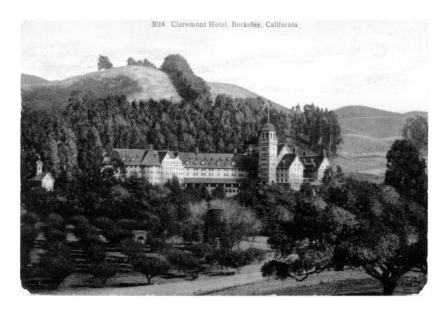

3014 Claremont Hotel, Berkeley, California.

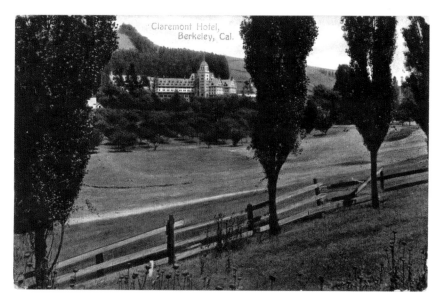

Claremont Hotel, Berkeley, Cal.

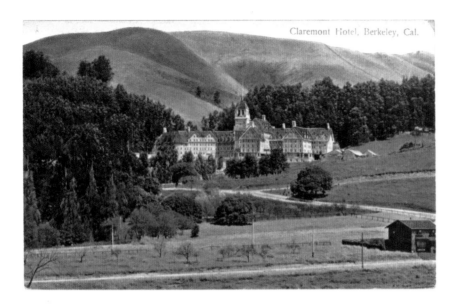

Claremont Hotel, Berkeley, Cal.

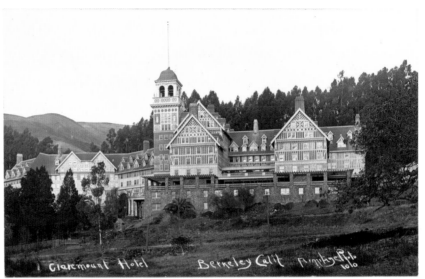

Claremount Hotel Berkeley Calif Armitage Ph.

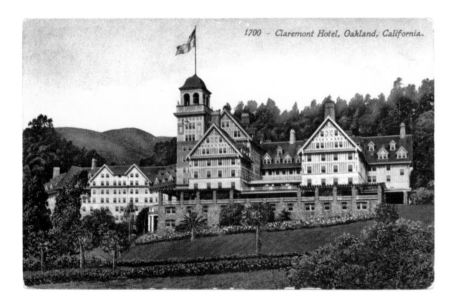

1700 - Claremont Hotel, Oakland, California.

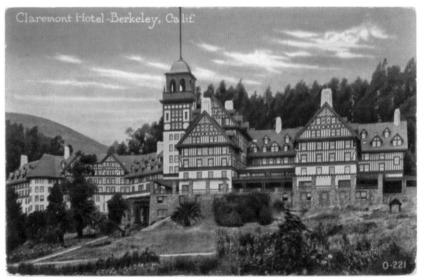

Claremont Hotel - Berkeley, Calif.

O-221

"Claremont Hotel, Berkeley, Cal."
Pacific Novelty Co., "Glosso Series" No. B. 44.

This view, taken about the time construction was stopped, shows the on-site planing mill to the right of the hotel. The road in the picture is Domingo Avenue, and the just-completed shingled house in the foreground is on The Plaza Drive.

"Claremont Hotel, Berkeley, Calif."
Real-photo postcard, Armitage Photo, No. 100.

The grand hotel sat empty, its dark, unpainted plaster surfaces and its trim with a coat of white primer giving the reverse effect of a traditional half-timbered exterior. Attempts were repeatedly and unsuccessfully made during the next several years to gather financing to complete the project. In the meantime, visible for miles around, the building had already become the great visual landmark of the Bay Area that it still is today.

"Claremont Hotel, Oakland, California."
Edward H. Mitchell, No. 1700.

Compare this reworked image to the Armitage photo card, and you will see the

liberties taken to create the impression of a functioning hostelry. The photo retouchers have tidied the gardens and added colorful beds of flowers. There is even a flag flying from the flag pole!

"Claremont Hotel, Berkeley, Calif."
Pacific Novelty Co.,
No. O-221.

The hotel property was eventually sold to Berkeleyan Erik Lindblom, who had become wealthy in the Alaska Gold Rush. Oakland architect John Carson was hired to supervise work, and by May of 1915 the Claremont Hotel was finally completed—in time to meet the rush of tourists coming to the Bay Area for the Panama-Pacific International Exposition. The timbering was at last painted brown.

This page:
"Claremont Hotel, Berkeley, Cal."
Pacific Novelty Co.,
"Glosso Series" No. O. 39.

Postcard publishers had to use their imagination to envision how the Claremont Hotel would look upon completion. Here, the coloring comes close, but artistic license was used for the broad flat lawns and hothouse plants.

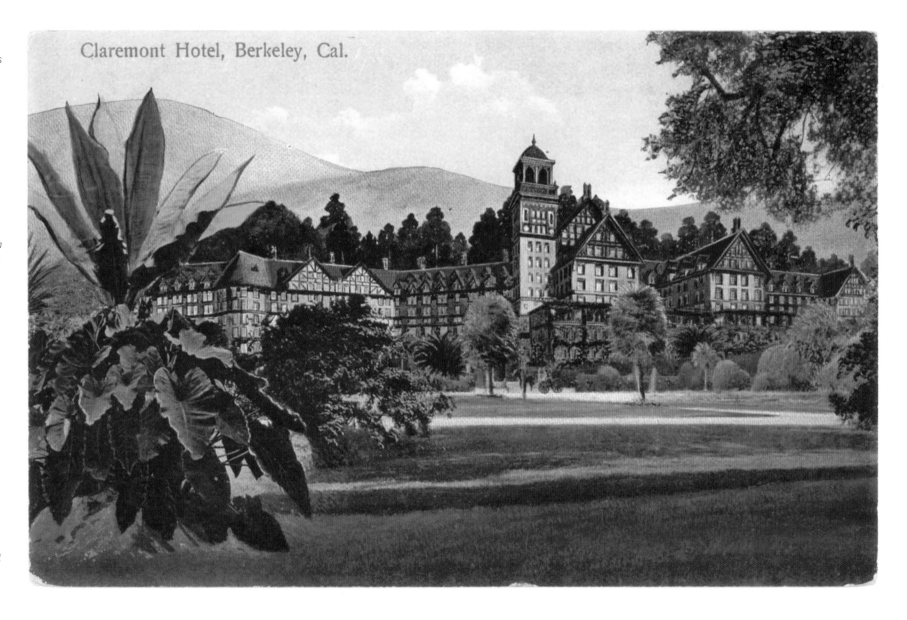

Claremont Hotel, Berkeley, Cal.

Private Residence,
Berkeley, Cal.

NORTHSIDE

The area just north of the University campus is now referred to as "Northside." Subdivided in 1889 as Daley's Scenic Park, it was Berkeley's first hillside subdivision. An early resident of the Scenic Park was Charles Keeler, a proponent of the American Arts and Crafts Movement. Keeler was the first client of architect Bernard Maybeck, who designed a home for him that was built entirely of unpainted redwood, both on the exterior and interior. Keeler was instrumental in the formation of the Hillside Club in 1898. The club was the vocal advocate of building in harmony with nature. Keeler wrote a book, *The Simple Home*, espousing the use of natural materials such as unpainted wood siding or shingles. He discouraged the use of nonessential decoration and white paint. Through a determined campaign by the Club, Berkeley became known as a city of brown-shingle houses.

The Scenic Park tract had originally been laid out in a grid pattern. But the Hillside Club advocated that hillside streets should curve with the contours of the land and lobbied for the regrading of their streets. Finally, in 1909, the grid was modified by curved corners, divided roadways, and a network of elegant pathways and staircases.

Soon the hillside was filled with homes, fraternity houses, a school, churches, and two hotels. Many of these buildings, including the public school, were covered with unpainted wood siding or shingles in conformance with the ideals of the Hillside Club. Northside became home to the four individuals most influential in the creation of the Beaux-Arts plan for the University in the early 1900s: benefactress Phoebe Apperson Hearst, University President Benjamin Ide Wheeler, and architects John Galen Howard and Bernard Maybeck. In 1923, two-thirds of Daley's Scenic Park burned to the ground.

More than 500 buildings, mostly homes, were lost. Postcards provide a colorful glimpse of pre-fire Northside.

NORTH BERKELEY SUBDIVISIONS

After the success of Claremont, Mason-McDuffie, in conjunction with the Realty Syndicate and the Key Route, moved on to develop North Berkeley in a similar fashion. Northbrae, much larger than Claremont and Claremont Court and more hilly, was designed by R. E. Mansell, a professor of landscape architecture at the University of California. The design included several parks where there were huge rock outcroppings. The subdivision opened in 1907, just as refugees from the 1906 Earthquake and Fire were seeking homes in the East Bay, and Berkeley became the fastest growing city in the United States. As in the earlier subdivisions, John Galen Howard designed the native-stone pillars used as street markers. He also designed The Circle, a roundabout at the juncture of Marin, Los Angeles, and Arlington avenues. Classic Revival balustrades surrounded the large fountain in The Circle and lined the formal Fountain Walk connecting The Circle with the interurban streetcar line below at the Solano Tunnel.

Later, lands further north and higher on the hillsides were subdivided for residences: Thousand Oaks, Cragmont, and North Cragmont in Berkeley, and Berkeley Heights just over the county line in Kensington.

Attractive promotional brochures were printed for all of these subdivisions that included photographs, drawings, and often a hand-drawn bird's-eye map. Some of these brochures were designed to be mailed in a legal size envelope.

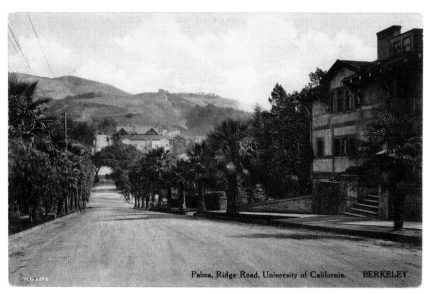

LE ROY AVENUE, BERKELEY, CAL PUBLISHED BY A. BLUMBERG, ALAMEDA, CAL.

"Midwinter Floral Hedge, Berkeley, California." Pacific Novelty Co., No. B 61.

A streetcar, having turned onto Hearst Avenue from Euclid Street, can be seen in this view of the famous ivy geraniums along the Hearst Avenue retaining wall.

"Palms, Ridge Road, University of California, Berkeley." Associated Students' Store, No. 191.

The Washingtonia palms, planted on Ridge Road in the 1890s, now tower over the Northside landscape. To the right is the Adolph Miller House, designed by John Galen Howard in 1906.

"Le Roy Avenue, Berkeley, Cal." Real-photo postcard, A. Blumberg.

The Hillside Club promoted the idea of preserving native trees by "bending" the road around them. "Annie's Oak," which stood in the center of Le Roy Avenue between Ridge Road and LeConte Avenue, was said to have been saved from street pavers by Annie (Mrs. Bernard) Maybeck. The Caroline Blossom House

(1904) and the Oscar
Maurer House (1905),
both by designer-builder
F. E. Armstrong, stand to
the left of the tree.

**"Street and Residence
Scene, Berkeley,
California."
Pacific Novelty Co.,
No. B. 67.**

*Washingtonia palms can be
seen in this view of Scenic
Avenue as it gently curves to
meet Hearst Avenue. The
home of University President
Benjamin Ide Wheeler (Edgar
A. Matthews, Architect, 1900)
is at the left.*

This page:
**Untitled
(Newcomb House).
Real-photo postcard.**
*This famous "chateauesque"
house, which stood at Arch
and Vine streets, was
designed by Cunningham
Bros. in 1899 for quicksilver
miner Bethuel Newcomb.
On the back of the card,
which was "taken last week:
May 1910," Mrs. Newcomb
remarked that "our view of
Golden Gate is grand." The
house was demolished in
1958, after an unsuccessful
preservation effort by local
citizens to preserve it as a
museum.*

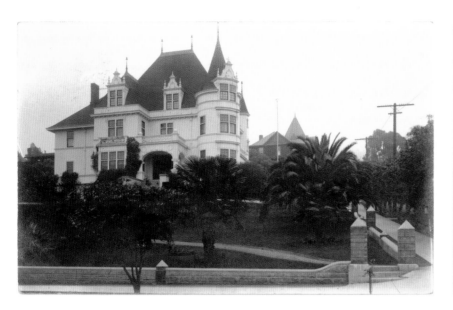

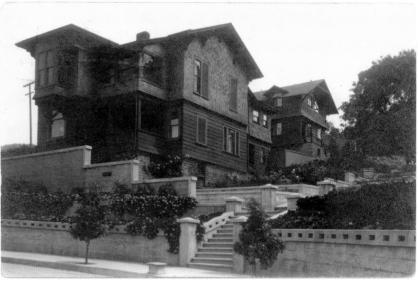

Untitled (McClure House).
Real-photo postcard.
*On yet another house card sent by the owner, Katherine
McClure wrote in 1912, "This is our Berkeley home [the
card was written from the McClures' Sacramento home],
taken some time ago." The house, built for State Engineer
Wilbur McClure, still stands on Scenic Avenue at Vine
Steps.*

**"Beta Theta Pi Fraternity,
University of California. Berkeley."
Associated Students' Store.**

*Designed for the Beta Theta Pi fraternity in 1893 by
architect Ernest Coxhead, this building, with its use of
unpainted shingles and rough, natural stucco, had a
profound influence on the development of the architec-
tural philosophy promoted for the Northside by Charles
Keeler and members of the Hillside Club. To the right,
at the rear, is a 1909 shingled addition by architects
Bakewell & Brown.*

Newman Hall,
Berkeley, Cal.

1819-College Hall, Berkeley, California.

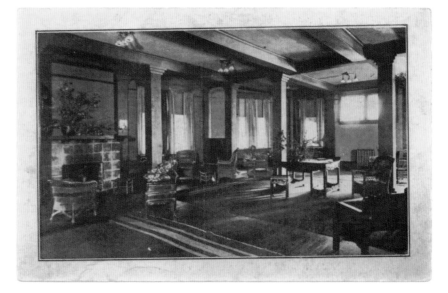

"College Hall, Berkeley, California."
Souvenir Publishing Co., No. 1819.

College Hall, designed by Theodore Lenzen in 1908, was an early dormitory erected in connection with the University. Privately owned, the building was managed by the University as a residence hall for women students, conveniently located across from Founders Rock at the corner of Hearst and La Loma avenues.

"College Hall Dormitory."
Publisher unknown.

Each of the two wings of College Hall had its own entrance and reception room—that of the east wing is pictured here. The building survived the 1923 Fire, only to be destroyed in the 1930s.

Facing page
Untitled (The Braemar).
Real-photo postcard.

The Braemar, located at 2417 LeConte Avenue, was one of two hotels, with Cloyne Court the other, in the Northside neighborhood. It was designed by the San Francisco architectural firm of Hladik & Thayer in 1910 for a Mr. Ure of London. The Braemar, as well as almost every building visible in this view, was destroyed in the 1923 Fire.

"Newman Hall, Berkeley, Cal." E. C. Kropp Co.

The Newman Club was organized at the University in 1899 for Catholic students, and in 1908 this impressive meeting place was built at the corner of Ridge Road and La Loma Avenue. It was designed by the architectural firm of Shea & Lofquist, which also designed St. Joseph's Catholic Church.

"Euclid Apartments, Berkeley, Cal."
Real-photo postcard.

John Galen Howard designed the Euclid Apartments in 1912 at the corner of Euclid and Hearst avenues, opposite the north entrance to the University. Its Beaux-Arts elegance reflects his classical ensemble in the center of the campus.

Untitled (Treehaven).
Real-photo postcard.

Its parklike setting among the oaks (two of which grew in the middle of the street) was the inspiration for the name of Treehaven Apartments (George W. Patton, Architect, 1909). The trees are now gone, but the sturdy columns supporting canvas-draped balconies give the building the appearance of a giant treehouse.

"Glen Garry."
Real-photo postcard,
Dooley, photographer.

The Glen Garry Apartments, on Le Roy Avenue across from Cloyne Court, was designed by Walter H. Ratcliff, Jr., in 1912 for gracious living (each apartment had a fireplace and balcony). Ratcliff had worked on the Hearst Mining Building under John Galen Howard and that important building seems to have been the inspiration for the design of the Glen Garry.

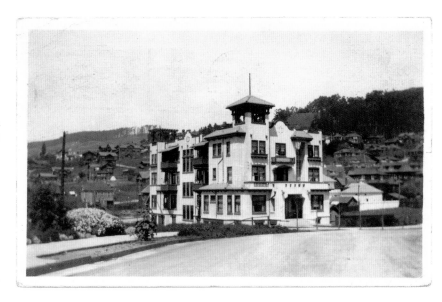

EUCLID APARTMENTS, BERKELEY, CAL.

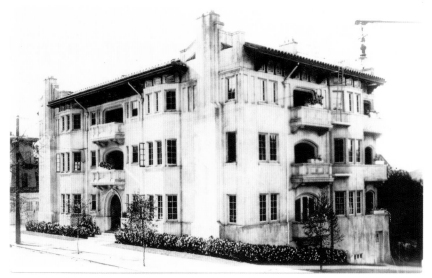

BERKELEY
HIGHLANDS.
THE MOST
ATTRACTIVE
EXCLUSIVE
RESIDENCE
DISTRICT IN
THE BAY
CITIES, IS
REACHED BY
THIS, THE
MOST DE-
LIGHTFUL
SCENIC DRIVE-
WAY ON SAN
FRANCISCO
BAY
ADEQUATE
BUILDING
RESTRICTIONS
INSURE HIGH-
CLASS HOMES
FOR CULTURED
PEOPLE.

WRITE FOR
BIRDS-EYE
VIEW AND
DESCRIPTIVE
BOOKLET.

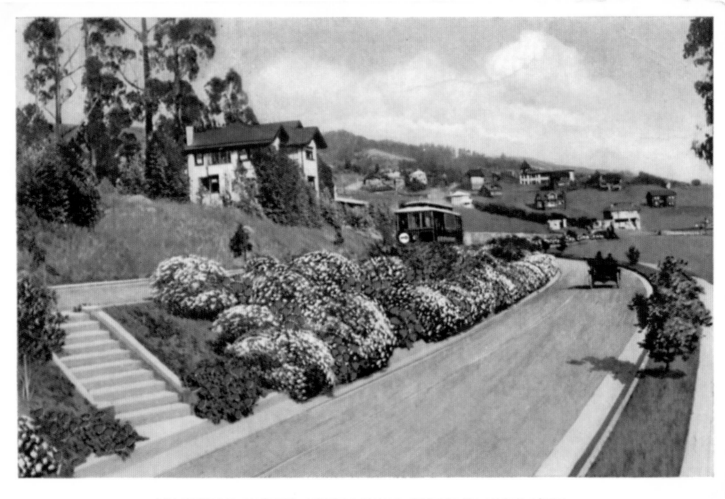

ARLINGTON AVENUE APPROACHING BERKELEY HIGHLANDS.

MEIKLE, BROCK & SKIDMORE, GENERAL AGENTS
ESTABLISHED 1892

2121 SHATTUCK AVE., BERKELEY, CAL
LARGEST BERKELEY DEALERS

"Arlington Avenue
Approaching Berkeley
Highlands."
Advertising postcard.

*Berkeley Highlands was
a subdivision in the neigh-
boring community of
Kensington, but this view
shows Berkeley's Northbrae
and Arlington Avenue, north
of the Marin Circle. Arlington,
with its divided contoured
roadway and flower-filled
median, was North
Berkeley's counterpart
to Piedmont Avenue.*

Untitled (Arlington Avenue).
Real-photo advertising postcard.

"This view on Arlington Avenue was taken in order to show the character of street work and homes being built at Berkeley Highlands," reads the message on the back, dated February 15, 1913. This stretch of Arlington is now Kensington's business district. The house on the left is still standing.

Untitled (Berkeley Highlands).
Real-photo advertising postcard.

This card states, "This entrance archway to Berkeley Highlands is just being completed at a cost of $3,000, although its appearance would indicate a cost of $5,000. It is soon to be surrounded by a small park. The fact that we had to excavate to a depth of over twenty feet in order to secure a foundation sufficiently solid for this gateway, will give you some idea of its massiveness, and of the quality of its construction. It was designed by [John] Hudson Thomas. February 18, 1913."

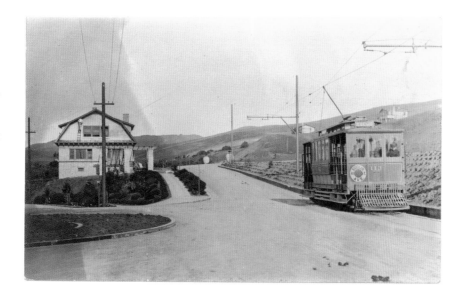

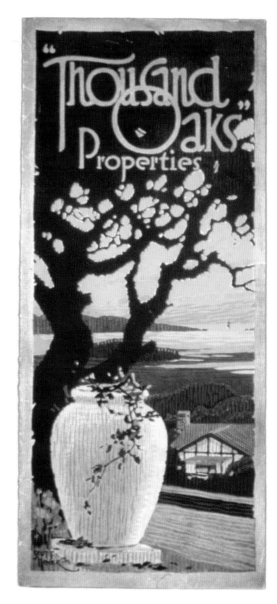

"Thousand Oaks Properties."
Cover, promotional folder, Thousand Oaks Properties, 1917.

"Northbrae, A Residence Park at Berkeley."
Cover, promotional folder, Mason-McDuffie Co., 1907. Artwork by W. H. Bull.

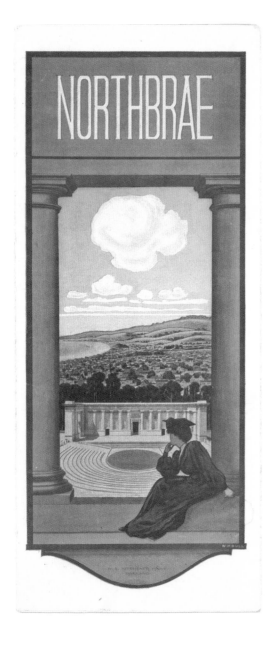

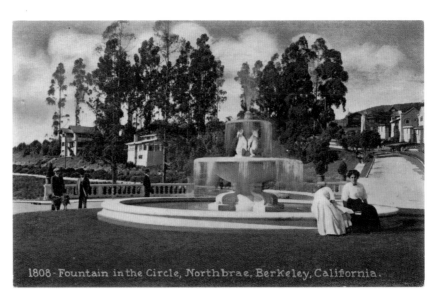

"Fountain in the Circle, Northbrae, Berkeley, California."
Edward H. Mitchell, No. 1808.

The "Bear Fountain," with grizzly bear cubs sculpted by Arthur Putnam, was the centerpiece of the Northbrae development. The Gardner House can be seen to the left of the fountain, and the group of Pratt Houses designed by John Hudson Thomas is visible on Indian Rock Avenue to the right. Compare this printed sepia card to the "real-photo" version on page 17.

"Residence District, Northbrae. Berkeley, Cal."
The Albertype Co.

Rock outcroppings were the visual theme in Northbrae, from the massive forms in Indian Rock Park (in the foreground) to stone walls, stone-edged pathways, and stone pillars bearing street names. The natural stucco surfaces and simple, geometric forms of John Hudson Thomas's Fleager and Grigsby houses from 1910 on Indian Rock Avenue seem appropriate in this rocky setting.

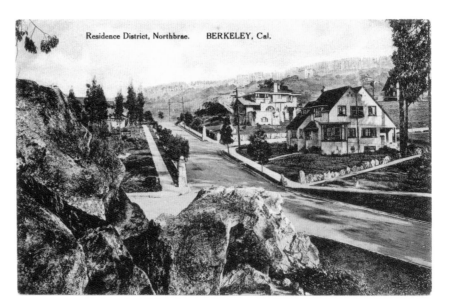

"Residence District, Northbrae. Berkeley, Cal."
The Albertype Co.

Northbrae was far from the center of town on the rock-dotted grassy northern slopes, and many early homebuilders favored a rustic look that was well-suited to this rural area. Pictured here is the Thomas House designed by Julia Morgan in 1911 on Arlington Avenue. The Davis House (Walter H. Ratcliff, Jr., Architect, 1912) is at the left.

"Residence District, Northbrae. Berkeley, Cal."
The Albertype Co.

Images of the Gardner House on Arlington Avenue, designed by Olin S. Grove in 1911, were often used to promote Northbrae.

"Indian Rock, Northbrae, Berkeley, California."
Edward H. Mitchell, No. 1809.

Perched high on steps cut into the stone, the two women give scale to mammoth Indian Rock.

"Indian Rock Park, Northbrae, Berkeley, California."
Edward H. Mitchell, No. 1810.

In the background is the Pierce House of 1910 on Oxford Street.

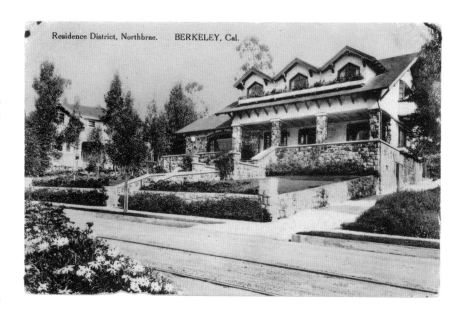

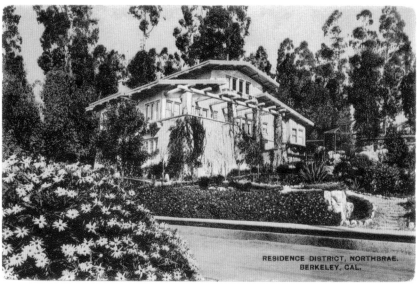

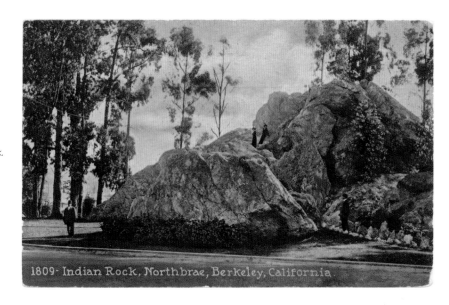

1809- Indian Rock, Northbrae, Berkeley, California

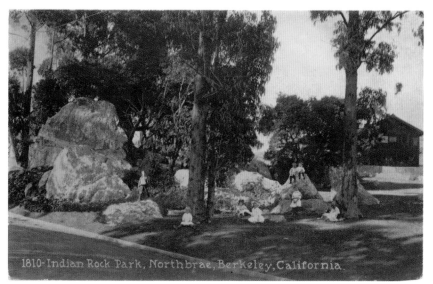

1810- Indian Rock Park, Northbrae, Berkeley, California

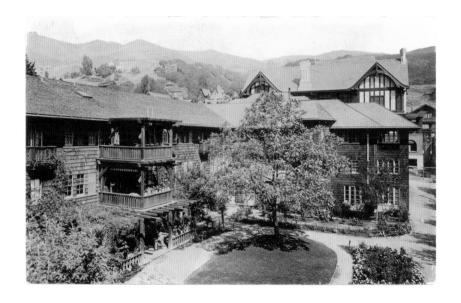

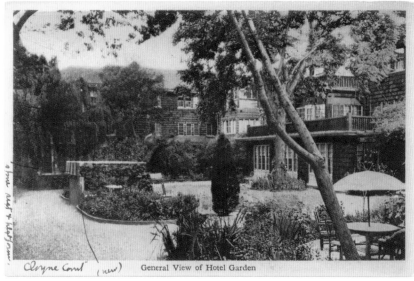

Cloyne Court (new) General View of Hotel Garden

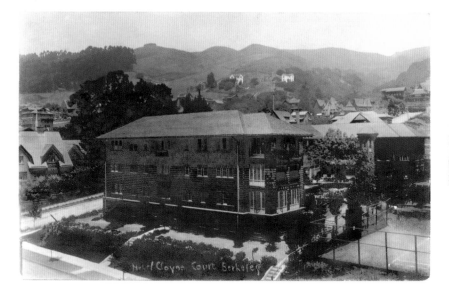

Hotel Cloyne Court Berkeley

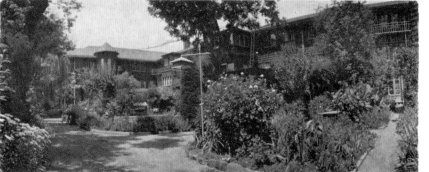

THE GARDEN AT CLOYNE COURT

This was snapped a few years ago. but seems on the whole the best view of the garden ever taken. Many thanks for your note in re Miss Kelley—

Untitled (Cloyne Court garden).
Real-photo postcard.

A view of the garden court-yard with Newman Hall rising above the east wing of Cloyne Court. This postcard was sent as a Christmas greeting in 1913 by the Pierce family, owners of Cloyne Court.

"General View of Hotel Garden."
"Printed in Japan."

A view looking west in the Cloyne Court garden.

"Hotel Cloyne Court, Berkeley."
Real-photo postcard.

Taken from Le Roy Avenue, this view looks into the garden courtyard at the back of Cloyne Court. The Freeman House (Coxhead & Coxhead, Architects, 1903) is to the left, and visible on the hillside beyond are two of the white-painted houses that were the object of scorn by members of the Hillside Club.

"The Garden at Cloyne Court."

"This was snapped a few years ago, but seems on the whole the best view of the garden ever taken," reads the message on this card sent by owner Mary Pierce.

CLOYNE COURT

Cloyne Court Hotel, 2600 Ridge Road in Northside, was named for the home of Bishop George Berkeley of Cloyne, Ireland, and was built in 1904 to serve guests associated with the University. The hotel was funded by a group of investors who called themselves the University Land and Improvement Company. These investors included several University professors, University benefactresses Phoebe Apperson Hearst and Jane K. Sather, future Regent James K. Moffitt (for whom a campus library is named), John Galen Howard (the architect of the Cloyne Court), and James M. Pierce (owner and manager of the hotel from 1914 until it closed in 1946).

Cloyne Court is an architecturally significant example of the American Arts and Crafts Movement, and it assimilates and integrates the American Shingle Style with the teachings of the Ecole des Beaux Arts in Paris. It reflects the philosophy that buildings should complement and enhance their natural surroundings. With the exception of modestly carved, heavy wood brackets over the entrance portico, there is a complete absence of ornamentation. The building turns its back on the street and opens up to a large south-facing garden courtyard. Cloyne Court is one of the few surviving large shingled residential buildings in the Bay Area, and it is the largest in Berkeley.

An early advertising brochure described Cloyne Court as a hotel/apartment house designed "particularly for members of the faculty of the University and their families, graduate students, and people who wish to live in Berkeley and also wish to avoid the annoyance and cost of housekeeping there. To these Cloyne Court offers the combined advantages of housekeeping and boarding." The hotel had its own chef and provided lectures and recitals.

Since 1946, the hotel building has been used by the University Students Cooperative Association.

PICTURING BERKELEY HOMES

Between 1903 and 1915, when Berkeley was one of the fastest growing cities in the country, postcards illustrating Berkeley's new homes were quite popular. There were two types of cards. In the first type were cards that were published and offered for sale. These were usually in color and depicted large homes or beautiful residential streetscapes such as Piedmont Way.

In the second type were private postcards, usually real-photo cards, which homeowners commissioned for their own use or even produced themselves. The Associated Students of the University produced many cards for fraternal organizations as well. Recorded for posterity on surviving postcards are pictures of homes and student houses, many of which are no longer standing, that show a wide variety of popular styles. These private postcards were produced in limited quantities so it is surprising how many have survived.

—Susan Dinkelspiel Cerny

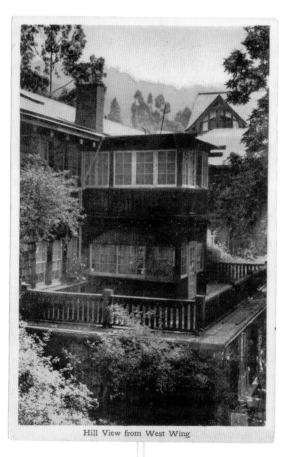

Hill View from West Wing

"Hill View from West Wing." "Printed in Japan."

The porches have been glassed in, giving Cloyne Court an almost Japanese appearance in this undated postcard printed in Japan.

Untitled (Whitton House).
Real-photo postcard.

This superb example of a Craftsman style house was designed in 1909 by J. Cather Newsom on the site of what is now People's Park. When the University cleared almost the entire block in 1968, this house alone was saved and was moved to Claremont Avenue.

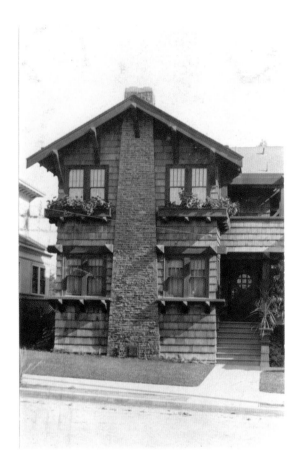

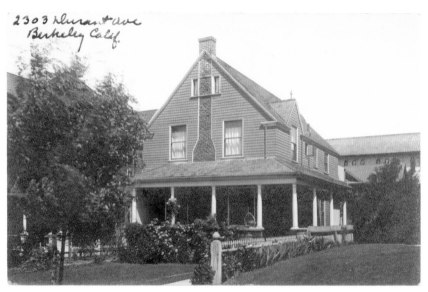

**Untitled
(2303 Durant Avenue).
Real-photo postcard.**

The history of this quaint, old-fashioned house is unknown. However, the top of the chimney appears to have been rebuilt, suggesting that it may have toppled over in the 1906 Earthquake. St. Mark's Episcopal Church can be seen behind it.

**Untitled
(2519 Hillegass Avenue).
Real-photo postcard.**

This circa 1906 house combined art stone, rough-cast plaster, and shingles in a lively and very perpendicular composition. The writer of the postcard lived in the classic Berkeley garden cottage seen at the rear.

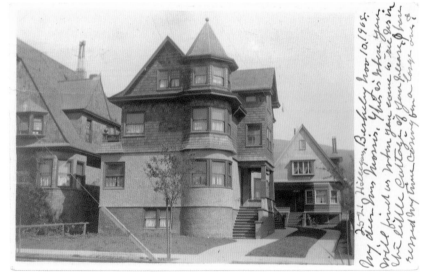

Untitled (Wehe House). Real-photo postcard.

No longer standing, the family home of Judge Frank E. Wehe was the centerpiece of a group of six houses designed by C. M. Cook in 1903 at the corner of Telegraph Avenue and Carleton Street for developer J. A. Marshall.

Untitled (unidentified house). Real-photo postcard.

This postcard of a typical Berkeley brown-shingle has a welcoming message written on the back. "My dear Emma—This is where you will find us when you come down to Berkeley to see me. Can't you see me out on the porch waiting for you? With love from Helen."

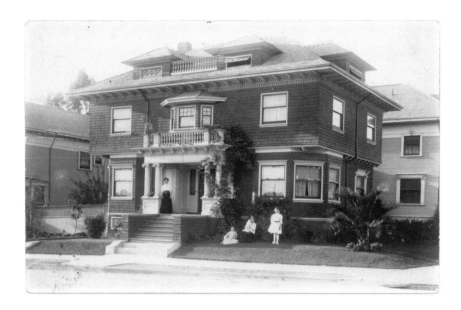

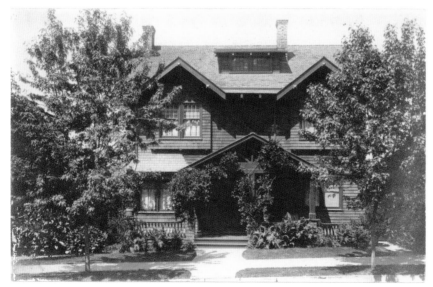

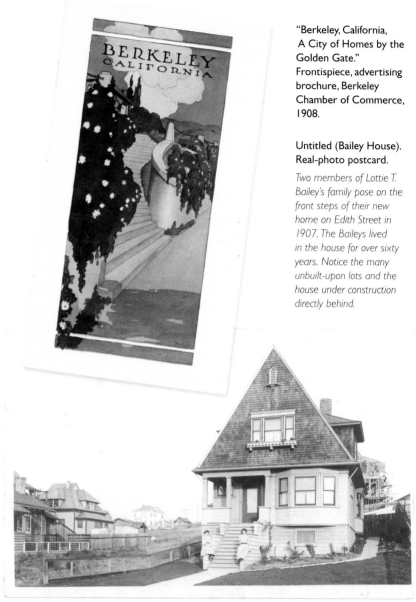

"Berkeley, California, A City of Homes by the Golden Gate." Frontispiece, advertising brochure, Berkeley Chamber of Commerce, 1908.

Untitled (Bailey House). Real-photo postcard.

Two members of Lottie T. Bailey's family pose on the front steps of their new home on Edith Street in 1907. The Baileys lived in the house for over sixty years. Notice the many unbuilt-upon lots and the house under construction directly behind.

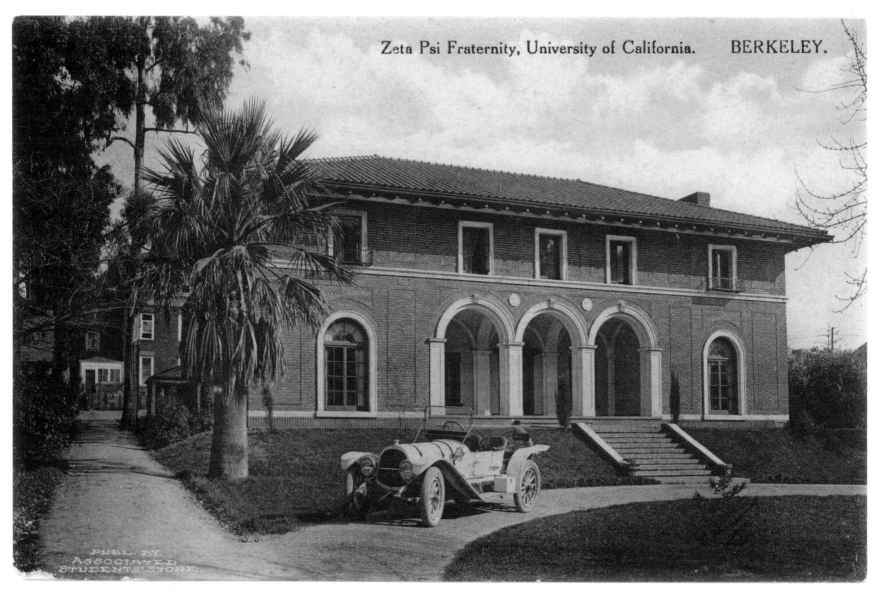

Zeta Psi Fraternity, University of California. BERKELEY.

PUBL. BY
ASSOCIATED
STUDENTS' STORE.

"Zeta Psi Fraternity,
University of California.
Berkeley."
Associated Students' Store.

*Zeta Psi was the first fraternity
established in the west.
Pictured here is the group's
second house, designed by
Charles Peter Weeks in 1910.
It stood on the northernmost
block of College Avenue, now
part of the University campus.
Today, the building is home to
the Archaeological Research
Facility. The original Zeta Psi
House of 1880 is in the left
background.*

Facing page:
"Kappa Alpha Theta
Fraternity [sic], University
of California. Berkeley."
Associated Students' Store.

*The Kappa Alpha Theta
sorority house at 2723 Durant
Avenue was designed by the
firm of Morgan & Hoover
(Julia Morgan) in 1908. It had
the distinction of being the
first sorority house erected
in Berkeley. Julia Morgan
was an 1894 graduate of
the University and a member
of this sorority.*

"Gamma Phi Beta Fraternity
[sic], University of California.
Berkeley."
Associated Students' Store.

The Gamma Phi Beta chapter

house at 2732 Channing Way was designed in 1912 by architect Elizabeth M. Austin, who, like Julia Morgan before her, was a "Cal" graduate (Class of 1911) and a member of the sorority. The house was built on the site that Maybeck's Hearst Hall first occupied from its construction in 1899 until it was moved to the University campus in 1901.

"Delta Gamma Fraternity [sic], University of California. Berkeley." Associated Students' Store.

Architect Walter H. Ratcliff, Jr., repeated the three arched windows of the nearby Gamma Phi House in his 1913 design for the Delta Gamma sorority house at 2710 Channing Way.

"Kappa Kappa Gamma Fraternity [sic], University of California. Berkeley." Associated Students' Store.

The Kappa Kappa Gamma sorority house at 2725 Channing Way was designed in 1912 by Oakland architect Ivan Satterlee. It is one of the few Greek letter houses pictured on postcards that is still standing.

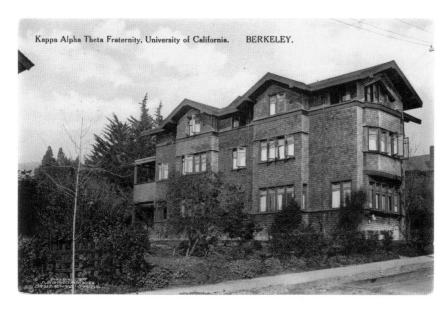

Kappa Alpha Theta Fraternity, University of California. BERKELEY.

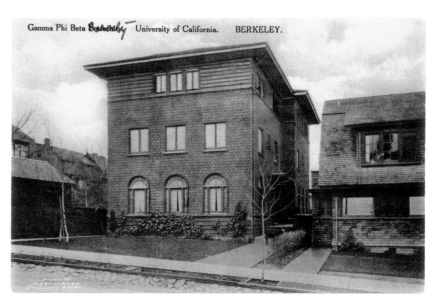

Gamma Phi Beta Fraternity, University of California. BERKELEY.

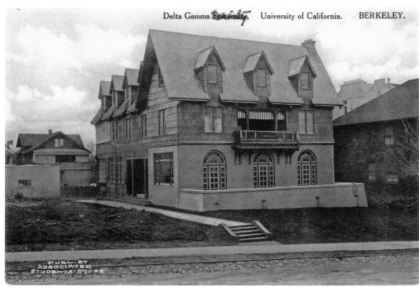

Delta Gamma Fraternity, University of California. BERKELEY.

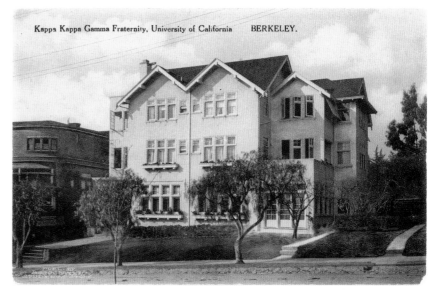

Kappa Kappa Gamma Fraternity, University of California BERKELEY.

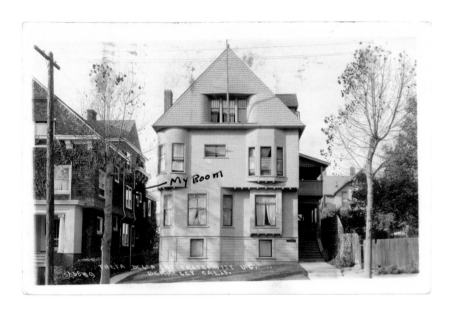

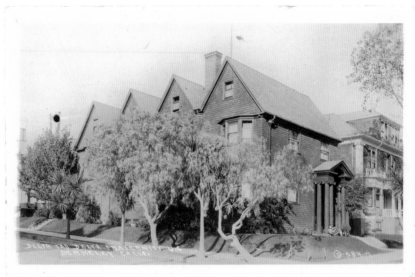

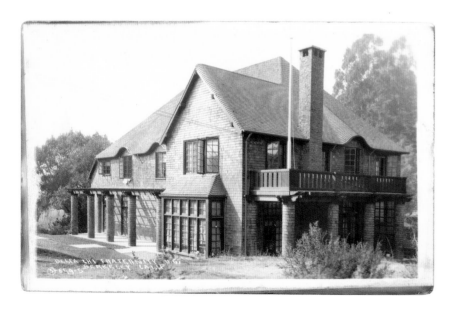

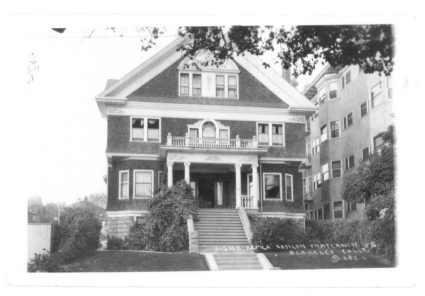

"Theta Delta Chi Fraternity, U.C., Berkeley, Calif." Real-photo postcard, No. S-584-9.

These two substantial turn-of-the-century houses on Durant Avenue were removed in the mid-1960s to make way for the University Art Museum.

"Delta Tau Delta Fraternity, U.C., Berkeley, Calif." Real-photo postcard, No. S-584-7.

Four identical gables and an entry portico distinguish the shingled Timothy Stack House at 2601 Durant Avenue, designed by Polk & Polk (Willis Polk) in 1897. It was purchased by Delta Tau Delta in 1903.

"Delta Chi Fraternity, U.C., Berkeley, Calif." Real-photo postcard, No. S-579-5.

No longer standing at 2200 Piedmont Avenue, the Delta Chi house was designed by Walter H. Ratcliff, Jr., in 1914.

"Sigma Alpha Epsilon Fraternity, U.C., Berkeley Calif." Real-photo postcard, No. S-582-1.

This house at 2519 Ridge Road was likely built as a fraternity, and appeared on several postcards (see page 171). Treehaven is at the right.

"Delta Kappa Epsilon."
Real-photo postcard, Gless-
ner, Morse & Geary Inc.

Charles Lee Tilden and Thomas
B. Bishop commissioned
architect Edward B. Seely in
1898 to design this impressive
structure on Telegraph Avenue
near Durant Avenue. It was
demolished in 1922.

Untitled (Delta Gamma).
Real-photo postcard.

Designed by builder F. E.
Armstrong in 1904, the Delta
Gamma house on Euclid
Avenue may have started out
as a private home.

"Delta Upsilon Fraternity,
University of California.
Berkeley."
Associated Students' Store.

The Delta Upsilon house at
2601 Channing Way was
designed in 1905 by Meyers &
Ward. It was razed in 1970.

"Alpha Tau Omega."
Real-photo postcard, Gless-
ner, Morse & Geary Inc.

Completing the group of
Colonial Revival style buildings
on this page is the Alpha Tau
Omega house at the now
nonexistent corner of Sylvan
Way and College Avenue.
Sylvan Way was a cul-de-sac
one block north of Bancroft
Way, but now has been fully
absorbed into the campus.

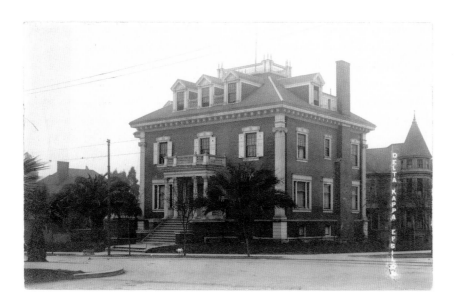

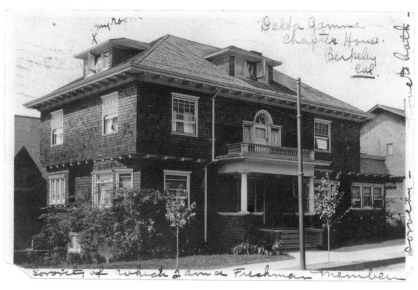

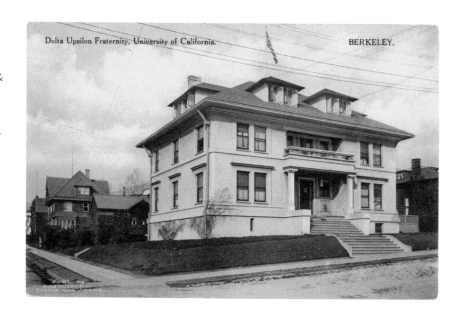

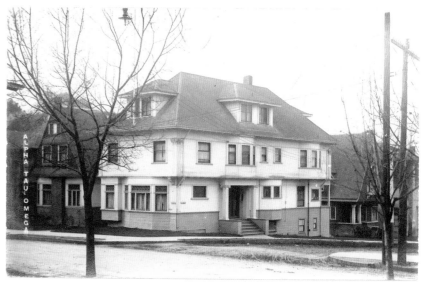

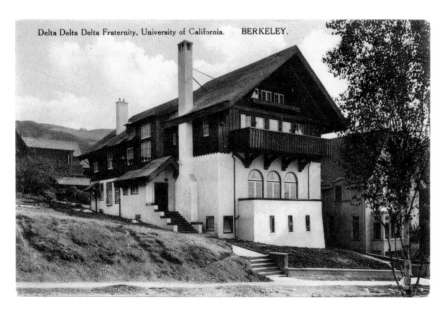

Delta Delta Delta Fraternity, University of California. BERKELEY.

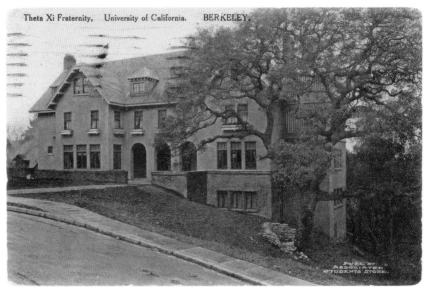

Theta Xi Fraternity, University of California. BERKELEY.

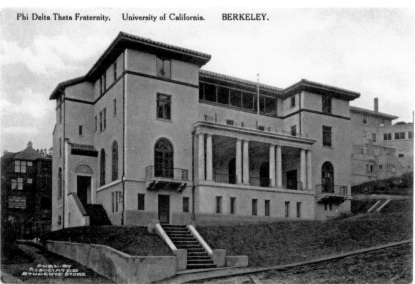

Phi Delta Theta Fraternity, University of California. BERKELEY.

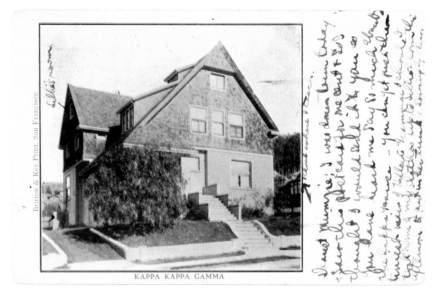

Britton & Rey. Print. San Francisco

KAPPA KAPPA GAMMA

"Delta Delta Delta Fraternity [sic], University of California. Berkeley."
Associated Students' Store.

This oversized chalet, designed by San Francisco architect George Applegarth in 1915, stood at 1715 Le Roy Avenue and was destroyed in the 1923 Fire.

"Theta Xi Fraternity, University of California. Berkeley."
Associated Students' Store.

This fraternity house at 1730 La Loma Avenue was designed by architects Drysdale & Thomas in 1914. Set on the steep banks of the north fork of Strawberry Creek, the building survived the Berkeley Fire.

"Phi Delta Theta Fraternity, University of California. Berkeley."
Associated Students' Store.

John Reid, Jr., the architect of this building, was a 1903 graduate of the University who had studied under John Galen Howard. He was also a member of Phi Delta Theta. The 1914 chapter house survives today at 2717 Hearst Avenue.

This page:
"Row of Fraternity Houses, Berkeley, California."
Edward H. Mitchell, No. 1704.

In this view, framed by the carefully preserved oaks near the site of the as-yet-unbuilt Treehaven, looking west on Ridge Road, the tower of University architect John Galen Howard's own home can be seen on the distant hill. This bucolic scene gives an idea of why people were attracted to Berkeley and wished to build there in harmony with nature.

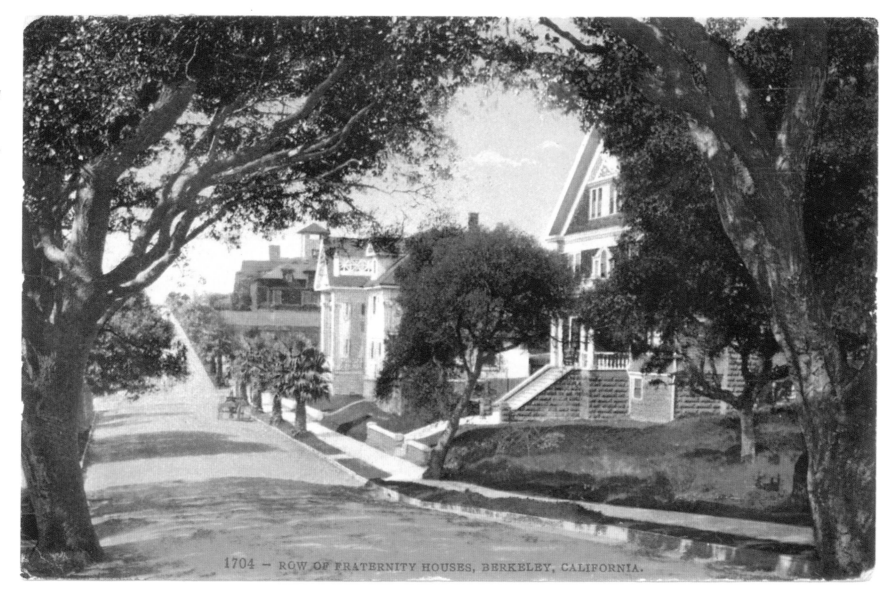

1704 — ROW OF FRATERNITY HOUSES, BERKELEY, CALIFORNIA.

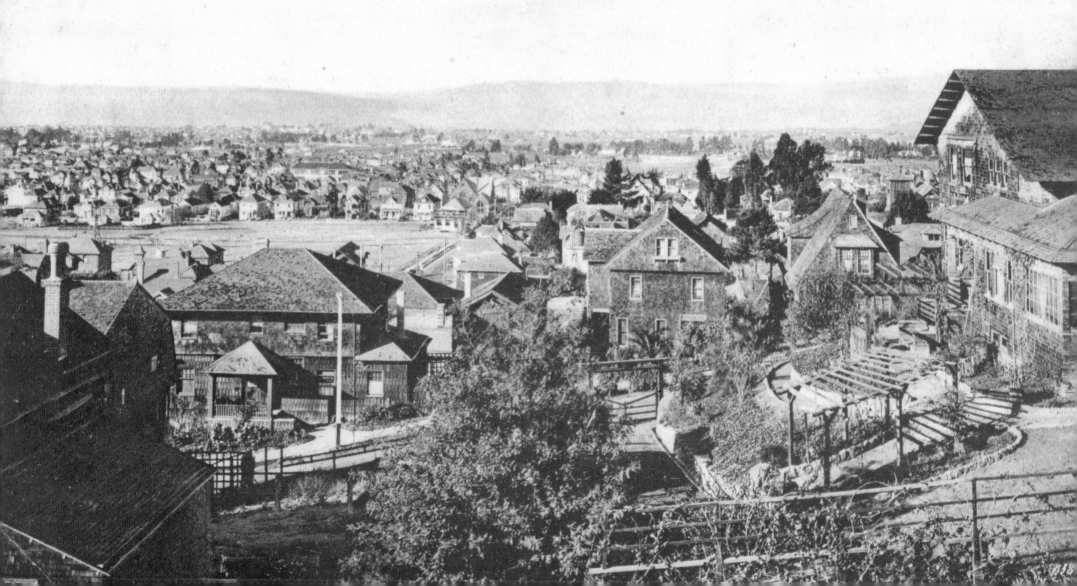

Berkeley, Cal. - Looking towards Golden Gate.

City in Ashes 8

THE FIRST DECADES OF THE TWENTIETH CENTURY SAW A RAPID INCREASE IN THE POPULATION OF BERKELEY. The San Francisco fire-quake sent people rushing to the suburbs, and the state University, growing in student numbers and reputation, offered cultural amenities that were an attraction to many. The residential areas spread beyond the limited area conceived in the Olmsted plan, and feeder streetcar lines pushed development into the foothills. By 1920, two-storied brown-shingle residences covered an area of more than a square mile north of the campus. They were homes of professionals who traveled to San Francisco by train and ferry, professors who walked to the University campus, and students who belonged to fraternal organizations.

On September 17, 1923, the North Berkeley residential community was disrupted. Around two o'clock in the afternoon a grassfire, starting from downed high-tension wires in Wildcat Canyon and propelled by dry northeast winds, swept over the Berkeley hills to the edge of the residential area. Janette Howard Wallace, daughter of John Galen Howard, recalls in her memoirs the intensity of the blaze:

> September 1923 was a very hot dry month. We were living at Rose and Leroy in Berkeley, and for days the north wind had been sweeping down over the hills above us, which at that time were almost empty of houses.…

> Our house was on a steep corner where the street went around uphill; across from us was an empty lot and just beyond that was a house which was in flames.… I remember the garden was on fire, too. The fire swept from the garden across the empty lot and then caught the Schott house, directly across from us on the corner. In twenty minutes it was absolutely flat to the ground while we stood and watched. It was like putting a cardboard box in the fireplace! Then the flames started coming across the street to our house, burning the insulation on the electric wires, right outside the window of my room. The next house, just around the corner, started to catch and Mom said "We'd better get out of here, we're going to be surrounded!"

In less than three hours the fire blackened 130 acres, destroying 584 buildings and seriously damaging 30 others. Most of the destruction was of single-family dwellings, but the flames also consumed 63 apartment buildings; 13 fraternity, sorority, and students' house-clubs; six hotels and boarding houses; four studios and libraries; two schools; one church; and one fire station.

At 4:20 p.m. the northeast wind shifted to the west and its velocity dropped from 33 miles per hour to six. With the wind shift came higher humidity, and, ironically, the weather

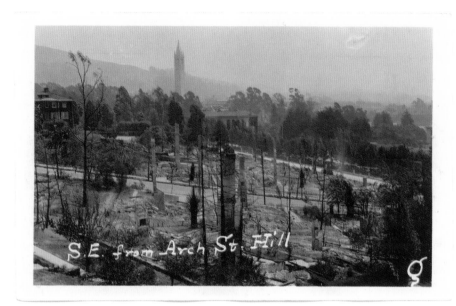

S.E. from Arch St. Hill

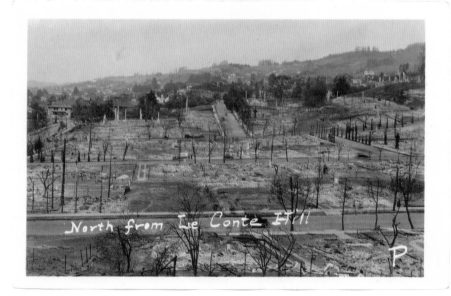

North from Le Conte Hill

change came coincident with the arrival of help from nearby cities.

Also quick to arrive were the photographers, who seized the opportunity of the disaster to take the photos that would soon be made into the postcards that the citizens of Berkeley, victims and nonvictims of the fire's destruction, would send to friends and relatives informing them of their terrifying experiences.

Again Janette Howard recalls:

In the end we did get out fast, with houses burning all around us—a traumatic experience. We got in the Buick and went down Leroy…straight down Euclid Avenue to the campus; Pop [John Galen Howard] was in San Francisco in his office, and Mom figured he would go looking for us at the Ark, as we called it, the Architecture Building…. Talk about refugees, people came pouring down Euclid Avenue with their belongings, thinking that they'd be safe on the campus because it was open. The north wind was blowing the flames and smoke down from the north and it was thought that maybe the Ark was going to go, because it was a shingle building. There was a valuable collection of books there, the Architectural Library that Pop had amassed, so a lot of the students loaded up their arms and went running to get them into a small fireproof building nearby…. Eventually Pop appeared and found us there at the Ark; Mr. Hayes, one of the professors, took us home with him to spend the night, because everything was in such chaos.

The busiest place in town the first night was the information desk at the Hotel Whitecotton (formerly the Shattuck Hotel), which had become sort of a "missing persons bureau." University and city buildings were made available

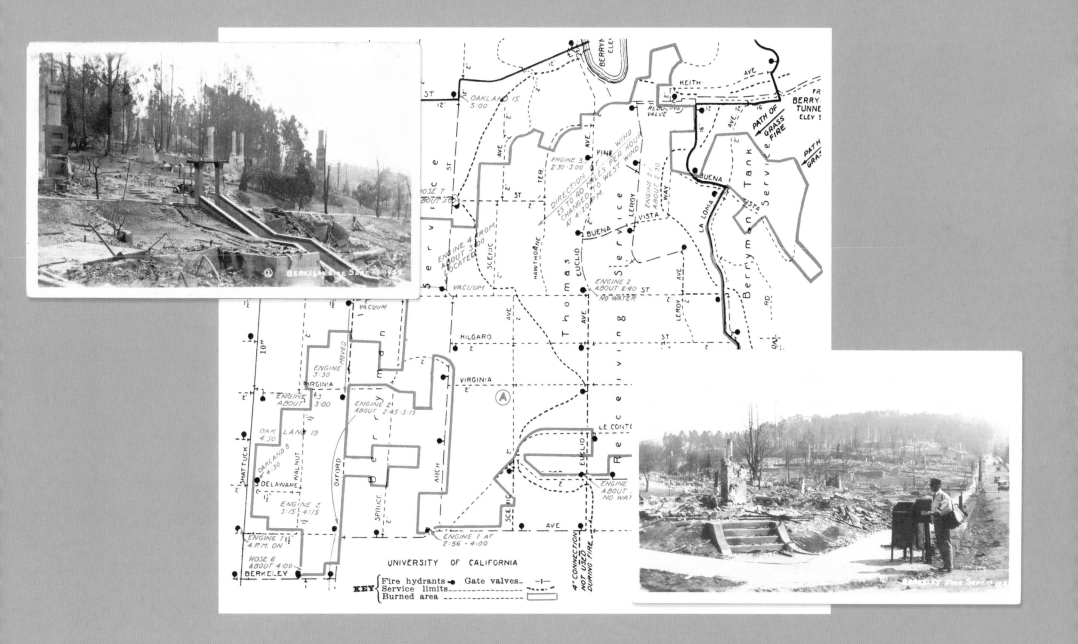

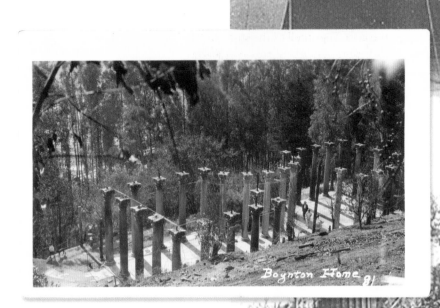

Before the fire, the concrete Corinthian capitals supported a wooden roof that Mrs. Boynton described as "a pair of sheltering wings."

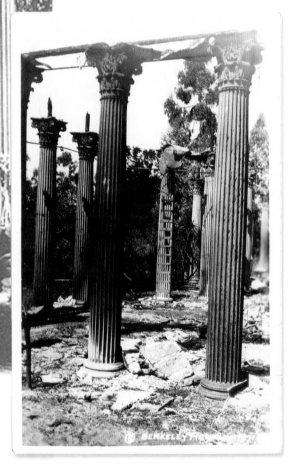

"Boynton Home."
Real-photo postcard.

This view of the Boynton home, "Temple of Wings," shows the site cleared of fire debris and ready for rebuilding.

for overnight shelter. At Stephens Hall, coeds helped search for relatives, and 900 homeless University students were fed. On the top floor, 100 children were cared for until their parents could be located.

All of the household goods which had been saved from the fire were piled in a huge mound at the foot of the Campanile and were guarded by members of the University's R.O.T.C. Those who had lost everything except their lives in the disaster told many stories of kindness and hospitality.

There was partial damage to more than 100 residences not in the direct path of the fire. It was a miracle that not a person was killed, either in the burning homes or in the rush to flee the flames; however, priceless books, antiques, private irreplaceable libraries, heirlooms, and paintings were destroyed. The property losses were conservatively estimated at ten million dollars.

Almost before the ashes had cooled, the survivors of North Berkeley were making plans to rebuild. Instead of wood-shingled frame structures, builders were now considering stucco exteriors and tile or slate roofs. The Howards took up residence in San Francisco, and Janette moved into her sorority house on the south side of campus. She recalls walking past the old neighborhood of the Howard house where she was born and spent her early years, which was now in ashes:

> While I lived in the Alpha Phi house I'd go up to the Gregory's to practice the piano, walking up through the devastation left from the fire. People had moved everything out of their houses as fast as they could, and the gutters were filled with all kinds of things. There were policemen standing with guns because they were afraid of stealing. If you stopped for a minute they came toward you, but I think Pop had gotten a pass permitting me to walk up through the area. The smell of the stuff that had burned, sodden with water (some of it was still smoldering) was dreadful; I can still remember it, and whenever I'm near a conflagration, the smell brings back the whole experience. You drive through north Berkeley now and you'd never think there had been devastation there….

Rehabilitation of the burned area proceeded quickly. Although an estimated 4,000 persons were left homeless, and many were treated for minor burns, the only serious injury was to a freshman who broke his leg.

Only 40 percent of homeowners were covered by insurance. In rebuilding, the architectural character of the area changed from a brown-shingle style to residences and apartment houses designed in the popular Mediterranean style with stucco exteriors and red tile roofs.

—Kenneth H. Cardwell

First-person account from Reminiscences of Janette Howard Wallace (daughter of John Galen Howard and Mary Robertson Howard); manuscript; Bancroft Library, University of California, Berkeley, California, 1986.

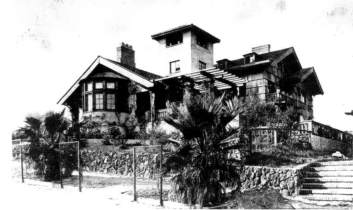

A HOME IN BERKELEY CAL

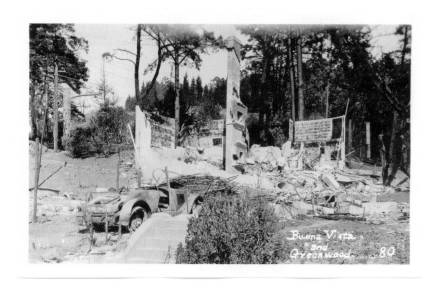

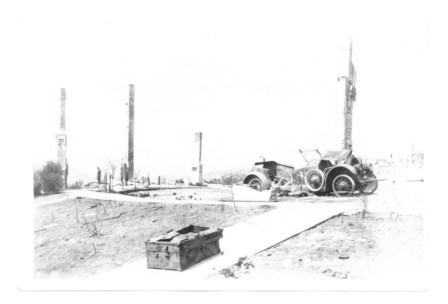

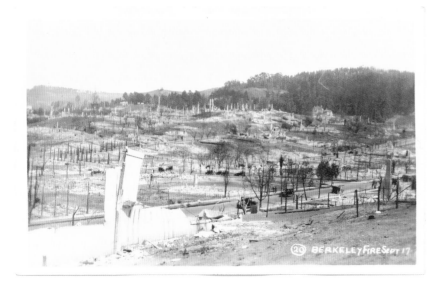

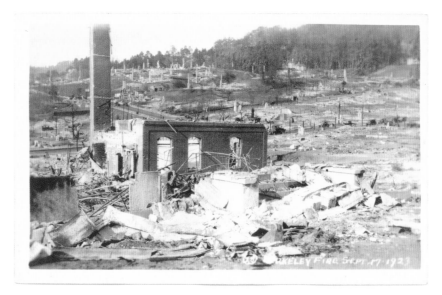

"Buena Vista and Greenwood."
Real-photo postcard.

A view near the northeastern edge of the residential district where the fire destroyed its first houses.

"Berkeley Fire Sept. 17."
Real-photo postcard.

The trunk did not make it to the car, and the car did not escape the flames. Did its owner not know how to drive?

"Berkeley Fire Sept. 17."
Real-photo postcard.

This card and the one to the right make a panoramic view of the northern half of the fire's destruction.

"Berkeley Fire
Sept. 17, 1923."
Real-photo postcard.

Even the masonry walls of this building were no impediment to the flames.

**"Berkeley Fire
Sept. 17, 1923."
Real-photo postcard.**

*The trees that lined the lower
end of Cedar Street were
burned beyond recovery.*

**"Berkeley Fire Sept. 17,
1923."
Real-photo postcard.**

*A card showing the great
amounts of debris that would
have to be removed before
rebuilding could begin.*

**"Fraternity Houses,
Berkeley."
Cardinell-Vincent Co.,
No. 1704.**

*A pre-fire view of a fraternity
house at the corner of Euclid
Avenue and Ridge Road.*

**"Berkeley Fire Sept. 17."
Real-photo postcard.**

*The same fraternity house at
the corner of Euclid Avenue
and Ridge Road after the fire.
The growth of the palm trees
record the interval between
the fire and the card pictured
to the left.*

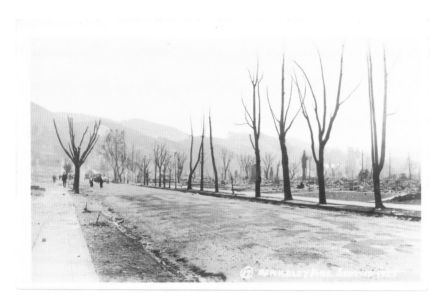

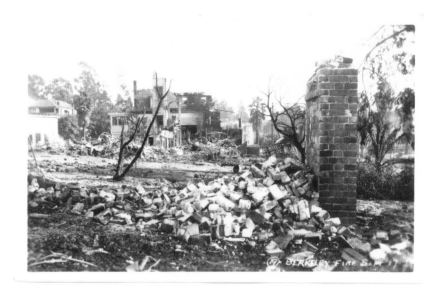

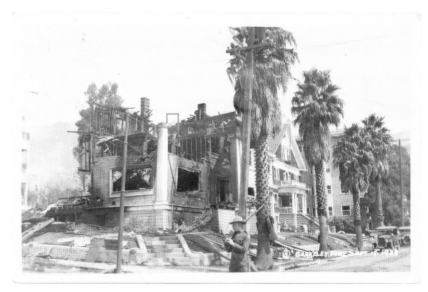

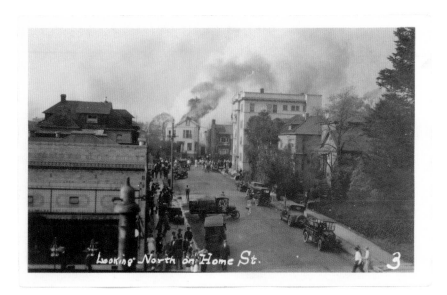

Looking North on Home St.

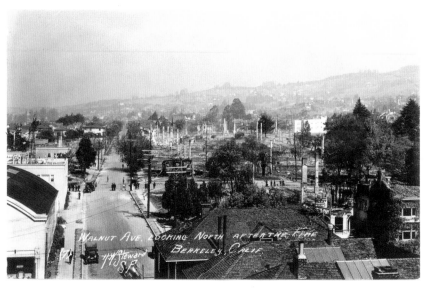

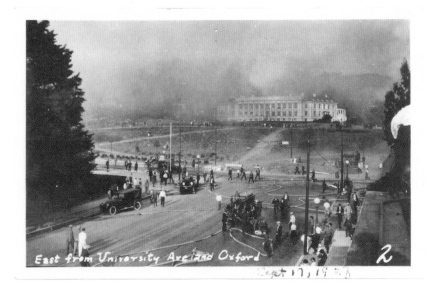

East from University Ave and Oxford

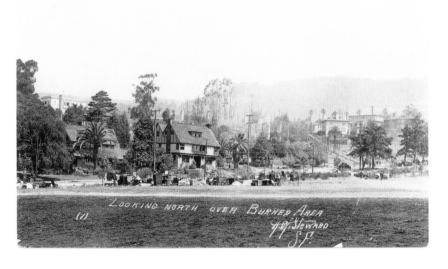

"Looking North on Home St." Real-photo postcard.

A view from University Avenue showing flames threatening the downtown district. Home Street has been renamed as a portion of Walnut Street.

"Walnut Ave. looking North after the Fire, Berkeley, Calif." Real-photo postcard, H. W. Steward, photographer.

Walnut Street, called Avenue on the postcard, became the western edge of the fire.

"East from University Ave. and Oxford." Real-photo postcard.

A photo taken as the fire reached the University campus reveals the obscuring flying ash and smoke.

"Looking north over Burned Area." Real-photo postcard, H. W. Steward, photographer.

A tongue of fire destroyed houses on Hearst Street between those visible on the left and the right sides of this view. Note the household goods gathered on the University campus.

"They have Worked
all night – Berkeley
Holocaust."
Real-photo postcard.

*Note that the photographer,
Wold, had misdated his
photograph.*

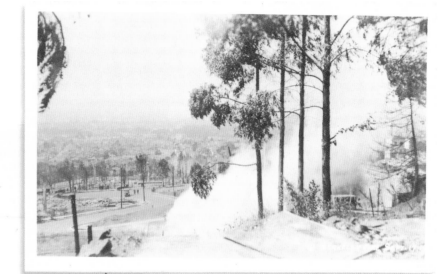

"Berkeley Fire Sept. 17."
Real-photo postcard.

*Dying embers cast smoke
over burned areas through
the night and the following
day. A view from La Loma
Avenue northwest.*

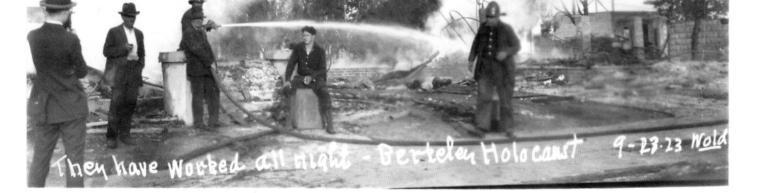

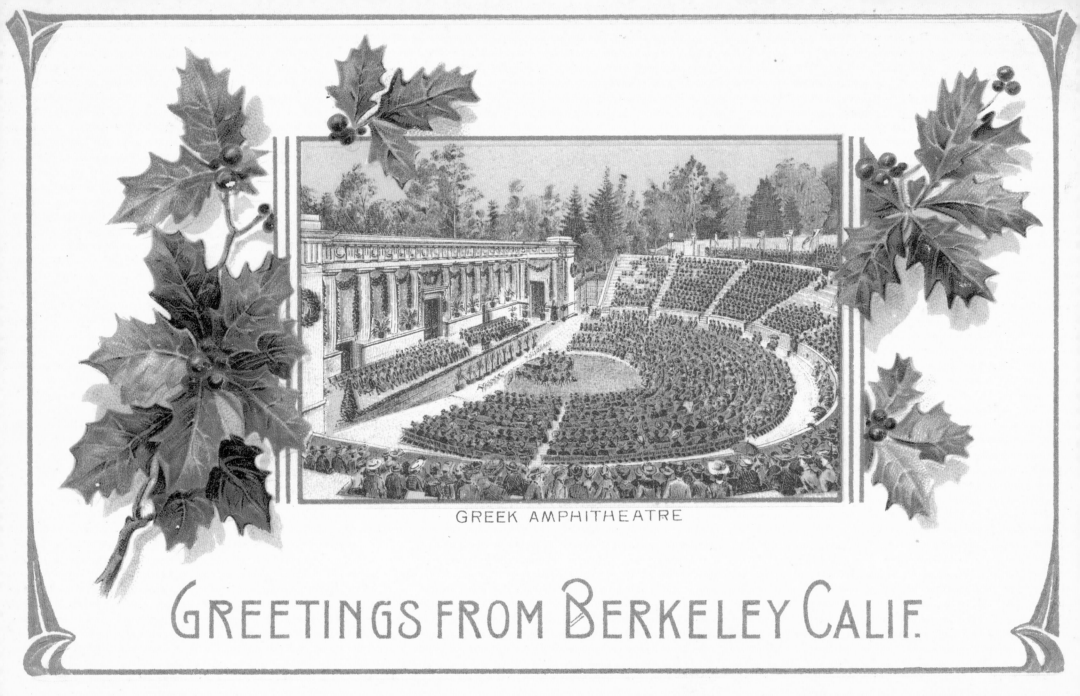

GREEK AMPHITHEATRE

GREETINGS FROM BERKELEY CALIF.

F. E. Sadler, Publisher, Berkeley Calif.

Made in German

Greetings from Berkeley

THE TERM "GREETING" POSTCARDS ENCOMPASSES TWO DISTINCT GROUPS. THE LARGER OF THE TWO COMPRISES cards sent conveying good wishes in connection with holidays or significant personal occasions. The first holiday cards were Christmas cards printed in England in the 1840s. These were not postcards and required an envelope for mailing. Nevertheless, the immense popularity they soon achieved would lead to the greeting postcards of the early twentieth century. Soon after 1900, the general postcard craze and the resulting change in postal regulations, which allowed senders to include a message on the backs of postcards, convinced publishers of greeting cards to adopt an almost exclusive postcard format. This style continued to dominate until the fervor began to subside around 1920. Thereafter, most holiday greeting cards would once again need envelopes for mailing.

The second group of greeting postcards is the "greetings from" type. These were produced in connection with towns, cities, regions, and countries and usually had no connection with holidays.

Berkeley, always striving to be at the vanguard of popular taste, wasted no time in joining in both categories. By 1898, Mitchell (a major San Francisco postcard publisher) was producing "greetings from" cards from San Francisco and many of the popular places in Northern California, including Berkeley. A few years later, Mitchell offered Christmas postcards with vignetted scenes of Berkeley as part of its series of California holiday cards.

By 1910, many local publishers had offered a wide assortment of greeting postcards with a Berkeley connection. The Associated Students' Store at the University of California published an attractive set of cards that juxtaposed scenes of the campus with attractively drawn flowers. School spirit, always ardent at the University, is represented by cards featuring the appropriate pennants and sentiments of the era. The firm of I. Scheff & Bros. of San Francisco, famous for their highly detailed views of the 1906 Earthquake and reconstruction, published at least one lovely "Greetings from Berkeley" card replete with cherubs tucked in between the views.

Competing with the local publishers for their share of the market, several eastern publishers issued versions of their "generic" greeting cards with the name "Berkeley" inserted in the blank spot intended for "any town, USA." While occasionally artistic, these somehow seem an intrusion by outsiders into the world of Berkeley postcards. But these, too, are part of the Berkeley postcard story.

—Ed Herny

"Greetings from Berkeley Calif."
F. E. Sadler.

This masterfully embossed and chromolithographed card from the early part of the undivided back era could be Berkeley's loveliest greeting card.

This series of hand-colored gravure cards was printed by the Albertype Co. of Brooklyn, N.Y. The artistic placement of the colored flowers among the views makes a pleasing combination.

"Eucalyptus Grove, University of California, Berkeley." Associated Students' Store, No. 411.

"Swimming Pool, University of California, Berkeley." Associated Students' Store, No. 410.

"The Library, University of California, Berkeley." Associated Students' Store, No. 415.

"Lovers Lane, Le Conte Oak, University of California, Berkeley." Associated Students' Store, No. 417.

"Foot Ball Statue,
University of California,
Berkeley."
Associated Students'
Store, No. 404.

"Sather Gate, Greetings
from University of
California, Berkeley,
A Merry Christmas
and Happy New Year."
Associated Students'
Store, No. 313.

"Mechanical and
Engineering Building,
University of California,
Berkeley."
Associated Students'
Store, No. 409.

"Hearst Memorial Mining
Building, University of
California, Berkeley."
Associated Students'
Store, No. 419.

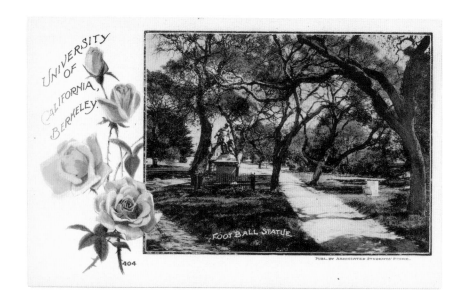

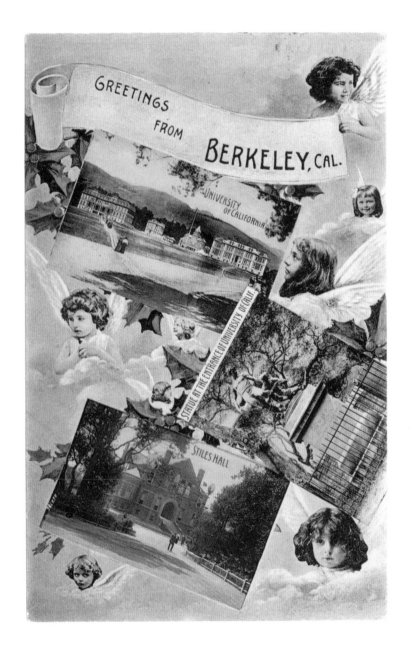

There's Lots of Class at

BERKELEY

U. C. it Everywhere

Welcome to
Berkeley Where

U.C.

The Only Greek Theatre
in America.

"Greetings from
Berkeley, Cal."
I. Scheff and Bros.

*Angel children, mini-views
of Berkeley, and holly are
creatively montaged into
a classic Christmas card.*

"There's Lots of Class
at Berkeley, U.C. it
Everywhere."
Edward H. Mitchell,
No. 1564.

"Welcome to Berkeley
Where U.C. The
Only Greek Theatre
in America."
Edward H. Mitchell,
No. 1565.

*A clever use of blue and gold
pennants as part of the
slogans works well in this
pair of "school spirit" cards.*

"On the Campus,
Berkeley, Cal."
Mark M. Hall.

This card employs the novel design concept of using the outline of a coed with a large hat carrying an art portfolio to define spaces for views of the campus.

"U.C.
Osky Wow Wow!
Whiskey Wee Wee
Oley-Muck-Ei!
Oley-Berkeley-Ei
Cali-Forni-Ei!
Wow!"
Newman Post Card Co.,
No.186.

This caricature of a Cal rooter delivering the famous "Osky Yell" bears the signature "ICK."

ON THE CAMPUS
BERKELEY, CAL. MARK M. HALL, PUBLISHER, S.F.

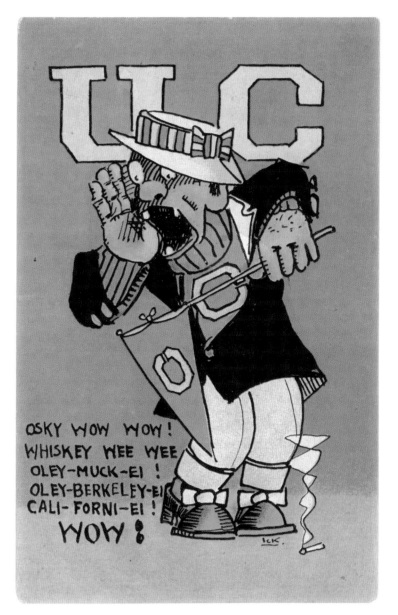

"A Bit of Woodland,
U. of C. Campus,
A Merrie Christmas and
a Happy New Year from
Berkeley, Calif."
Richard Behrendt.

"The Le Conte Oak,
Christmas Greetings
From Berkeley, Calif."
Richard Behrendt.

"Greek Theatre U. of C.
A Merry Christmas
From Berkeley, Calif."
Richard Behrendt.

"First Unitarian Church
Greetings From
Berkeley, Cal."
Glessner, Morse & Geary.

Another series of hand-colored gravure cards, these must have competed with those from the Associated Students' Store—a difficult choice for the Christmas card shopper.

"Greek Theatre, Berkeley,
Best Christmas Wishes
from California."
Edward H. Mitchell.

*A beautifully composed
Christmas greeting, the
reverse side is framed by
a green printed border of
holly leaves and berries.*

"Greetings from
Berkeley, California."

*An unusual card, the words
"Greetings from California"
appear twice, with the word
"Berkeley" apparently over-
printed (and outlined with
glitter) later.*

"Greetings from
California."

*Rendering of the original
card without overprinting.*

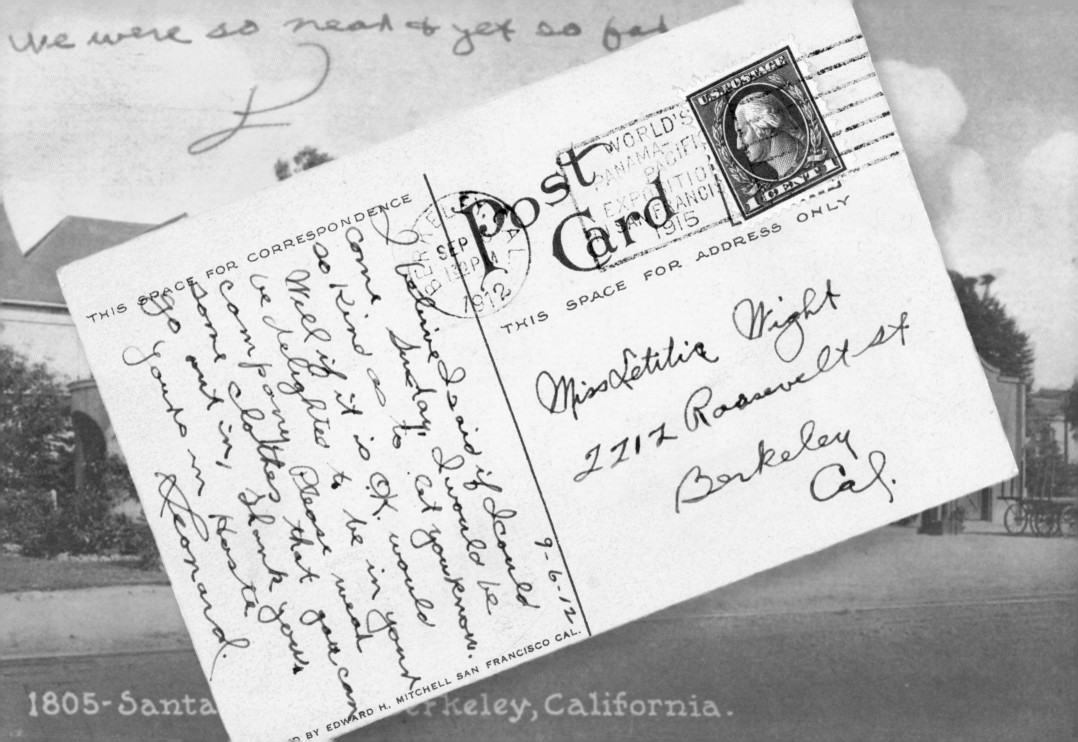

The Other Side

Often overlooked, old postcard messages are a window on the past. We are eavesdropping on correspondence that shuttled between senders and receivers who had no notion that many years later we might be reading what they had to say. There is the student from Berkeley who writes to his father in 1884: "Please open my box of books and send at once by mail the book entitled Loomis's *Analytical Geometry And Calculus*, in one volume...." The card was undoubtedly written with quill pen and ink and is signed formally, "Resp—Jas D. Layman."

Then there is the chilling postcard of the San Francisco Earthquake and Fire as seen from Berkeley. It was sent home to "Dear Mother" from Berkeley on August 16, 1906, just months after the actual event. But the message that works its way around the picture of clouds of smoke is cheerful. "Father started home this morning. Tell him my lamp came alright this morning. I have finished the fixing up of my room. I have so many drawers and such a big closet that I really feel lost...."

On the other side of a real-photo postcard of the Cloyne Court Hotel, signed merely "M," we get a glimpse of a busy academic life that ends with "Last night to hear 'Wm Pitt', Zona Gale's play...extremely interesting...as New England as cod-fish."

Messages from and to a young disabled teenager, a University President, a father traveling by train en route to London, a much-loved and forgotten man who helped found the Arts and Crafts Movement in Berkeley, a principled and courageous African-American woman...we want to know more about them after reading their postcards.

By using old city directories, by viewing library and museum archives, and sometimes by locating descendants or friends, we were able to fill in the missing pieces to recreate the life beyond the handwritten message, giving a larger context to the "moment in time" that each postcard represents.

CHARLES KEELER

At the turn of the twentieth century, Charles Keeler might fairly have been considered Berkeley's leading contender for the title of "Renaissance Man," so broadly ranging were his influences and achievements.

Arriving in Berkeley in 1887, Keeler enrolled in the University in 1889. There he pursued an interest in natural history, particularly evolution. Forced to cut short his student days by the death of his mother in 1891, the promising young man had already initiated lifelong friendships with several eminent professors, including Joseph Le Conte (naturalist/geologist) and George Holmes Howison (philosophy).

He soon secured a position at the California Academy of Sciences in San Francisco, where in 1893 he completed and had

"Santa Fe Depot, Berkeley, California." Edward H. Mitchell, No. 1805, front and back views.

published his first literary work, *Evolution of the Colors of North American Land Birds*. Later on, he would write another bird book, *Bird Notes Afield*, but already his focus was beginning to shift from science to philosophy and idealism. Also in 1893, he met artist William Keith when he bought one of his paintings, and the two remained close friends. By 1894, Keeler's first poetry book (of seven) was published.

By then, he had also met and fallen in love with Louise Mapes Bunnell. The two were true kindred spirits, sharing a passionate love for art and literature, and Louise, an artist in her own right, later designed and illustrated several of his books. They were married in 1893. Two years later, when they were expecting their first child, Keeler's friend and architect Bernard Maybeck designed a home for the young couple in the hills north of the University

This home, where the Keelers would live for the next twelve years, proved an inspiration to Keeler, to Maybeck, and to Berkeleyans generally. Its beauty lay in the simplicity and honesty of its design, and soon other North Berkeley residents, at Keeler's urging, were asking Maybeck to design "simple homes" for them. Keeler continued to promote the cause of "artistic homes and neighborhoods" in Berkeley, and soon the Hillside Club was organized with the same goals. While at first strictly a women's club, after a few years it admitted men to its ranks. Keeler was its president from 1903 to 1905. During this time, he produced what would become his most important book, *The Simple Home*. In this work, he continued to champion Maybeck's ideas of simplicity and "form following

function" in design and to decry architectural pretentiousness and artificiality. Much of the beauty of the neighborhoods of North Berkeley that we see today is the result.

In 1899, Keeler was invited to join the Harriman Expedition to Alaska. He observed and reported on the Alaskan birds, but, perhaps more significantly, he also shared a shipboard cabin with John Muir, which initiated another great and lasting friendship.

Both Charles and Louise were very active in the relief efforts following the Earthquake and Fire of 1906. Louise, never very robust, collapsed while engaged in this work and never recovered, passing away in February of 1907. Charles never completely got over her loss.

In 1911, he embarked on a round-the-world poetry reading tour, where he was well received. He arrived in New York in 1912 and remained there until 1917, when he returned to Berkeley. In 1920, Keeler became managing director of the Berkeley Chamber of Commerce and held this position until 1927.

He married Ormeida Harrison Curtis in 1921 and both were active in the California Writers Club. He wrote *An Epitome of Cosmic Religion* and founded "The First Berkeley Cosmic Society" in 1925. This was an attempt to collect and put into practice all his spiritual ideas. He achieved some success with this, but by 1930 tough economic times had cooled public interest. He died in relative obscurity in 1937, and only the revival of interest in the Arts and Crafts Movement that began in the 1970s has brought appreciation once again to his achievements.

Untitled (House on El Camino Real).
Photo.

This is the "studio home" that Keeler built in 1907 in what is now The Uplands neighborhood of Berkeley.

Clockwise from top:
Untitled.
Real-photo postcard, front and back views.

This postcard of Charles Keeler and two Japanese friends was sent from Tokyo to Berkeley to his daughter Merodine who was then (1911) 15 years old. At the time, Keeler was in the middle of a round-the-world poetry reading tour.

Untitled.
Photo.

Charles and Louise Keeler, circa 1895.

Untitled.
Photo, courtesy of the Bancroft Library, University of California, Berkeley.

Two of Charles Keeler's children, Eloise and Leonarde, pose with their grandmother Catherine Tylie Bunnel (Mrs. James) in front of 2727 Dwight Way in 1912.

Mitsukosi

POST CARD.
COMMUNICATION. | ADDRESS.

Tokyo, Sept. 29 1911
Dearest Merodine :—
Greetings to
you and the dear babies
and all. Here I am
with some of my
new-found friends
who have been so
kind to me. Father

Miss Merodine
2727 Dwight
Berkeley, C

To Dean & Mrs Hurst: Kindliest cheer for the [tower]

Christmas days and much comfortable blessing within your gates. This is the desire of our hearts toward you in memory of much cheer and encouragement and help which you have given us.

Benj. I. & Amey W. Wheeler

BENJAMIN IDE WHEELER

The choice of this real-photo postcard (facing page) for a Christmas message is not so surprising when one realizes that the sender was Benjamin Ide Wheeler, President of the University from 1899–1919. We can imagine him at his mahogany writing desk, fountain pen in hand, glancing at the view from an upstairs window at the President's House. It is the same view seen on the postcard. There is no postmark on the card, which means it was probably mailed in an envelope, circa 1915, or hand-delivered by messenger to Dean Thomas Forsythe and Mrs. Hunt. They lived a few blocks away at 1802 Le Roy Avenue.

Benjamin Ide Wheeler was born in Randolph, Massachusetts, in 1854. He was a promising Greek scholar at Brown University, where he met and married Amey Webb. After receiving his doctorate *summa cum laude* from Heidelberg, Germany, in 1885, he returned to America as professor of Greek and Latin at Harvard and later Cornell.

In 1899, Amey and Benjamin Ide Wheeler moved to Berkeley, where he accepted the position as President of the University. His twenty-year tenure there saw the transformation of a small, undistinguished University to a modern, professional, research-based institution of several thousand students. He brought dozens of world-renowned faculty to the University.

Wheeler was very popular with the students. He treated them as adults, allowing them to govern themselves. Under his leadership, students could investigate student conduct violations, propose regulations, and elect their own government. President and Mrs. Wheeler and their son Benjamin Webb Wheeler were devoted fans of the Cal football team and attended games regularly.

Benjamin Ide Wheeler retired on his 65th birthday in 1919. He died in 1927.

SOME LAOS PATIENTS,

OF

DR. C. H. DENMAN,

HOMEOPATHIC PHYSICIAN, NOW LOCATED AT
2220 BANCROFT WAY, BERKELEY.

OFFICE HOURS 9-10; 2-4; 7-8 PHONE BERKELEY 4550

Samuel A. Pinkerton,

1931 Berryman St,

Berkeley,

Calif.

RES J. A. PINKERTON
BERKELEY, CAL.

Clockwise from left:

"Some Laos patients
of Dr. C.H. Denman."
Real-photo postcard,
front and back views.

Untitled.
Photo.

*The Pinkerton Family, 1903.
From left: Hazel, James,
Ruth, Grace, Mrs. Reeves
(Ada's mother), Anna Belle
Reeves, Ada Pinkerton, and
son Samuel.*

"Res. [Residence]
J. A. Pinkerton,
Berkely [sic]. Cal."
Real-photo postcard.

*This 1910 card shows their
large barn at far right.
James Pinkerton died in
1940, but his wife Ada
remained in the house until
her death in the 1960s.*

THE JAMES PINKERTON FAMILY

The rare and unusual postcard of Dr. Denman's Laotian patients was received in 1907 by fourteen-year-old Samuel A. Pinkerton. He undoubtedly shared it with his sisters Ruth, Hazel, and Grace, brother Edgar, and his parents Ada and James Pinkerton, all of whom were then living at the family home at 1931 Berryman Street.

Born in McCoy, Nebraska, in 1893, young Samuel Pinkerton developed tuberculosis of the bone from drinking unpasturized milk. His parents brought him to Shriner's Hospital in San Francisco, where he received the country's best care for the disease. After more than a year in the hospital, he recovered with only some bone loss in one leg.

By 1903, the family had settled in Berkeley, where they lived in a "temporary" small house while James Pinkerton built a more substantial one at 1931 Berryman Street. He also built a large barn on the property where he kept his building materials and a buggy and a wagon. The horses for pulling the wagon were older government horses…they had USA brands on their rumps!

James Pinkerton built many family houses on Milvia, Addison, Delaware, and Prince streets. At first he used standard blueprints for the styles then popular. After the 1906 San Francisco Earthquake and Fire, he was in great demand by the notable architects of Berkeley. The Kerr House (1907), now a fraternity at 2421 Prospect Avenue, was designed by George Plowman and John Hudson Thomas. Pinkerton was chosen to be the builder. The house stands today as a reminder of a man who came West to save his son's life and stayed to shape Berkeley's architectural heritage.

Untitled.
Photo.

*The Pinkerton family enjoys
one of Berkeley's first auto-
mobiles. James is driving.*

Untitled (Berry picking).
Photo.

*From left: a neighbor, Ada
Pinkerton, Mrs. Reeves, a
neighbor, Anna Belle Reeves.*

Oct 9, 1920

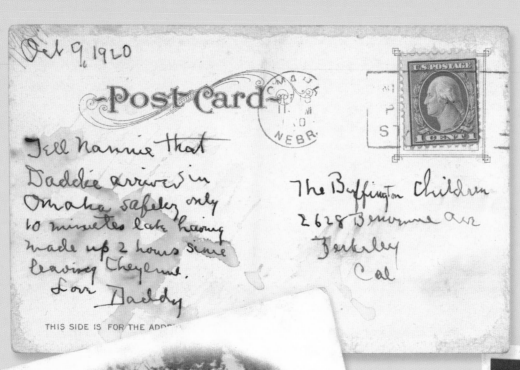

Post Card

Tell Nannie that
Daddie arrived in
Omaha safely only
10 minutes late having
made up 2 hours since
leaving Cheyenne.
For Daddy

The Buffington Children
2628 Benvenue Ave
Berkeley
Cal

THIS SIDE IS FOR THE ADDRESS

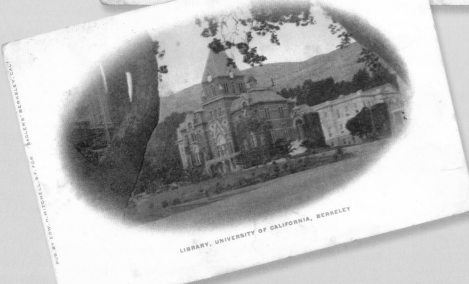

PUB. BY EDW. H. MITCHELL, S.F. FOR SADLER'S, BERKELEY, CAL.

LIBRARY, UNIVERSITY OF CALIFORNIA, BERKELEY

THE BUFFINGTON CHILDREN

The "Daddy" who sent this thoughtful postcard, just two days away from home, was one Charles L. Rhodes, an attorney for the Eastern Viavi Company in San Francisco. He was enroute to London on business, a three-week trip by train and ship. Many more postcards would follow to the family left at home: his wife Mary A. Rhodes ("Nannie") and the Buffington children: Mary Ann, age eight; Charlotte, six; and the twins, Bianca and Gene, who were four.

Mr. and Mrs. Rhodes had met years before in Honolulu at the time of the annexation of Hawaii as an American Territory. They had witnessed the changeover of the royal Iolani Palace and even purchased some of its furnishings at auction. Mr. Rhodes was the City Editor of the *Hawaiian Star*, and Mrs. Rhodes was the proprietress of a curio shop specializing in arts and crafts of Hawaii and the South Pacific. Mr. Rhodes was a regular guest at her boarding house, and in 1901 the couple were married.

By 1909, the couple had returned to San Francisco, and Mr. Rhodes accepted the position with the Viavi Company. Three years later Mr. and Mrs. Rhodes purchased the large brown-shingle home at 2628 Benvenue Avenue in Berkeley, directly across the street from the residence of John Weston Havens, heir to the Shattuck real estate trust.

In 1919, their lives changed greatly when they opened their home to Mrs. Rhodes' grandchildren. Mr. and Mrs. Rhodes were nearing sixty years of age but, nevertheless, happily assumed the responsibility for the four Buffington children.

The Buffington children and their grandparents continued to live at 2628 Benvenue Avenue for many years. Mrs. Rhodes died in 1942. Her portrait sat on the top of Mr. Rhodes' dresser in an ornate brass frame. When Mrs. Rhodes' favorite Algerian irises were in bloom, the thoughtful widower always had a bouquet of them placed beside it. Mr. Rhodes died in 1954 at age 93.

Buck Meadow

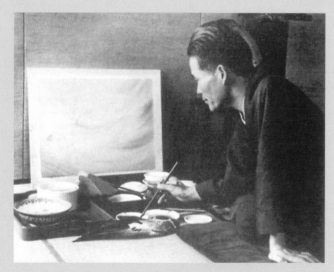

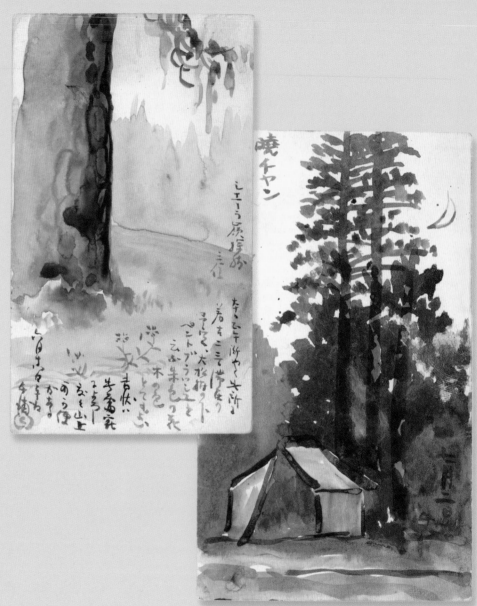

CHIURA OBATA

The hand-painted watercolor postcards that noted artist Chiura Obata sent to his wife Haruko are one-of-a-kind. Painted during his first summer in Yosemite, 1927, they were personal messages and were never commercially printed.

Chiura Obata was already a talented artist when he emigrated from Japan in 1903. By 1921, he had helped to found the East West Art Society, whose goal was the artistic synthesis of two traditons: Eastern reverence for nature and expressiveness with Western realism. Obata developed a reputation as a modernist artist in California, as well as in Japan, with works that showed how water-based painting could equal oil painting in freshness and execution. This approach found resonance with the group of artists who came to be known as the California Watercolor School in the 1930s.

In 1932, he joined the University of California, Berkeley, art faculty, but his work there was interrupted ten years later, at the height of his popularity, by his internment during World War II. After his release, Obata resumed his teaching duties and purchased a small stucco house on a quiet street in Berkeley's Elmwood district. His family continued to live there after Obata retired from the University in 1954.

Haruko, his wife, also made a name for herself in the arts and crafts movement. She taught Ikebana in Berkeley for decades, reaching thousands and earning a renown rare for a Japanese woman in California at that time.

Both Chiura and Haruko Obata received awards from the Emperor of Japan for their lifetime of work promoting good will between the United States and Japan. Chiura Obata died at age 90 in 1975. Haruko continued to teach Ikebana, offering demonstrations of her art until her death in 1989 at age 94.

"Sather Gate at Dusk,
1939."
Berkeley Historical
Society. Artwork by
Chiura Obata.

12/2/78

FOUR STUDIES OF A NEGRO'S HEAD
Peter Paul Rubens (1577–1640)
25.4 x 64.8 cm.
THE J. PAUL GETTY MUSEUM, Malibu, California

THE LAND OF THE FREE · THE HOME OF THE BRAVE
USA 15¢

Dear Erma:
Envelope read & donation
sent off.
 We journeyed up here today
in 2 buses. Have an hour til
bus leaves at 4 P.M. for Chinatown
& dinner. We don't get home til
midnight! It's a long, long day,
but a beautiful one — lovely warm
weather, beautiful objects of art,
architecture, gardens and paintings.
 Good to talk to you & Lonnie
know you are loved.
 Chris

Erma Harris
2312 Sacramento St
Berkeley
Calif. 94702

ERNA P. HARRIS

The recipient of this postcard at 2312 Sacramento Street was one of Berkeley's treasures. Tiny, charismatic, erudite, and witty, Erna Prather Harris dedicated her life to the struggle for peace and justice. She lived the last four decades of her life in Berkeley.

Harris was born in Kingfisher, Oklahoma, in 1908. Her parents followed Gandhi's principles of nonviolence—a

stance that was unusual and very courageous at a time when lynchings were still a reality—and their example greatly influenced Harris' thinking about nonviolence as the way to achieve political and social goals.

She eagerly left segregated Oklahoma to attend Wichita [now Wichita State] University, where she was the first African-American to graduate with a degree in journalism. Because she graduated during the Depression, when jobs were scarce, she started her own newspaper, *The Kansas Journal*, which she published for three years until her unpopular opinions about a possible draft scared off her advertisers.

In 1941, Harris moved to Los Angeles where she worked for the *Los Angeles Tribune*. She was an outspoken critic of Japanese internment and an advocate of an open immigration policy for Jewish refugees in Europe. She joined CORE (Congress of Racial Equality) and the War Resisters League, and spent time visiting wartime conscientious objectors, who at that time were sent to work camps.

She moved to Berkeley in 1952 and opened a print and copy shop. She was attracted to the area by the Pacifica radio station KPFA, founded in 1949 by fellow pacifists, and by the Consumers Cooperative of Berkeley. She became involved with the Berkeley Co-op Market, eventually becoming a board member, and helped to found U.A. [University Avenue] Housing, an organization dedicated to affordable co-op housing.

Her passion, however, was the Women's International League for Peace and Freedom, the venerable peace and social justice organization founded by Jane Addams. She served on the national board, and was a delegate to WILPF Congresses in England, the Netherlands, India, and even the Soviet Union (during the height of the Cold War in 1964).

Harris loved music, the theater, and language in all of its forms. For many years she attended an Esperanto summer class at San Francisco State, seeing Esperanto as yet another building block for world peace. In 1978, Harris was rewarded for her lifetime of community and public service with an honorary doctorate from the Black Studies Department of the Graduate Theological Union in Berkeley.

Erna P. Harris died in Berkeley in 1996. The U.A. housing complex at 1330 University Avenue was named in her honor.

—Burl Willes

Untitled.
Photo.

*Harris and members of
the WILPF delegation listen
to an unidentified speaker
at the Soviet-American
Women's Conference in
1964. Madame Khrushchev
was also in attendance.*

POSTAL CARD.

NOTHING BUT THE ADDRESS CAN BE PLACED ON THIS SIDE.

BERKELEY
FEB 18 188
CAL.

U.S. POSTAGE
ONE CENT

Mr. John F. Layman,
Cloverdale.

Berkeley, Cal., Mon. Feb. 18-'84.
Dear Father,— Please open my box of books and send me at once by mail the book entitled Loomis's Analytical Geometry and Calculus, in one volume. The postage will be 15 or 20 cts.
Resp— Jas. O. Layman.

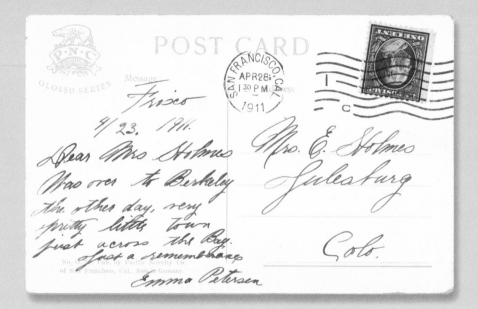

POST CARD

P·N·C
GLOSSO SERIES Message

SAN FRANCISCO, CAL.
APR 28
1 30 P M
1911

Frisco
4/23. 1911.
Dear Mrs Holmes
Was over to Berkeley
the other day, very
pretty little town
just across the Bay.
Just a remembrance
Emma Petersen

No. O. Pub. by Pacific Novelty Co.
of San Francisco, Cal. Made in Germany.

Mrs. E. Holmes
Julesburg

Colo.

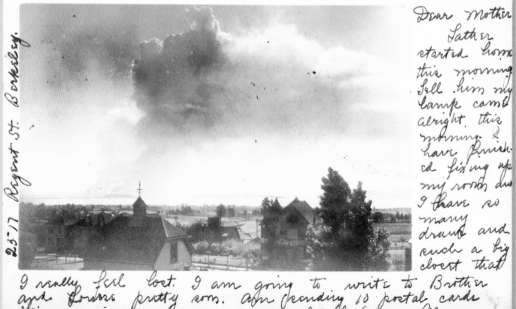

23-17 Regent St. Berkeley.

Dear Mother
Father started home
this morning. Tell him my
lamp came alright. this
morning & have finished fixing up
my room & I have so
many drawers and such a big
closet that I really feel lost. I am going to write to Brother
and Louise pretty soon. am sending 10 postal cards
this morning. With lots of love. Lilian.

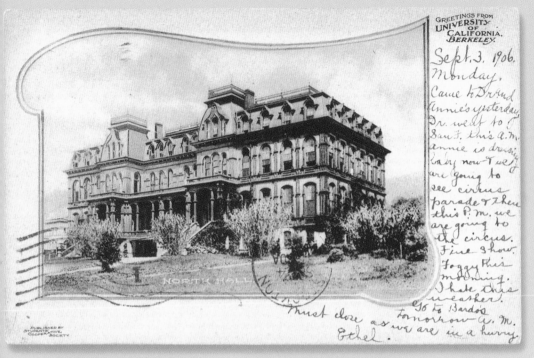

GREETINGS FROM
UNIVERSITY
OF
CALIFORNIA.
BERKELEY.

NORTH HALL

Sept. 3. 1906.
Monday.
Came to Friend
Annie's yesterday
Dr. went to
San F. this a.m.
Annie is dressing
baby now & we
are going to
see circus
parade & then
this P.M. we
are going to
the circus.
Fine show.
Foggy this
morning.
I hate this
weather.
Go to Bardo's
tomorrow A. M.
Must close as we are in a hurry.
Ethel.

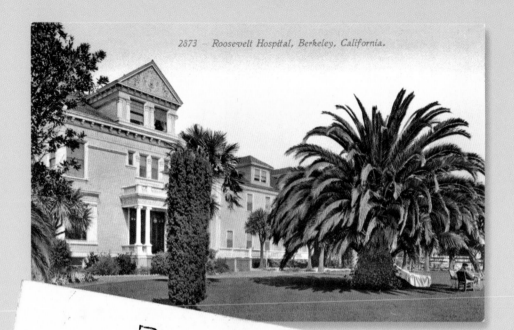

2873 - Roosevelt Hospital, Berkeley, California.

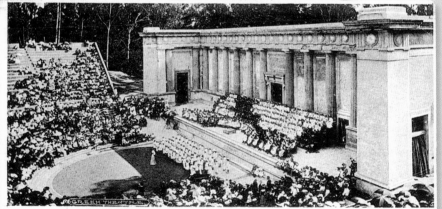

GREETINGS FROM
UNIVERSITY
OF
CALIFORNIA.
BERKELEY.

GREEN THEATRE

Sep7. 22.
Dear Sister-
 I am all to the merry. Do
Not expect me till 7 or 8 P.M. Sat.
Herb was over last night. Bill.

POST CARD
CORRESPONDENCE HERE FOR ADDRESS ONLY

BERKELEY
FEB 18
11-AM
19 08
CAL.

2

Dear Lois:
 Etta is
still on night duty
&I am on special.
We will be up soon.
Etta sends her
love. From Myrtle,

Miss Lois Shafer,
2815 Woolsey St.,
Berkeley,
California

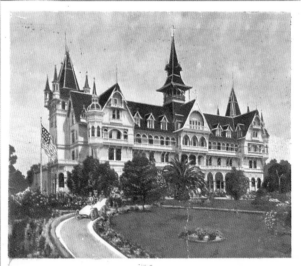

SAINT JOSEPH'S ACADEMY
Peralta Park, Berkeley
California

FOUNDED in Oakland — 1870. Transferred to Berkeley — 1903. Select Boarding School for Boys under Fifteen Years conducted by the Christian Brothers. The only school—of its kind in the West. Number of students limited to one hundred fifty. Forty-five minutes' ride from San Francisco. One mile from University of California. Unsurpassed climate. Ideal location. Extensive grounds—twenty acres. Commodious buildings. Beautiful gardens. Ten school grades. Vocal and Instrumental Music. German, French and Spanish classes. Complete Gymnasium. Physical culture. Matrons to help care for smaller boys. Home comforts. Visitors always welcome. Terms moderate, Students received any time during the year. Send for circular

U.S. POSTAGE
1 CENT

CORRESPONDENCE

Dear Friend Johnie.
I wish you were here. I am sending a picture of the School. I sent one also to your sister.
Your friend
George Palmer

Master J. T. Seitz
Benica
Calif

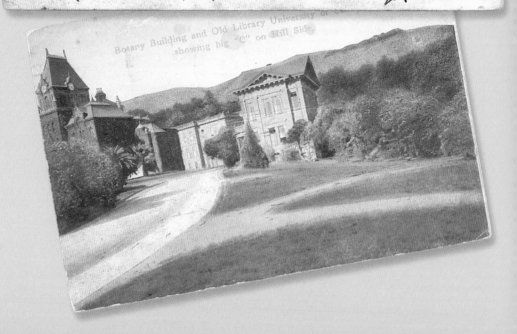

POST CARD

COMMUNICATION

ADDRESS ONLY

Place Stamp Here Domestic One Cent. Foreign Two Cents.

SOUTH BERKELEY STATION

SEP 1
5 PM
1927
CAL.

1535 Oregon St.
Berkeley, Calif.

Mr. & Mrs. Maeda.
2634 Sutter st,
San Francisco,
Calif.

Botany Building and Old Library University of California, showing big "C" on Hill Side.

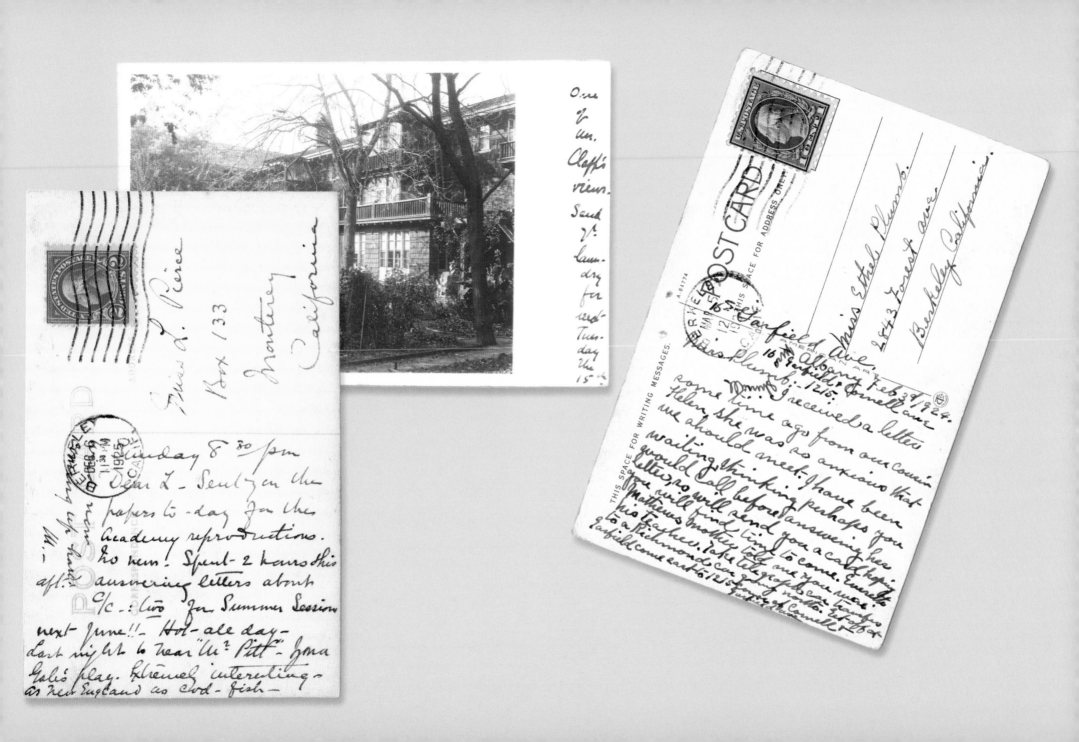

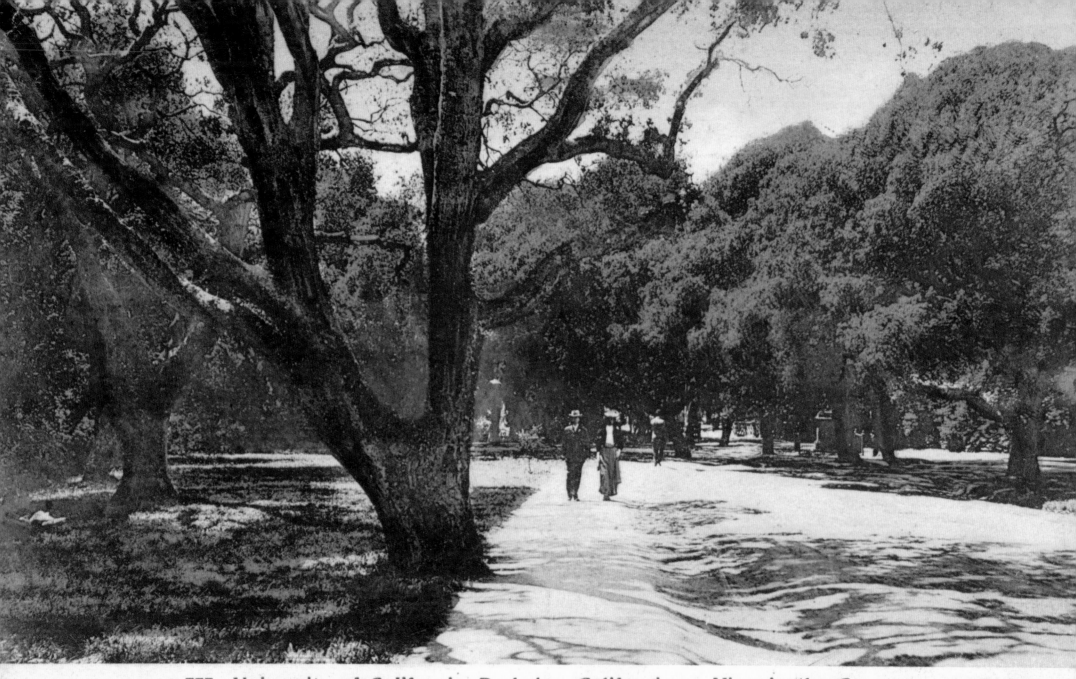

777 University of California, Berkeley, California — View in the Campus.

THERE WERE APPROXIMATELY 2,000 DIFFERENT PICTURE POSTCARDS OF BERKELEY PUBLISHED BETWEEN 1898 and 1960. At least 50 publishers, local and national, small-time operators to big corporations, contributed to this impressive output. Some published a large variety of different subjects and places, with just a few cards of Berkeley. Others were local outfits that published Berkeley cards exclusively. Below is a description of those considered most significant in the history of Berkeley postcard publishing.

N. J. Abbott & Son. Berkeley, California

Mrs. Nellie J. Abbot and her son Clyde ran a combination book and stationery store in downtown Berkeley for at least 15 years starting around 1890. Their address changed frequently, but they stayed in the same close vicinity in the Center Street-Shattuck Avenue-Allston Way area. They produced at least 30 gravure-printed cards of Berkeley.

The Albertype Co. Brooklyn, New York

The Albertype Co. was famous for its high-quality gravure-printed cards. A huge company, they produced postcards for thousands of different communities in America. The company not only published and printed its own cards, of which about 40 are of Berkeley, but also printed cards for other publishers.

"University of California, Berkeley, California—View in the Campus." Cardinell-Vincent Co., No. 777.

This romantic spot beneath the oaks is called "Lover's Lane" on some of the postcards.

Armitage Photo. Berkeley, California

Percy C. Armitage was a local photographer who published real-photo cards under his own name beginning about 1909, and later as one of the partners in A. & W. Photo Co. At least 40 cards are known, and their photo quality is very clear and detailed.

Richard Behrendt. San Francisco, California

Behrendt published more than 30 Berkeley postcards. Most were high-quality hand-colored gravures. He also published attractive cards of many other towns in northern California.

Cardinell-Vincent Co. San Francisco, California

Cardinell-Vincent, a major San Francisco publisher, issued at least 60 Berkeley cards. They received the concession to be the official photographers of the Panama-Pacific International Exposition in San Francisco in 1915.

Glessner, Morse & Geary. Berkeley, California

A local bookstore and publisher, all of their postcards were real-photos of Berkeley. At least 20 are known, and they are noted for their views of U.C. sports and spirit activities. They began in 1908 as Glessner-Morse (H. H. Glessner was a school principal in Berkeley). In 1912, G. C. Geary joined the partnership and the "Glessner, Morse & Geary" imprint that we find

on the backs of most of these cards first appeared. In 1913, the name changed again, this time to Glessner and Geary, Inc.

Edward H. Mitchell. San Francisco, California

By far the largest of the San Francisco postcard publishers, they published at least 200 Berkeley cards, starting in the Private Mailing Card era and lasting into the White Border Era. Mitchell purchased and absorbed other postcard publishing companies and produced close to 50,000 different postcards. Among their most attractive Berkeley cards are a vignetted series that they printed for Sadler's.

Pacific Novelty Co. San Francisco, California

This company gave Mitchell serious competition, publishing over 160 Berkeley cards. They employed a large variety of different printing techniques.

Pillsbury Picture Co. San Francisco, Oakland, and Berkeley, California

A. C. Pillsbury, a photographer since the 1890s, began publishing real-photo postcards in 1906. By the 1920s, he had published at least 2,000 different real-photo cards, mostly of California. He is most noted for his views of Yosemite, Tahoe, Monterey, the Great White Fleet visit in 1908, the Panama-Pacific Exposition, the 1906 San Francisco Earthquake and the rebuilding of downtown San Francisco afterward. He published about 20 real-photo and 9 printed cards of Berkeley.

Mike Roberts Color Production. Berkeley, California

This company published at least 186 Berkeley postcards, all of them "chromes." Starting out in the 1940s on Allston Way, the company still publishes postcards at another location close by. Mike Roberts pioneered the color chrome process that soon became the most popular printing process for postcards.

F. E. Sadler. Berkeley, California

Another local stationer and bookseller, Frank E. Sadler published at least 21 Berkeley cards, including an attractive series of vignetted views that were printed by Edward H. Mitchell. His address is recorded on Center Street in Berkeley starting in 1903. The store moved to Dwight Way in 1909 and to Telegraph Avenue in 1911 where it continued for several more years.

Students Cooperative Society, later Associated Students. Berkeley, California

The largest group of Berkeley cards was published by the student body of the University of California. At least 260 cards are known, all of them gravures. The earliest ones were printed during the Undivided Back era and the later ones during the White Border era, and nearly all were printed by the Albertype Company. The Students' Co-op was located in North Hall on the U.C. Berkeley campus for many years. The name eventually changed to Associated Students.

"It Is No Crime to Kiss, in Berkeley, Cal."

THE PRESENCE OF AN INDIGENOUS POPULATION IN THE AREA THAT WAS TO BECOME BERKELEY IS EVIDENCED by shell mounds and burials in the vicinity of University Avenue and Second Street and in Emeryville, which were excavated in 1902. Impressions made by mortars and pestles during the grinding of acorns are found in some stone outcroppings in the Berkeley Hills.

The first European exploration occured on March 27, 1772, when Lieutenant Pedro Fages of the Spanish army and Padre Juan Crespi, a Franciscan missionary, camped next to Strawberry Creek while attempting to find a way around the bay by land.

In 1820, the King of Spain gave a large land grant to Don Luis Maria Peralta that is now Alameda County. In the early 1840s, Don Luis gave his son Jose Domingo Peralta the northern portion that would become Berkeley. By the early 1850s, after California had become part of the United States, Peralta began to sell off his land.

The area closest to the bay shore was first settled in 1853 by James Jacobs and William J. Bowen who, respectively, opened a wharf and an inn. The community which grew up between the wharf and inn, along Delaware Street, was called Ocean View. The hills were used as pasture, and central Berkeley was dotted with farms.

The future site of the University of California was chosen in 1860 by its predecessor, the College of California. The college engaged Frederick Law Olmsted in 1864 to design a plan for its new campus and a residential neighborhood. The campus and its surrounding neighborhood were named Berkeley in 1866, in honor of George Berkeley, Bishop of Cloyne, Ireland, who came to America early in the eighteenth century for the purpose of establishing colleges.

A State University was chartered in 1868, and that same year the College of California deeded their Berkeley campus and Oakland facilities to the newly chartered University. Classes were first held on the Berkeley campus in 1873.

Transportation played a big role in the settlement of the Bay Area. The transcontinental railroad was opened in 1869, and by 1876 a spur line was laid along Shattuck Avenue, establishing the location of downtown. With the promise of convenient transportation and an increasing population, the towns of Berkeley and Ocean View incorporated as Berkeley in 1878.

During the 1880s and 1890s, farms began to disappear as tracts of land along the rail lines and newly established streetcar lines were subdivided and developed as commuter suburbs for Oakland and San Francisco. In 1890, the population of Berkeley was 5,000 and in 1900, 13,000. After the 1906 San Francisco Earthquake and Fire, the population swelled, growing to

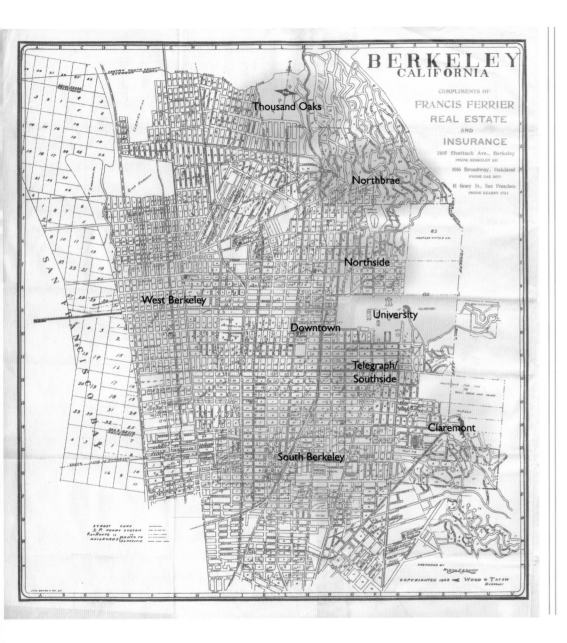

"Berkeley, California."
Wood & Tatum.

Shaded color and district names have been added to this 1909 map in order to show the location of the University and some of Berkeley's neighborhoods. Note that most of the tidelands have been filled in since 1909 to create the Berkeley Marina and other areas east of the railroad tracks.

42,000 by 1910, and to nearly 60,000 by 1915. The growth in population stimulated both economic and social development.

Between 1902–1927, with the support of philanthropists such as Phoebe Apperson Hearst and Jane Sather, and under the supervision of architect John Galen Howard, elegant Beaux Arts styled academic buildings were built on the campus.

On September 17, 1923, a devastating wildfire raged through the North Berkeley Hills destroying approximately 500 buildings. In response, voters approved the public water district, and in 1930 water from the Mokelumne River in the Sierra Nevada flowed into San Pablo Reservoir.

Other significant events in Berkeley's history include the 1933 Regional Park District Act passed by the State Legislature and the 1966 bond issue to underground the Bay Area Rapid Transit (BART) lines through Berkeley. The 1989 Loma Prieta Earthquake caused major damage around the Bay Area, but Berkeley escaped with minor damage. In 1991, the Oakland-Berkeley Hills Firestorm destroyed approximately 3,000 buildings, 65 of them within the city limits of Berkeley.

A city that contains only 11 square miles, with a population of 102,500, Berkeley today offers museums, galleries, libraries, botanical gardens, theater and musical events, more movie screens than any mall, world-famous restaurants, bookstores, and, best of all, hidden winding streets lined with artistic homes, oak-covered creeks, lush parks, a network of hillside paths and stairways, and exquisite bay views.

—Susan Dinkelspiel Cerny

ACKNOWLEDGMENTS

Many people made this endeavor a reality and a pleasure, but first and foremost is Ken Cardwell. His encouragement and help as well as his contribution to the text and design are much appreciated. In addition, Ken scanned all the color images in the book.

Susan Cerny, writer and lecturer on Berkeley history and architecture, kept us going with her good humor and expertise. Anthony Bruce's encyclopedic knowledge of Berkeley's past made each caption a vignette of history. Many of the postcards and ephemera were graciously loaned from his private collection.

We could never have found a better person than Ed Herny to write "The History of the Picture Postcard." Ed also contributed the Charles Keeler biography in "The Other Side" and let us use his postcards.

Sarah Wikander's nonpareil Berkeley postcard collection made this book possible. Sarah also put in hundreds of hours sorting, cataloging, and selecting cards for the project. Her comments and suggestions were always helpful.

Many people allowed us to use photographs and postcards from their private collections. We offer special thanks to Jane FitzGibbon; Norma Grey and Father Crespin, St. Joseph the Worker's Church; Asline Jones and the Reverend Dr. D. Mark Wilson, McGee Avenue Baptist Church; Bart White; Dean Yabuki; Kimi Kodani Hill; Lesley Emmington Jones; the late Charles Marinovich; Ken Stein; Richard Schwartz; Kathleen Tandy; and the late Albert Oaken for his generosity and encouragement. John Stansfield, docent extraordinaire at the Berkeley Historical Society, deserves special recognition. We used many postcards (including the rare Laotian card) that were among those he donated to the Society's collection. John also graciously helped with research.

Thank you also to Erin Kornblaum at the Western Jewish History Library at the Judah L. Magnes Museum; all the helpful staff at the African American Museum and Library: Veronica Lee, Sidney Brinn, Martha Van Devender and curator Rick Moss; Melvin Terry, Northern California Center for African American History and Life; and Theresa Salazar at the Bancroft Library.

Scott Thomas Bruce was an able research assistant who also made fine suggestions about postcards we might have otherwise overlooked. Carl Wikander was our editor and also kindly offered to do the index. Sayre Van Young and John L. Hayes also provided valuable proofreading and editing assistance.

Kathleen Tandy did the design and production of the book's interior and jacket. She guided the book from its beginning up to and including the printing process. It was a much more complicated endeavor than any of us expected. Thank you so much, Kathleen!

—Burl Willes

INDEX

References in **bold** *are to subjects appearing only in figures or captions on the page.*